To Don —
Happy Anniversary!.
All my love.
E Sthuine.

January 11th, 1979.

MODIGLIANI

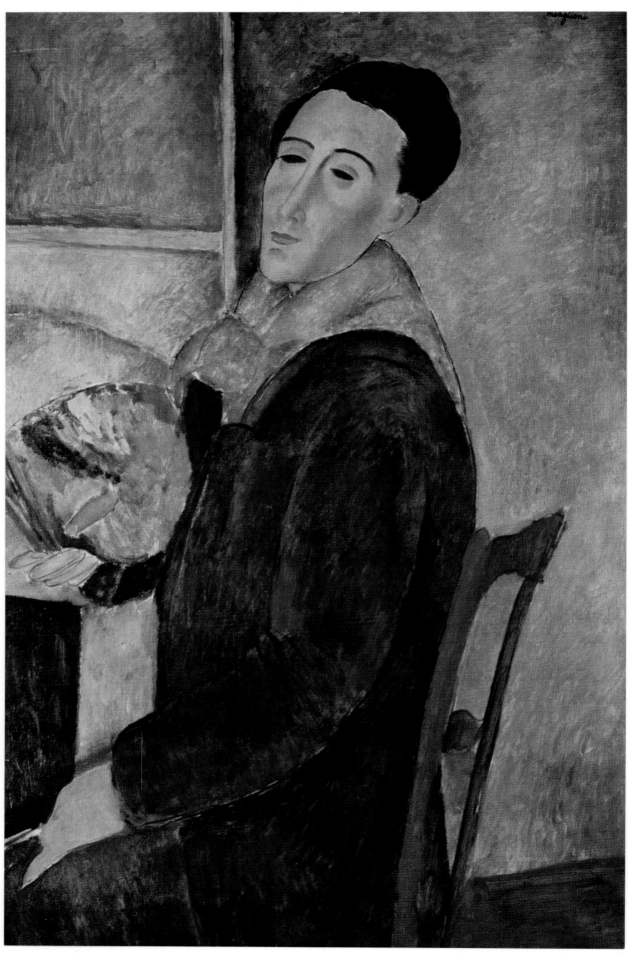

LIFT PICTURE FOR TITLE AND COMMENTARY

AMEDEO

Modigliani

TEXT BY

ALFRED WERNER

THE LIBRARY OF GREAT PAINTERS

HARRY N. ABRAMS, INC., *Publishers*, NEW YORK

Library of Congress Catalog Card Number 66-10990
Standard Book Number: 8109-0323-7
HARRY N. ABRAMS INCORPORATED, New York
Printed and bound in Yugoslavia

CONTENTS

COLORPLATES

MODIGLIANI

Modigliani

MODIGLIANI'S FRIEND AND COLLEAGUE, the maladjusted Chaim Soutine, was once asked, "You have had a great unhappiness in your life, haven't you?" His answer was a proud rebuke. "No. What makes you think that? I have always been a happy man." Strangely enough, he was telling the truth.

Had the question been addressed to Amedeo Modigliani, he would undoubtedly have answered in the same defiant spirit, and he, too, would have been telling the truth. To an artist, the term "happiness" stands for something different than it means to the average man. The artist is more likely to endure long years of poverty and concomitant miseries than is his neighbor, and besides these practical difficulties he usually suffers the unmitigated anguish of the creator. Yet when an artist tells us that he has been a happy man, his remark is sincere, and unchallengeable. A creative person can never be entirely unhappy. Beethoven, deaf and isolated, wrote in a letter that only the artist or the scholar "carries his happiness within him." Rodin considered true artists "almost the only men who do their work with pleasure."

Modigliani did not live to celebrate his thirty-sixth birthday. He wanted to be a sculptor, yet circumstances forced him to concentrate on painting. Though he lived and worked in the opening years of a century in which youth was to be considered an asset, Modigliani received little encouragement from critics or patrons; so little, indeed, that his single one-man show was a spectacular failure. He was frail, imprudent, and heedless of friends who advocated greater moderation. He caused suffering to those close to him,

9

not because he was sadistic, but because his attitude precluded compromise. He often starved, along with the woman who was his companion at the particular moment, yet on the rare occasions when a picture was sold, he scattered his money to the winds. He might still be alive and enjoying the fruits of fame, like his coevals Picasso, Segonzac, and Chagall, had he not acted on his instincts rather than following his highly developed, even brilliant, intellect.

Goethe has the Italian Renaissance poet Torquato Tasso say that while the ordinary man must suffer speechlessly, he, Tasso, could express his woe. Modigliani's drawings, paintings, and sculpture express his woe, but even more the pleasures he experienced during his brief years. "Although he died so young, he accomplished what he wanted," the sculptor Jacques Lipchitz has remarked, recalling that Amedeo said to him many times that all he desired was *"une vie brève mais intense."*

With all its turmoil, Modigliani's life was perhaps not so uniformly tragic as is customarily thought; but it was an extremely neurotic one.

Like the Expressionists with whom Modigliani is grouped in exhibition halls and in books on the École de Paris, he suffered from the psychoneurosis that afflicted so many excellent men of his generation. Nobody has characterized Modigliani more accurately than the Swiss psychoanalyst Oskar Pfister, though when he wrote *Expressionism in Art* (around 1920) Pfister apparently was not even aware of Modigliani's existence. When Pfister describes the solipsist whose paintings are exclusively self-portraits, symbolic representations of his own soul regardless of the subject, the neurotic who in his artistic activity strengthens his life force and overcomes the warring sides of his nature through projection and objectivation on the canvas —we clearly recognize Modigliani. Pfister's portrait of the vengeful, frustrated, almost megalomaniacal artist who creates his own outlets, and whose pictures contain the fulfillment of desires that are hidden even from himself, is as apt as his description of Expressionism—"a cry of distress, like a stream of lava forcing itself forward by the soul's misery and a ravenous hunger after life."

Before Modigliani's work became popularly

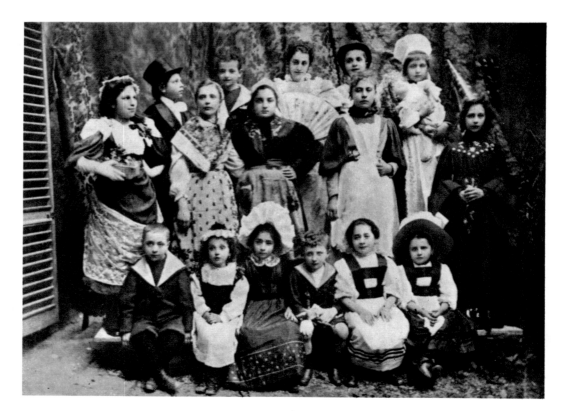

1. School-day theatricals, 1897. Modigliani is fourth from left in the back row

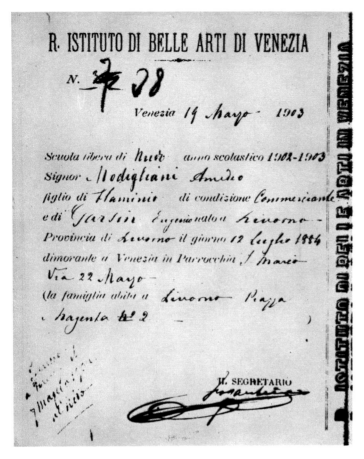

2. Certificate from the Istituto di Belle Arti in Venice.
In the lower left-hand corner is a confirmation of Modigliani's
enrollment in the free life-class school in Florence

talent, he molded his fantasies into new kinds of realities, which are accepted as valuable likenesses of reality.

In other words, he created for himself a world in which he could live comfortably, even happily. Whatever "pathological" traits an artist may show in his life, his creations may be healthy. Viewing the quiet, well-composed Parisian scenes by Modigliani's drinking companion Maurice Utrillo, one would hardly guess that their creator was a notorious dipsomaniac and a public nuisance. Many observers have noted with surprise the contrast between the stability of Modigliani's work and the instability of his life. The disorderly and sordid external experience of the man was unimportant compared with the inner life of the artist.

3. Modigliani, about 1905

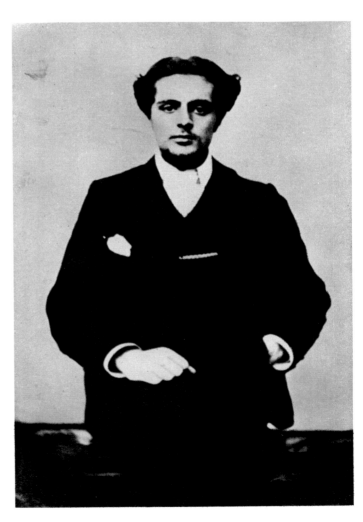

known, Pfister had provided this characterization of artists like him: "Repelled from the external world by bitter experiences, the cognitive subject hides itself away in its own inner world and magnifies itself into a world-creator. The immense self-conceit of the Expressionist artist is not vanity, but a psychologically well-founded experience, a necessary means to avoid the collapse of a lonely personality denuded of all reality. But this paranoiac autism has to be paid for with bitter martyrdom."

Had not Modigliani concentrated on his art, he would have ended as one of the countless unrecorded victims of Montparnasse Bohemianism. As a true, hard-working artist, however, he managed, through spontaneous expression, to maintain a balance between his dream life and reality. He was able to solve the artist's eternal dilemma by finding—to use Sigmund Freud's language— the way back to reality: thanks to his special

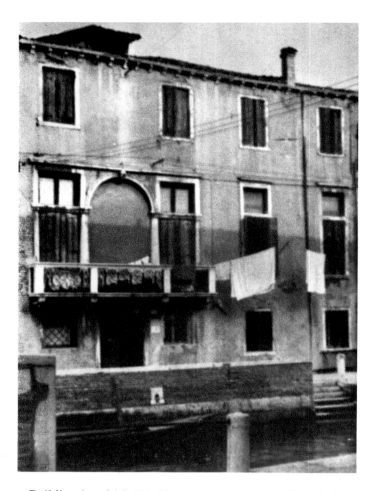

4. Building in which Modigliani occupied a studio. Venice

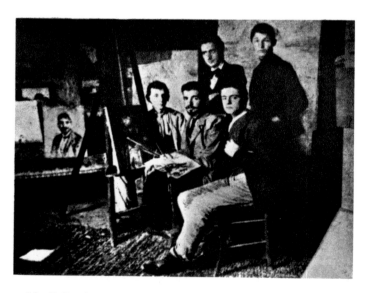

5. Modigliani (seated, far right) and fellow art students in the studio of one of them, Gino Romiti. Livorno, about 1910

What Modigliani felt, what paintings and sculptures influenced his art, what books he read are more significant than how he may have diverted

women from their husbands or lovers, how he misbehaved at noisy Montparnasse parties, and how his frail health rapidly deteriorated through use of alcohol and drugs. There is hardly an artist whose life has been embellished with as many legends as that of Modigliani. In the 1920s and '30s, when his fame and the prices of his oils mounted, scores of individuals began to claim to have been on intimate terms with him. If even a fraction of the episodes posthumously linked with his name were true, Modigliani could hardly have found the time to complete a single canvas.

Jeanne Modigliani, who devoted years to gathering accurate information from people who knew her father in his native country and in Paris, has presented the raw material for a biography, if not the biography itself. She explains that Modigliani's infrequent misbehavior had many witnesses, all of whom repeated the story in their own versions, but that when he worked soberly in his studio, he had only his models as witnesses. And she quotes his loyal dealer, Leopold Zborowski:

"He was a son of the stars for whom reality did not exist"

MODIGLIANI'S EARLY YOUTH

The city of Livorno—Leghorn to the English-speaking world—is neither interesting nor old. Long a swampy village on the Tyrrhenian coast, it was made a seaport by one of the Grand Dukes of Tuscany around 1600, after Florence, Pisa, and Siena had reached their peaks. Around 1900, when Modigliani was a boy, his native city had close to eighty thousand inhabitants, most of them active in seafaring, shipbuilding, or commerce. Its palaces and churches were new for a country with millenniums of cultural tradition, and its local museum contained only a few paintings of the Italian Renaissance masters.

Yet Livorno once served as a haven of refuge for thousands who were persecuted because of their faith, or who migrated there to escape from political oppression. There was a fairly large community of Sephardic—Spanish and Portuguese—

Jews who, from the city's beginnings, enjoyed privileges given to Jews nowhere else in Europe. Among the Jews who immigrated to Livorno in the eighteenth century was Solomon Garsin, great-grandfather of Eugenia Garsin, the mother of Amedeo Modigliani. In 1872, at Livorno, Eugenia Garsin married Flaminio Modigliani, of a Jewish family which had come from Rome.

Flaminio Modigliani was a small and unsuccessful businessman. His wife, Eugenia, was well educated and literary. She gave lessons in English and French, made translations into Italian, and is even supposed to have ghost-written novels in English. She was especially devoted to "Dédo," her fourth and youngest child.

When she gave birth to Amedeo ("beloved of God"), the family's fortunes were so low that Signor Modigliani had to declare himself bankrupt. Amedeo saw the light of the world in a

7. Passage de l'Élysée des Beaux-Arts, Paris, where Modigliani lived about 1911

6. The "Bateau-Lavoir" in Paris, where Modigliani, Picasso, and many other artists had studios early in their careers

shabby apartment to which the family had moved after having lived in a more elegant section of the city. Luckily, an odd legal provision governing the seizure of a debtor's property forbade the officers of the law from impounding a bed in which a woman had just given birth. Mother and child were covered by a mound of family possessions piled on the bed to be saved from confiscation.

Their poverty notwithstanding, the children received a substantial education. Amedeo went to the primary school, then to the *liceo*, the secondary school, where for about four years he received the traditional classical training. Though the family was not deeply religious—it was more Italian than Jewish—Amedeo at thirteen probably was prepared for *bar mitzvah* (the confirmation ceremony) in the synagogue.

It is uncertain at what age his talent emerged. Eugenia must have had a premonition, for when

13

Amedeo was only eleven, she wrote in her diary: "The child's character is still so unformed that I cannot say what I think of it. He behaves like a spoiled child, but he does not lack intelligence. We shall have to wait and see what is inside this chrysalis. Perhaps an artist?"

We know that his maternal grandfather, Isaco Garsin, besides helping his daughter's family financially, took a great interest in her youngest son's development. Much to the annoyance of his two older brothers, who were more interested in ships and sailors, Dédo engaged in serious discussions with the elderly man about philosophy and art.

Young Amedeo remained with his mother long

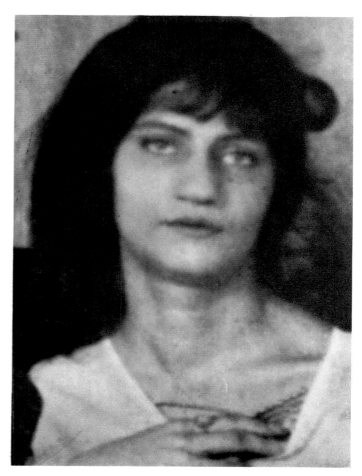

9. Jeanne Hébuterne

8. Jeanne Hébuterne in 1917, aged 19

after his two brothers had left for schools of higher learning. He read a lot, committing large parts of Dante, Petrarch, Leopardi, and Carduzzi to memory; and he admired Baudelaire and Nietzsche. But while he seems to have begun drawing and painting at some very early date, it was only at the age of fourteen, when he fell sick with typhoid fever, that his inner strivings clearly came to the fore: in his delirium he raved about the paintings in the Palazzo Pitti and the Uffizi in Florence, about which he had heard, weeping because he could not go to see them. Thereupon his mother promised that as soon as he recovered they would go to Florence together. She not only kept her promise, but also sent him to the best art teacher in Livorno, a painter named Guglielmo Micheli, (1866–1926). On April 10, 1899, Eugenia Modigliani could write: "Dédo has completely given up his studies [at the *liceo*] and does nothing

but paint, but he does it all day and every day with an unflagging ardor that amazes and enchants me. If he does not succeed in this way, there is nothing more to be done. His teacher is very pleased with him, and although I know nothing about it, it seems that for someone who has studied for only three or four months, he does not paint too badly and draws very well indeed."

MODIGLIANI AS AN ART STUDENT

Amedeo Modigliani worked in the studio of Guglielmo Micheli between 1898 and 1900, and thus his early training relates him to nineteenth-century Italian art. Because this century was not a fertile period in Italian art, there is a tendency to underestimate its personalities and creations. But the fact that little of Modigliani's early, pre-Parisian work has come to us should not prevent us from glancing at Italian art of the time as an inevitable source of inspiration for the budding artist. More of the work he did between 1898 and 1906 may yet be recovered at Livorno, Florence, or Venice; it should shed light on the painter's artistic beginnings. Moreover, there are statements on his earliest creations. We cannot believe that he dismissed the "modern" art of his country; we know that young Modigliani was no less impressed by Italian nineteenth-century art than he was by the work of the Renaissance. There is in Modigliani's early Parisian work as much Boldini as there is Toulouse-Lautrec.

During a stay in Rome in 1901, Modigliani admired the works of Domenico Morelli (1826–1901) and his school. Morelli's melodramatic paintings of Biblical subjects, historical events, and scenes from Tasso, Shakespeare, and Byron are now all but forgotten. However, in historical perspective, Morelli appears not as a reactionary but as one who paved the way for the later iconoclasts. A bold step far beyond Morelli was taken by a group of somewhat younger men, the Macchiaioli (from *macchia*, "dash of color"). A predominantly Tuscan school, it had its beginnings at the Café Michelangelo in Florence, where these revolutionaries met in the 1850s and united in abhorrence of the prevalent bourgeois taste of the academic genre painters. The Macchiaioli were related to the Impressionists in their subject matter; they liked to paint peasant houses, country roads, and the radiance of the sun on earth and water, but in technique they were not so bold as the followers of Monet.

In all likelihood the art student Modigliani was, for a time, a Macchiaiolo. His teacher, Micheli, was himself a favorite pupil of one of the founders of this school, Giovanni Fattori (1828–1905), of Livorno. Micheli was a landscape painter of some renown, and he achieved local success through his seascapes, fresh and vibrant with light. He was even more successful as a teacher. Nevertheless Amedeo wrote disdainfully to his fellow student Oscar Ghiglia from Capri a year after having left his master: "Micheli? Oh my God, how many of his kind there are in Capri ... regiments!" Though his first teacher was

10. Modigliani, about 1909

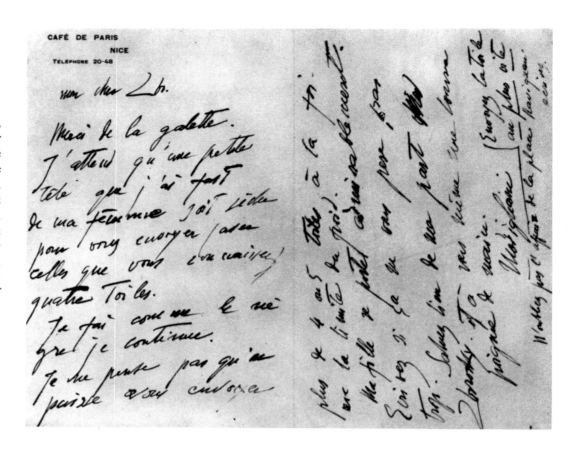

11. *Letter to Zborowski:* "My dear Zbo, Thanks for the dough. I am waiting for the little head that I did of my wife to dry so that I can send you (with those you know) four canvases. Like a Negro, I go on being just what I am. I don't think that I can send you more than four or five canvases at a time, what with the cold. My daughter is doing admirably. Write if it isn't too much trouble. Give my best greetings to Madame Zborowski, and for yourself a good handshake.

Modigliani

Send the canvas as quickly as possible. Don't forget the business about the Place Ravignan. Write.

a landscapist, Modigliani, after his student days, produced very few landscapes—probably no more than three; with their austere proto-Cubist color patterns they were obviously influenced by Cézanne rather than the Macchiaioli.

Amedeo was forced to break off his work with Micheli in 1900, when he contracted tuberculosis. Neither the local hospital, nor sunshine, to which Signora Modigliani had her son exposed in the south of Italy, could completely arrest the illness; it was to flare up again when the artist was in his mid-thirties. Amedeo did recover sufficiently to visit Capri, Amalfi, and other places. In Rome he attended Easter services at St. Peter's; he visited the art galleries, seeing old as well as new Italian masters.

Modigliani then went to Florence, where he took the examination at the Accademia di Belle Arti (Scuola Libera di Nudo); he passed it, but does not seem to have done much studying there. In 1902 and 1903 he lived and worked in Florence, and he spent the better part of the next three years at Venice, where he enrolled at the Istituto

di Belle Arti, periodically returning to his native city to be with his family, or, more precisely, with his beloved mother.

We have some scant knowledge of Modigliani's Italian years. A photo taken when he was twenty shows him as an unusually handsome young man with thick dark hair, thoughtful black eyes, and a soft mouth. A Spanish artist in Venice, Manuel Ortiz de Zarate, described him as a dandy who was popular with the ladies, and who painted in an academic manner. To De Zarate, Modigliani confided his burning desire to become a sculptor. He had to forego sculpting because of the high cost of the materials, and resigned himself to remaining a painter, *faute de mieux.*

The best source of information, however, is a group of five letters addressed by the seventeen-year-old Modigliani in 1901 to his friend Oscar Ghiglia. There was an extensive correspondence between these two young men. Modigliani's letters show such an independence of mind and idealistic attitude toward life and art as to make us ques-

16

tion the statements of De Zarate and others concerning Modigliani's early creations. Unfortunately, there are no statements in these letters referring to the writer's own work.

Ghiglia was Modigliani's senior by eight years. In his portraits of women and children he never went beyond the technique of the Impressionists, having started out as a Macchiaiolo himself. Ghiglia's decent but rather unoriginal work sold well from the start. In 1901 Modigliani looked up to his friend Oscar, who had already scored a success by having a self-portrait accepted by the Biennale in Venice. Their friendship must have started when the two met in Micheli's studio; they indulged in lengthy literary discussions while walking along the beaches of Livorno. Their topics must have included painting, too, but we have no idea who the artistic gods of these young men were. In 1902—the year after these letters were written—they shared quarters in Florence. After 1903 their friendship seems to have cooled.

Paolo D'Ancona, who published these letters in 1930, sees the influence of Nietzsche in them. Nietzschean, indeed, is Modigliani's thought that life should be fully lived, without useless sacrifice, without concern for obstacles, but with definite dutiful intent, and sometimes even with pain, in order to "save one's own dream." Nietzschean, too, is the advice he gives to his friend, to cultivate and hold sacred all "which can exalt and excite your intelligence," and to "seek to provoke . . . and to perpetuate . . . these fertile stimuli, because they can push the intelligence to its maximum creative power."

There are few precepts of art in these letters. Art for Modigliani was not a trade to be learned through great assiduousness, but rather a state of grace arrived at only by virtue of intellectual elevation. Once this exaltation is attained, it is followed by "the awakening and dissolution of powerful energies," and subsequently by the stage in which "excitement" is induced. Then and only then does one know the joy and liberation of creation: " . . . I am rich and fertile now, and I need work," Modigliani exclaims.

A decade later, in Paris, he would have smiled at this juvenile exuberance. But he would not have denied or negated it, for his idealism remained throughout his short, harried life. To the end he would have subscribed to the dictum of the seventeen-year-old: "Beauty . . . has some painful duties; these duties create, nevertheless, the most beautiful expressions of the soul."

MODIGLIANI'S FIRST SOJOURN IN PARIS

In 1906 three young foreigners, destined to leave their mark on art, arrived in Paris—Gino Severini, Juan Gris, and Amedeo Modigliani. Modigliani was a reserved, almost timid Italian Jew of twenty-two whose unostentatious yet perfectly appointed wardrobe showed that his family, though anything but rich, had taken good care of him.

Dédo did not fail to live up to the promises he had made to his mother, although he settled, of course, in the artists' quarter of Montmartre, then almost a suburb of Paris, renting a studio on the Rue Caulaincourt. When the critic André Salmon first saw it, the room was conventionally furnished with an upright piano and plush drapes; on the walls hung reproductions of Italian Renaissance masters and a plaster cast of Beethoven. Though Modigliani had changed into "artistic" attire—brown corduroys, scarlet scarf, and large black hat à la Bohème—he still looked like a bourgeois playboy in disguise.

For a time he was the perfect student away from home, writing regularly to his mother, and weeping with excitement upon reading her letters. He attended art classes at the Colarossi school, diligently sketching nudes. He drank wine moderately, and nothing stronger, eschewed vices, and kept his bachelor apartment in order. Being unsure of himself, he would not discuss art with strangers. He was also a bit of a prig. Once, when he encountered Picasso, who then sported soiled workmen's clothes, in one of the artists' cafés, Modigliani made a derogatory remark: Picasso might have talent, but that did not excuse his uncouth appearance.

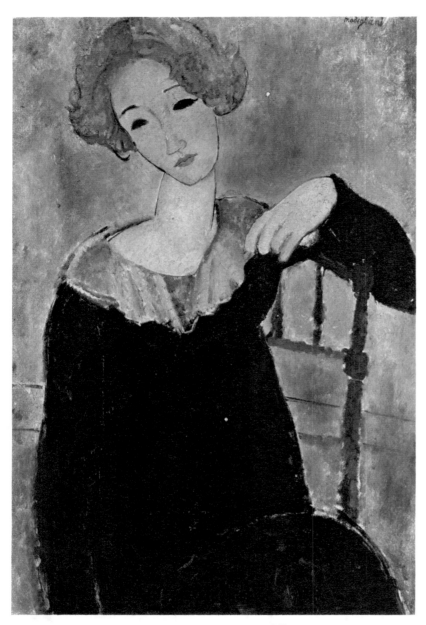

12. WOMAN WITH RED HAIR. 1917. Oil on canvas,
36 1/4 × 23 7/8″. *National Gallery of Art, Washington, D.C.*
(*Chester Dale Collection*)

come a *peintre tragique*, a *peintre maudit*, and the uncrowned king of vagabonds?

A few months after Salmon's visit, Louis Latourette, a poet and journalist, paid a call on the young artist at the Rue Caulaincourt studio; its occupant had already become an alcoholic and drug addict, and the pleasant, orderly room

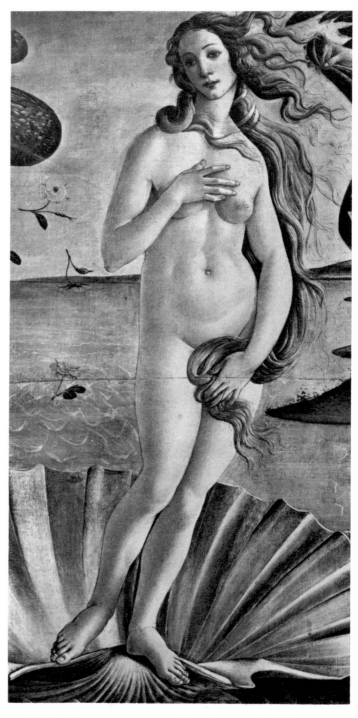

13. Botticelli: BIRTH OF VENUS (detail). c. 1480. Oil on canvas,
68 7/8 × 109 7/8″. *Uffizi Gallery, Florence*

An art historian, primarily concerned with the master's work and his place in twentieth-century art, might pass by such a story were it not that any information is welcome as a clue to both the work and personality of this artist about whom so little documented evidence exists.

Within a year after his arrival in Paris, this strait-laced young bourgeois became a Bohemian vagabond par excellence; and an academician without originality became "Modigliani." What led this scion of conservative businessmen to be-

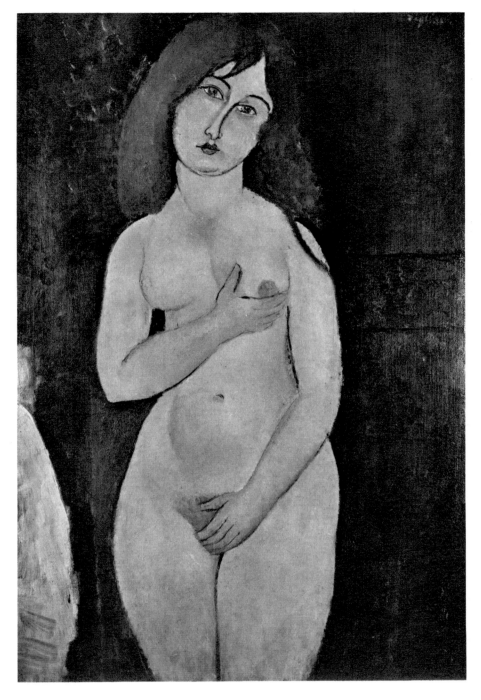

14. VENUS. 1918. Oil on canvas,
39 1/8 × 25 1/2″.
Perls Galleries, New York

had suffered a chaotic upheaval. The Renaissance reproductions had been thrust in a box. On another occasion, taking these out to show to the critic Gustave Coquiot, Modigliani remarked with a smile, "From the time when I was still a bourgeois." Once, as he was destroying nearly all of his early work, he explained to his neighbors, who thought that he had gone mad: "Childish baubles, done when I was a dirty bourgeois." His new gods, though he did not imitate them, were the Douanier Rousseau and

Picasso. It is not astonishing that he revolted against the bourgeois respectability of his father's family.

His tuberculosis, which never completely left him, was another factor in both Modigliani's craving for attention and love and his self-destructive tendencies. Lack of recognition possibly induced the artist to seek approval from fellow dipsomaniacs such as Utrillo and Soutine, who were as lonesome and frustrated.

Paris produced neither his talent nor his

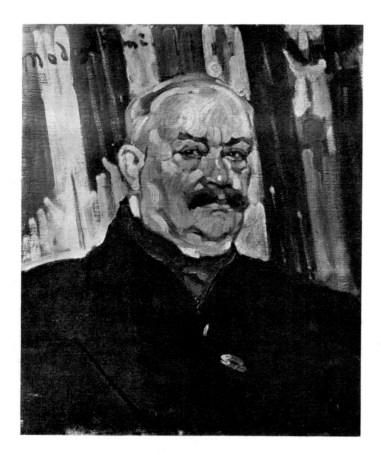

15. JOSEPH LEVI. 1910. Oil on canvas, 21 1/4 × 19 5/8".
Collection Mrs. Gaston Levi, New York

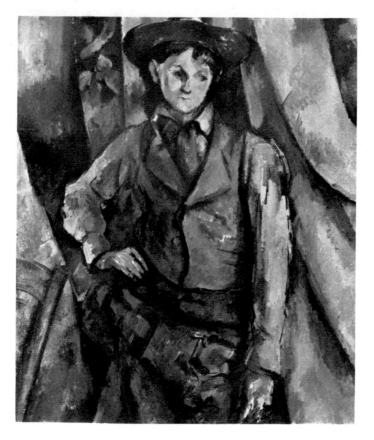

16. Cézanne: BOY IN A RED VEST. 1890–95. Oil on canvas,
36 1/4 × 28 3/4". *Collection Mr. and Mrs. Paul Mellon, Pittsburgh*

neurosis; it merely emphasized the morbid symptoms of both. Renting a studio in Montmartre did not automatically make one a member of the Bohemian family, nor did absinthe and hashish make one a great artist. These facts should be stressed, for from the 1920s on there have been many Parisian "Modiglianis" who have imagined that genius could be induced by deranging the senses. Perhaps this misconception is fostered by some writers who have carried the ideas in Murger's *Scènes de la vie de Bohème* into the twentieth century. André Salmon, for instance, has dangerously misinterpreted the role absinthe and hashish played in Modigliani's life. He kept on reiterating his theory that Modigliani's talent was directly due to his debaucheries: as long as he was sober and morally proper, he showed "nothing that would predict a brilliant career." But, adds Salmon, "from the day he abandoned himself to certain forms of debauchery, an unexpected light came upon him, transforming his art. From that day on, he became one who must be counted among the masters of living art."

The notion that artificial stimulants are essential to creative people is older than Montmartre and Montparnasse. Superficial observers have remarked that art and alcohol are "inseparably wedded as in the Greek myth Apollo and Dionysos imaged beauty and ecstasy," and that artists constitute "a small group of geniuses . . . whose spiritual and artistic powers are liberated, at propitious times, by alcohol." It would be nearer to the truth to say that use of drink and drugs among artists results from the same causes that drive the underprivileged to whisky and narcotics: poverty, lack of attention and security, and a desire to be bold.

Modigliani might have become an even greater artist had he been able to control his self-indulgent nature, as others managed to do in the face of adversity. In the Blue Period, Picasso lived in a room without a lamp, existed on a diet of cheap sausages, and had to burn his own drawings in the stove for a little occasional warmth. But he permitted nothing to interfere with his work, and

finally recognition and financial success came when Gertrude and Leo Stein and Sergei I. Shchukin bought his pictures. Modigliani's entire career, however, was destined to be a "Blue Period"; it lasted for thirteen years, and there was no one to stop him from ruining himself.

Alcohol and drugs may release tension and increase self-confidence in timid people. But against such advantages there are the dangers resulting from large-scale consumption of either poison: in the long run, reason is almost bound to be impaired; whatever euphoria is produced, the flight from reality may also release other dormant tendencies, such as obscenity, homosexuality, and the evasion of responsibility. While alcohol can help artists to overcome difficulties in starting their work, or in unblocking inhibited ideas, the

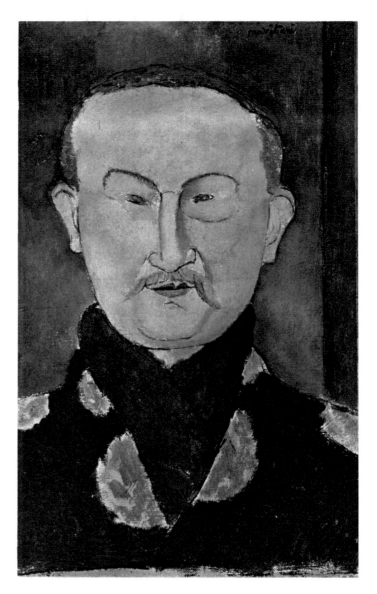

18. LEON BAKST. C. 1915. Oil on canvas, 21 3/4 × 13″. *National Gallery of Art, Washington, D.C. (Chester Dale Collection)*

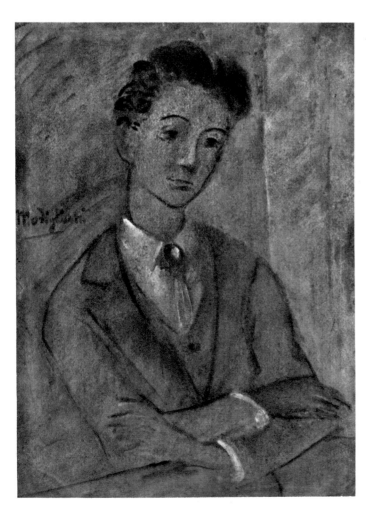

17. PORTRAIT OF A YOUNG MAN. C. 1910. Oil on canvas, 13 1/4 × 9 1/4″

value of this aid becomes manifest in sober intervals rather than in a state of intoxication. It is unknown which of Modigliani's works were produced under the influence of alcohol, but it seems that alcoholism contributed its share toward a certain monotony and repetitiousness in the works of the two great drinking partners, Modigliani and Utrillo. Unlike such sober and well-integrated personalities as Matisse and Picasso, they were limited to few media and few themes, and they actually gave few fresh ideas to art.

Alcoholism, except for lending courage to a timid artist, does not seem to have a direct influ-

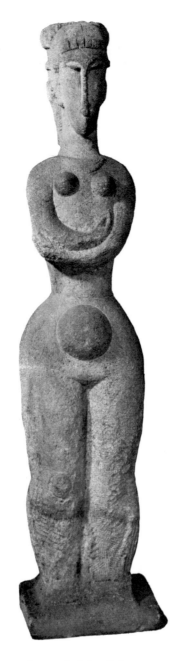

19. FIGURE. C. 1910. Stone, height 63″.
Collection Mr. and Mrs. Gustave Schindler, New York

20. CARYATID. 1911–12. Oil, 32 5/8 × 18 7/8″.
Collection Galerie Berggruen, Paris

ence on painting, though a deterioration of quality may be its by-product. There are minor Modiglianis, but (perhaps because the artist never actually reached the stage of *delirium tremens*) even these are well organized and co-ordinated. Nor can any trace of obscenity be found in his utterly frank nudes.

Hashish and related drugs, on the other hand, do affect creativity. No scientific attempt has been made to examine artists who are drug addicts, but writers such as De Quincey and Baude-

laire have given us their observations on the effects of narcotics. Two American scientists who claim that hashish causes the "loss of the ability to discriminate between what is good and what is bad" have noted the frequency of marijuana addiction among jazz players: "A three-piece honky-tonk may sound to them like a top-notch orchestra. This may be the reason why some musicians think they can play better under the influence of marijuana."

But there is no medical reason for suggesting

that either alcohol or hashish made Modigliani "invent" the features by which even a layman recognizes one of his paintings. Nor is it scientifically tenable to trace these "distortions" to defective eyesight, as has been attempted also in the case of El Greco. The artist's motivations for elongating figures are many and varied in the history of art, but mere optical deficiency is surely the least demonstrable—or likely—of these. The lengthening of figures is entirely absent from Modigliani's early works; and if astigmatism had developed in him at a later period, the faulty vision would have produced lengthenings in one direction only, not in different directions. It is, finally, perhaps possible that an artist suffering

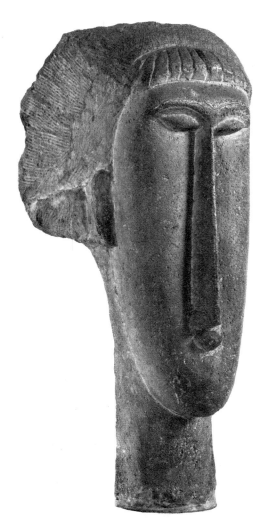

22. HEAD. C. 1910. Limestone, height 25 1/2".
National Gallery of Art, Washington, D.C.
(*Chester Dale Collection*)

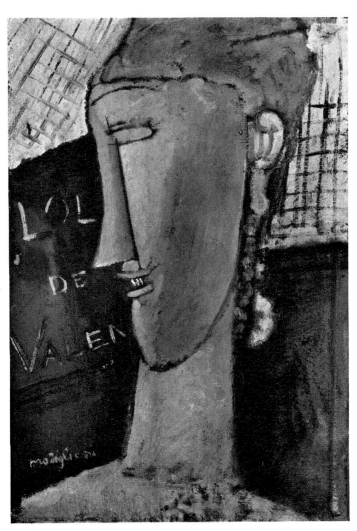

21. LOLA DE VALENCE. 1916. Oil on canvas, 20 × 13".
Collection Miss Adelaide Milton de Groot, New York

from eye defect could, at an early stage, learn how to compensate for it. And, whatever weird effects alcohol may have on the mind of an artist, it will not in any way change his vision so as to produce elongations.

Particularly irresponsible is the assertion that Modigliani's miraculous cure from the curse of mediocrity was caused by his debaucheries. "One morning," Salmon writes, "Amedeo Modigliani awakened transformed" And Charles Douglas, quoting the painter André Utter: "One night, at an alcohol and hashish orgy chez Pigeard . . . Modigliani suddenly gave a yell and, grabbing paper and pencil, began to draw feverishly, shouting that he had found 'the way.' When he had finished he triumphantly produced a study of

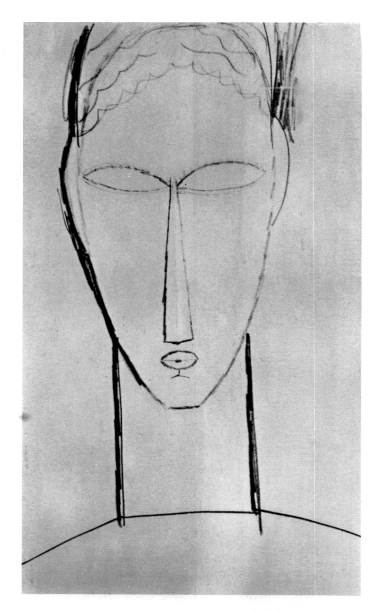

23. STUDY FOR SCULPTURE HEAD. C. 1910. Black crayon,
16 1/2 × 10 1/8″. *Collection Mrs. Sydney G. Biddle, Philadelphia*

a woman's head and the swan neck for which he
has become famous."

Actually, because he wanted to be free to
"distort" (i.e., to force his artistic concepts upon
reality), he had to live the life that would guarantee
him a maximum of freedom. One of the main
reasons he indulged in alcohol, hashish, and
sexual promiscuity was that these liberated him
from Livorno and all it stood for. He knew that
his family, his beloved mother not excepted,
would reject his new style of painting as crazy,
for nothing of that sort could be found in the

respected old masters. The bourgeois Italian
Jews lived chaste lives, drank only wine, married
early, and raised families. But this maverick
chose for a friend the ugly drunkard Utrillo, who
would never have been permitted to enter Signo-
ra Modigliani's apartment at Livorno. And he car-
ried on affairs with all kinds of women. His
whole life, it seems, was a series of protests:
against the bourgeois smugness of his family of
businessmen, against all that his art teacher
Micheli represented, against a society that failed
to recognize and reward his talent. While drunk,
he often carried his exhibitionism to extremes:
he would strip nude at social gatherings. In
painting, his exuberance led him always to reveal
his own face, as it were, within that of his sitter.

Modigliani worked as wildly as he lived.
Alcohol and hashish never diminished his feverish
desire for work. There may have been times
when lack of public response made him lie idle in
desperation. Reproached by a friend for doing
nothing, the artist retorted: "I do at least three
paintings a day in my head. What's the use of
spoiling canvas when nobody will buy?" On
the other hand, Arthur Pfannstiel, author of
Modigliani et son oeuvre, reports that the young
artist sketched incessantly and feverishly, filling
his blue-covered notebooks with drawings, and
producing up to a hundred a day.

It must be remembered that in this period
Modigliani still dreamed of becoming a sculptor,
and much, if not most, of his effort went into
sculpture. Critical by nature, he periodically
destroyed work that to him seemed inferior. But
he also lost many of his works as he furtively
moved from one shelter to another, being in ar-
rears in rent most of the time. Angry landlords
destroyed the "crazy" paintings he left in lieu of
payment, and bistro owners, to whom he bartered
his works for drinks rather than for food, did not
care much for them either. Other works were
carelessly given to his many casual girl friends,
who did not preserve them. Modigliani never
kept a record of his works.

He had a one-man show of sorts for the first

24

time in 1911, in the studio of his friend, the Portuguese painter Amedeo de Suza Cardoso, but this exhibition of drawings and sculptures was very limited. However, he had become a member of the Société des Artistes Indépendants in 1907 and had six entries in its show of 1908.

While Picasso, Van Dongen, Vlaminck, and Derain, close to him in age, by 1908 were already modestly successful, Modigliani only occasionally sold his works. "I've only got one buyer and he's blind," the artist used to say, jokingly. This was the dealer Père Angely.

On the strength of the early works alone, nobody could have predicted the marvelous accomplishments of the 1915–20 era. Yet these works are interesting because they fill the gap

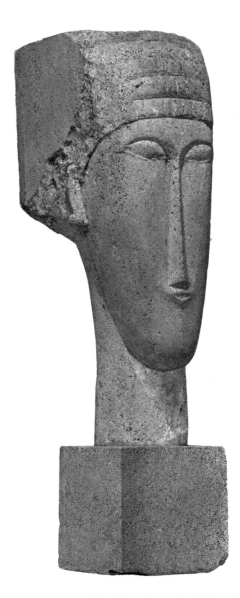

25. HEAD. 1912 (?). Limestone, height 25″.
The Solomon R. Guggenheim Museum, New York

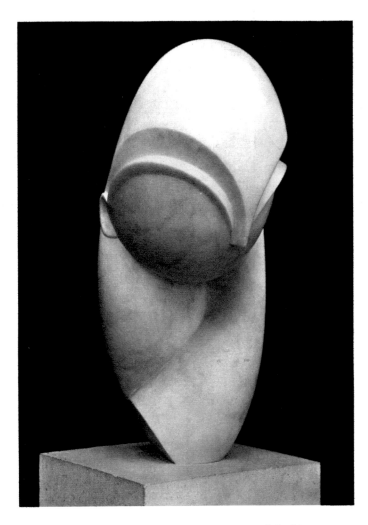

24. Brancusi: MADEMOISELLE POGANY. 1931. Marble on stone base, height (head and neck) 19″. *Philadelphia Museum of Art (Louise and Walter Arensberg Collection)*

between nineteenth-century realism and the new ventures of the École de Paris.

The artist himself called *Head of a Woman*, done before 1908, his "Whistler," and its delicacy and decorativeness are reminiscent of the American expatriate painter. Certain portraits done in 1908—*Maud Abrantès*, for example, and *Equestrienne* (page 75)—are reminiscent of Boldini in their elegance and charm, and of Toulouse-Lautrec in their wit. The colors, however, are usually subdued and cool.

Toward the end of his first Parisian sojourn Modigliani fell under the spell of Cézanne. He must have seen the 1907 Cézanne retrospective at the Salon d'Automne; he probably also saw

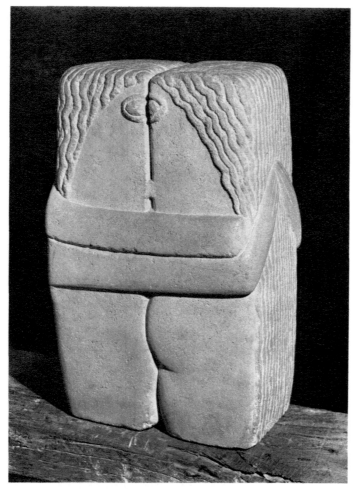

26. Brancusi: THE KISS. 1908. Stone, height 23".
Philadelphia Museum of Art
(Louise and Walter Arensberg Collection)

so little influence upon the young artist. Fauvism emphasized color, whereas line was Modigliani's preoccupation. In the beginning he complained that his "damned Italian eyes" could not get accustomed to the special light of Paris. His palette was not richly varied, and only once or twice did he experiment with colors in the manner of the Neo-Impressionists or the Fauves. As a rule, he would surround large areas of even color with thin yet distinctly drawn lines. Cubism, with its dehumanization, was too cerebral for Modigliani, whose art was a means of registering strong emotion.

While the early oils, despite an admirable technique and occasional traces of original charm and lyricism, are not really outstanding, the drawings of 1906–09 anticipate the mature painter

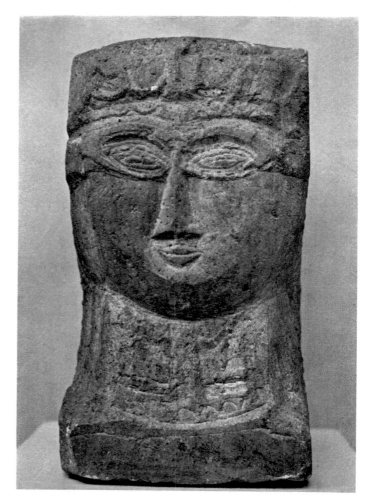

the four smaller shows held at the gallery of Bernheim-Jeune between 1907 and 1909.

From Cézanne he learned how to build with broad planes and large areas of color, and also how to "distort" and deviate from realism for the sake of aesthetic beauty or emotional pitch. But no Cézanne influence is noticeable in any works created prior to the artist's return to Italy in the spring of 1909. The first real fruit of the Cézanne study was *The Beggar* (page 79), done during his eight-month stay in Italy (1909), and correctly characterized by Pfannstiel as *"une copie d'après Cézanne."* It was followed by the far superior *Cellist* painted after the artist's return to Paris, where he saw one version of *Boy in a Red Vest*.

It is significant that Fauvism and Cubism had

27. HEAD. 1912. Stone, height 18 1/8".
Musée National d'Art Moderne, Paris

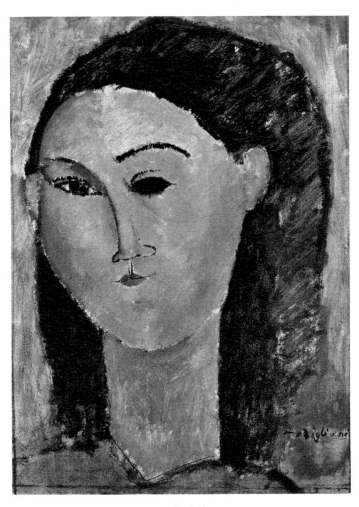

28. PORTRAIT OF A GIRL. 1916. Oil on canvas,
18 1/8 × 12 3/4″. *Private collection, New York*

There are, as far as we know, few drawings and no oils from the early part of 1909. Having made the acquaintance of Constantin Brancusi, and having fallen under the spell of African Negro art, Modigliani returned, with great vigor, to his original idea—concentrating on sculpture. Exhaustion from frenzied work in this refractory medium, an imprudent mode of life, and absolute lack of recognition jointly contributed to the artist's collapse. Taking his works into their safekeeping, friends put the emaciated Modigliani on a train to Livorno, to his mother, whom he had not seen for three years.

FROM 1909 TO 1920

We are not well informed about any of the periods in Modigliani's brief but intense life, even though he was able to express himself well in

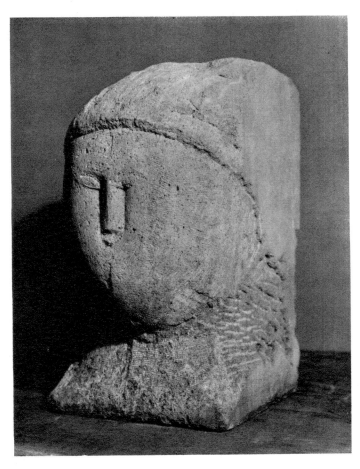

29. HEAD. C. 1914. Limestone, height 18 1/2″.
Photo courtesy Perls Galleries, New York

of 1915–20. They are not all of great significance; some are mere sketches of café patrons, the usual sketches sold by hungry artists for a few francs. But there exists a series of excellent studies, in ink or crayon, of actors, comedians, and harlequins as seen in *café-concert* performances. In subject matter and in sureness of execution, they are reminiscent of a lithograph album executed by Toulouse-Lautrec in 1893. Like him, Modigliani knew how to grasp a pose or a sudden quick movement and, while rendering a few absolutely necessary details realistically, to be on the whole "abstract." As a painter he was still fettered by his Italian academic training, but as a draftsman he had already achieved an admirable freedom, expressing himself through a few bold lines, relying upon swift suggestion rather than precise definition.

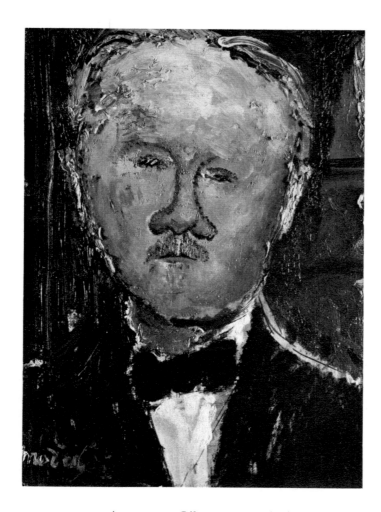

30. MONSIEUR CHÉRON. 1917. Oil on canvas, 18 1/8 × 12 7/8″.
Collection Mrs. Evelyn Sharp, New York

words, as is indicated by the five long letters he wrote to Oscar Ghiglia. But the usually short letters he addressed later in life, to his mother or to Leopold Zborowski, give little information about his inner or outer life. "Letters and I are enemies, but don't think I forgot you and the others," he explained apologetically on a card he sent his mother in 1915. He wrote her, briefly, about his success (he wanted her to think that he was gaining recognition), his health, and the baby that was born to him and his companion, Jeanne Hébuterne. The letters from Nice to his dealer, Zborowski, contain little more than pleas for money and references to the sale of pictures. We can reconstruct Van Gogh's life from his letters but Modigliani left us no such aid.

Nor did Modigliani have a lifelong friend, as Toulouse-Lautrec had in Maurice Joyant, who devoted much energy to the preservation of Lautrec's work and the elucidation of his personality. Modigliani was known to the outstanding critics and writers of France, among them André Salmon, Jean Cocteau, Blaise Cendrars, and Francis Carco, yet most of them wrote only gossipy pieces about the painter after he had died. Thus the artist's daughter, who has studied all the sources most carefully, is forced to write:

"When it comes to Modigliani's visits to Livorno as well as to his successive addresses in Paris, utter confusion reigns and all the monographs contradict one another Definite dates for the period from 1909 to the war are scarce Between 1912 and 1914 there are no reliable dates for Modigliani's life and work" And so on.

He spent the summer of 1909 with his family in Livorno, and among the pictures he painted there was the one called *The Beggar*. This *Beggar* as well as the two versions of *The Cellist* were among the six pictures he exhibited in 1910 at the Salon des Artistes Indépendants. By this time he already had the support of many critics, poets, and fellow artists, but except for the loyal Dr. Paul Alexandre, no one wanted to buy his work. He moved from one place to another, never able to afford a decent studio. At one time he lived in *La Ruche* (the "Beehive"), an odd ramshackle building in the Rue Dantzig, where Chagall, Kisling, Soutine, and many other foreign artists also had their tiny studios.

Between 1909 and 1915 he considered himself a sculptor and did very little painting. In these years he began many interesting and rewarding friendships. In 1913 he first met Chaim Soutine, an uncouth immigrant from Lithuania whose intimate friend he became and whom he tried to teach manners. Soutine was ten years younger and painted in explosions of thick paint, hardly a style that one might think attractive to his Italian friend. In 1914 the poet Max Jacob introduced Modigliani to Paul Guillaume, the first dealer to arouse the interest of his clientele in the painter's work. Yet a much deeper re-

lationship developed between Modigliani and another dealer, Leopold Zborowski, whom he met in 1916. The help of Zborowski and his wife made it possible for him to create the substantial oeuvre of his last three or four years. Zborowski was an anomaly among modern art dealers in that he devoted a fanatical love to his protégé despite obstacles—particularly the artist's rashness and hot temper—that would have discouraged a less dedicated person.

Besides his mother, two women played important roles in the artist's life. The first was Beatrice Hastings, an English journalist and poet whose Montmartre apartment he shared in 1915 and 1916. We know her energetic, hard features

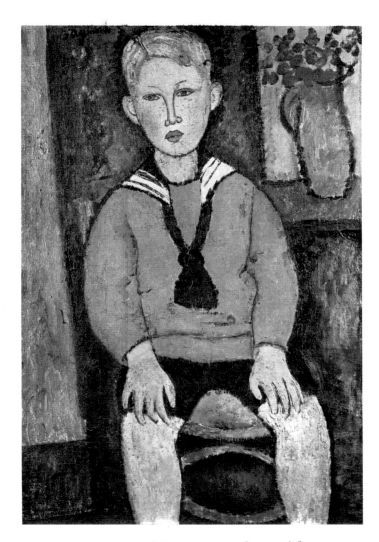

31. BOY IN RED. 1917. Oil on canvas, 36 × 23 1/2″.
Collection Mrs. Evelyn Sharp, New York

from the numerous portraits Modigliani has left. There were often turbulent scenes in their ménage on the Rue Norvins.

In the summer of 1917 he met the woman who all but legally became his wife. She was Jeanne Hébuterne, an art student, fourteen years his junior, small, attractive, quiet, and docile. A statement of three lines scribbled in ink by Modigliani reads: "Today, July 7, 1919, I pledge myself to marry Mlle. Jane [sic] Hébuterne as soon as the documents arrive."

This statement was signed by the artist and his fiancée, and was witnessed by Zborowski and by Lunia Czechowska. Yet, whether it was because of the failure of the documents to arrive, or for some other reason, the union between the two lovers was never legalized.

In December, 1917, Modigliani had his only real one-man show, organized by Zborowski at the gallery of Berthe Weill. Instead of success, it brought scandal. A crowd gathered before the window in which a painting of a nude was hung. The police insisted that this oil and four other nudes be removed from the show. Not a single painting was sold.

The years of the First World War were not propitious to the arts. Sitting in the Café de la Rotonde, Modigliani would draw quick pencil sketches of the customers and offer them for five francs apiece. In all likelihood sales were few.

By the spring of 1918, Modigliani's health had deteriorated rapidly. Jeanne was expecting a child. The Zborowskis and the Hébuternes decided that something must be done for the health of the couple, and sent them to the south of France. On November 29, 1918, in the maternity hospital at Nice, a daughter was born, registered as Jeanne Hébuterne. In Nice the artist worked feverishly. He was introduced to Renoir who, then in his late seventies and in poor health, was living at nearby Cagnes-sur-Mer. The meeting was brief and unsatisfactory, largely, it seems, owing to Modigliani's arrogant behavior.

In May, 1919, Modigliani was back in Paris, to be followed soon by Jeanne. There were signs

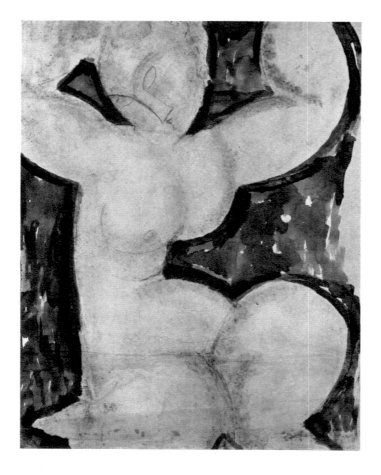

that he was gaining recognition. Newspapermen wrote about him. Several of his canvases were included in an exhibition of French paintings in London. His work began to sell. Modigliani would have had reasons for rejoicing, had not his health taken another turn for the worse. He vacillated between optimism and despair. In a moment of hope he wrote to his mother that he was planning to visit her the following spring. In other moments he felt the approach of death. Had he looked after himself, abstained from liquor, and permitted himself sufficient rest, he might have lived a little longer. Instead, he continued to work feverishly and in his spare hours to wander in desperation from one café to another.

He fell ill with a grave kidney disease which was soon complicated by tuberculous inflammation of the cerebral cortex. One day in January, 1920, he had to be taken to a hospital. Jeanne Hébuterne, pregnant again, saw him there on January 24, and was with him when he died. His last words are said to have been, *"Cara Italia!"* The next morning Jeanne threw herself from the fifth-floor window of her parents' home and was killed instantly. There were two funerals, a small one for the young woman, whose body was interred in a cemetery outside Paris, and a large one at the Père Lachaise cemetery. There a rabbi recited the prayers. The Hébuternes had resented their daughter's union with a Jew and would not even allow their bodies to be united in death, but in 1923 Senator Emmanuele Modigliani, the artist's oldest brother, persuaded them to permit the remains of their daughter to be reinterred at Père Lachaise with her lover.

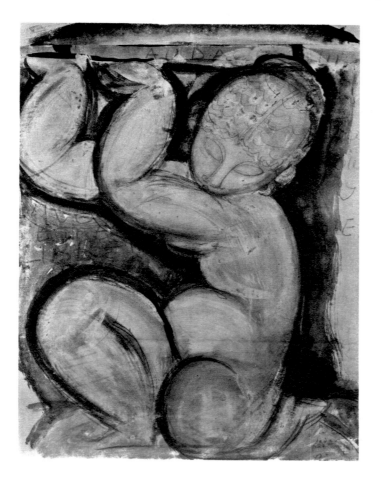

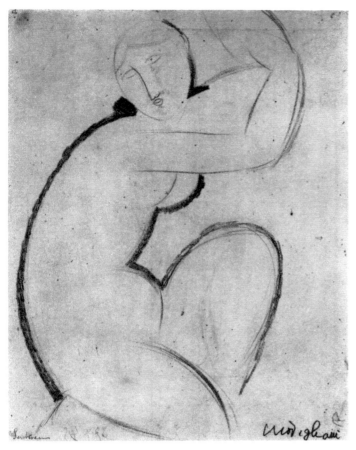

34. CARYATID. C. 1914. Pencil and crayon, 13 1/2 × 10 1/2″

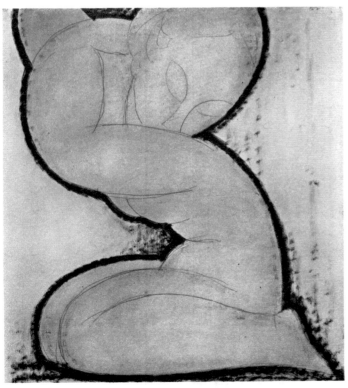

35. CARYATID. C. 1914. Red crayon, india ink, pencil, 22 1/2 × 19 3/8″. *Collection Mr. and Mrs. Crozer F. Martin, Philadelphia*

The following inscription was incised into the flat granite stone that covers both graves:

Amedeo Modigliani, painter, born in Livorno on July 12, 1884; died in Paris, on January 24, 1920. Death took him at the moment he achieved glory. Jeanne Hébuterne, born in Paris on April 6, 1898, died in Paris on January 25, 1920 —Faithful companion even in the ultimate sacrifice.

The Parisian newspapers and magazines of 1920 were filled with obituaries and commemorative

36. GREEN CARYATID. C. 1914. Gouache, 29 3/4 × 16 3/4″. *Collection Guy B. Gorelik, New York*

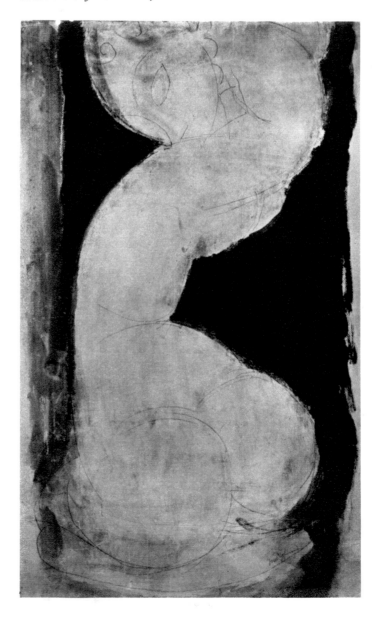

articles. Modigliani's significance was summed up by the French poet Francis Carco:

"A life marked by poverty, worry, the desire to escape platitudes by contradictions, by the wish to surpass, by thirst for punishment and the willingness to become a target for the supposedly astute. Life of an artist, life of exaltation! I shall not recount the picturesque Bohemianisms of it or the paradoxical and constant defiance of rule; or the absence of all traces of domesticity. But for all that, for all the defects and qualities, the taste for unhappiness and the exceptional, the torrent of graces, the deliriousness and the naughtiness,

Modigliani leaves a void behind him that cannot soon be filled."

THE INNER LIFE OF MODIGLIANI

Life is a gift / from the few to the many / from those who know and who have, to those who know not and have not.
(Inscription by Modigliani on several drawings)

Since Amedeo Modigliani lived in a self-destructive, turbulent manner, it is perhaps suprising that he could produce drawings, paintings, and

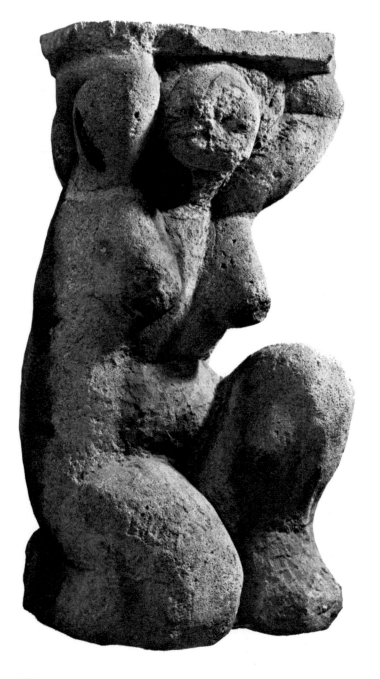

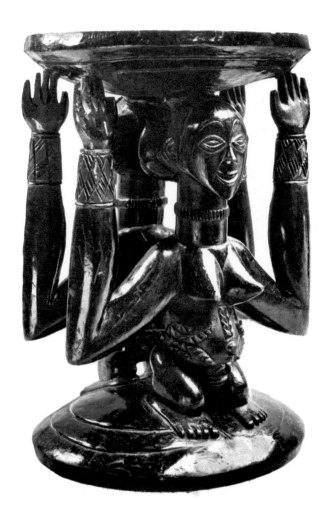

Left:
37. CARYATID. 1913–14. Limestone, height 36 1/4″.
Museum of Modern Art, New York

Above:
38. Stool supported by two squatting figures,
from Baluba, Republic of the Congo. Wood, height 16″.
Musée Royal du Congo Belge, Tervuren, Belgium

sculpture of such cool purposefulness, firmness of line, color, and controlled design. One would rather expect thick impastos of orgiastic color, and irregular shapes, as in the work of his *copain* Soutine.

He did not fight his alcoholism, but he gladly dedicated all his strength to the aesthetic transfiguration of his inner imagery. His pictures convince us that he was as strong-willed and as virile as the robust and luckier Picasso, that he died fighting within himself his lonely and heroic battle between lust and asceticism, discipline and abandon.

Of Modigliani's numerous biographers, few shed light on his oeuvre. There are, however, two revealing stories. The Swiss critic Gotthard Jedlicka tells us that Modigliani had a boundless admiration for Cézanne. At the mention of Cézanne's name, a reverent expression would come over his face. He would, with a slow and secretive gesture, take from his pocket a reproduction of *Boy in a Red Vest*, hold it like a breviary up to his face, draw it to his lips, and kiss it. The other story is told by Franco Russoli, the important young Italian art historian. Summoned to paint the portrait of a collector, Modigliani spotted a work by Picasso in the apartment and begged the owner to keep it nearby while he was painting, as an example and an inspiration.

This deification of art by the painter seems to be far more significant than any of the acts of exhibitionism he may have committed in the bars of Montmartre and Montparnasse. Modigliani represents the school which holds that art grows upon art, not upon the observation of nature. His work is the very antithesis of Courbet's or Pissarro's, and it seems linked intellectually to Delacroix, who repeatedly warned against close imitation of nature, and to Degas, who declared, "The air we see in the paintings of the Old Masters is never the air we breathe."

For Modigliani, nature was not important. He painted only three landscapes—if one may apply this term to the hard, dry renderings of Midi vistas he made toward the end of his career—and no

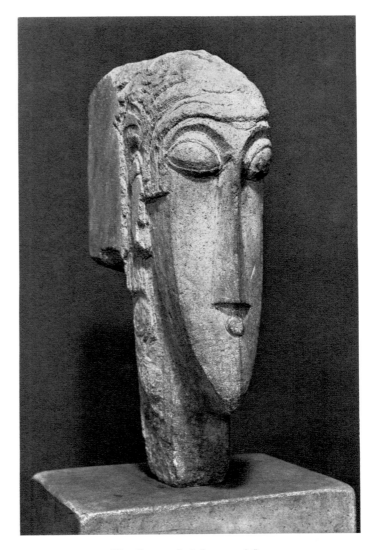

39. HEAD. 1915 (?). Stone, height 22 1/4".
The Museum of Modern Art, New York. Gift of Abby Aldrich Rockefeller in memory of Mrs. Cornelius J. Sullivan

still life is known, although a still life is mentioned by one biographer. He never portrayed people amid green foliage; *La Belle Épicière* is seen in front of a few trees—but they are stylized and leafless. His backgrounds are nearly always simple —modulated areas of aquamarine, turquoise, greenish-gray, or brown. His portraits and his studies of nudes use people as points of departure; they are pictures rather than slices of life. Whistler called his mother's portrait *Arrangement in Gray and Black*. Modigliani, who initially admired Whistler, might have described his own pictures as "Arrangements of Ovoids and Cylinders." Though responsive to the currents leading to

abstract art, Modigliani is really related to all artists who simplify and generalize nature for compelling reasons—from the medieval "primitives" of his native Tuscany to the Pre-Raphaelite brotherhood, the Pointillists, the maverick Whistler who willy-nilly contributed to the antinaturalistic trend that was to reach its apex in our time.

But Modigliani was *sui generis*. While Whistler's predominantly decorative portrait studies are cold, those of Modigliani glow with subdued fire. It is curious that whenever Modigliani is called an Expressionist the cry goes up that Expressionism cannot possibly include the classical *finesse* of a Modigliani; but Expressionism's stress is on *inwardness* more than on anything else, while its

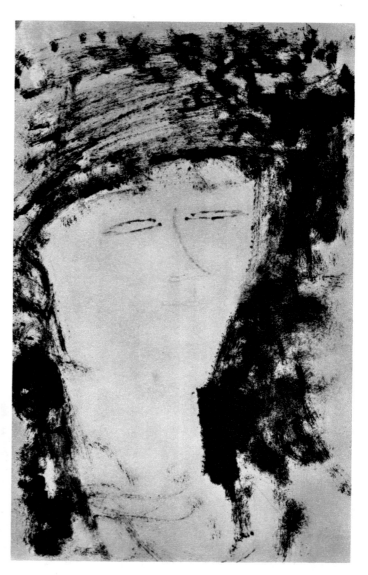

41. PORTRAIT OF BEATRICE HASTINGS. 1916. Oil and pencil on paper, 17 1/8 × 10 1/2″. *Perls Galleries, New York*

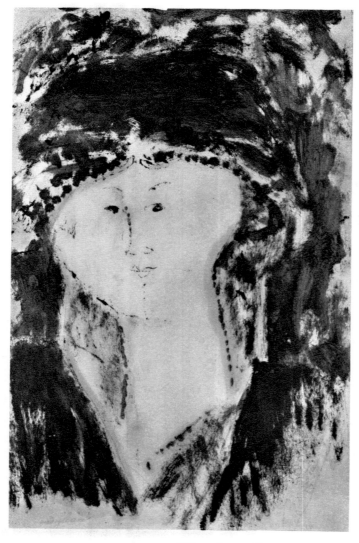

40. BEATRICE HASTINGS. 1915. Oil and pencil on paper, 16 1/8 × 10 1/4″. *Perls Galleries, New York*

distortions of the ordinary forms and colors of nature are merely instruments used by each individual artist as he sees fit, with stronger control in one case, greater spontaneity in another.

Modigliani is as much an Expressionist as, for instance, Soutine. The English critic Patrick Heron has even insisted that "underneath the broken and distorted surfaces, the swirling Prussian blues and brick-reds, the form of Soutine's figures is very nearly identical with Modigliani's skittle-shaped ladies and gentlemen." Modigliani is classically firm but not cold, wise but not over-intellectual. If this middle-class Jew from Livorno, blown by a strange wind from the quasi-Impres-

34

sionist studio of his first teacher and from the conservative academies of Florence and Venice into the seething caldron of Paris, can be associated with any school at all, it would be that of Expressionism. For the anticlassical crudeness of the Fauves was not for him, though there is Fauve color in some of his early paintings, and Cubism was too rational for his fervent soul, though there is a faint echo of it in the stereometric forms to which his figures can be reduced. Futurism, with its proto-Fascist glorification of machine and war, its hatred of the nude and the art of the museums, was anathema to him, and he refused to sign the *Futurist Manifesto*, even though the movement's originators were Italians like himself.

Modigliani succeeded in being both representa-tional and nonrepresentational at the same time. He fulfilled the demands of the purists, who emphasized that a picture was a plane surface covered with colors assembled in a certain order, but he also provided his canvases with rich human, sexual, and social implications. He reveals and conceals, takes away and adds, seduces and soothes. This inspired eclectic—who was aristocrat, Socialist, and sensualist in one person—employs the tricks of the Ivory Coast craftsmen (whose statues excite us without involving us) and those of Byzantine and early Renaissance icon makers (who touch us but cannot stir us to our depths) and, *e pluribus*, shapes a pulsating "Modigliani."

There is more in his pictures than meets the impatient glance. A quick look takes in the charac-

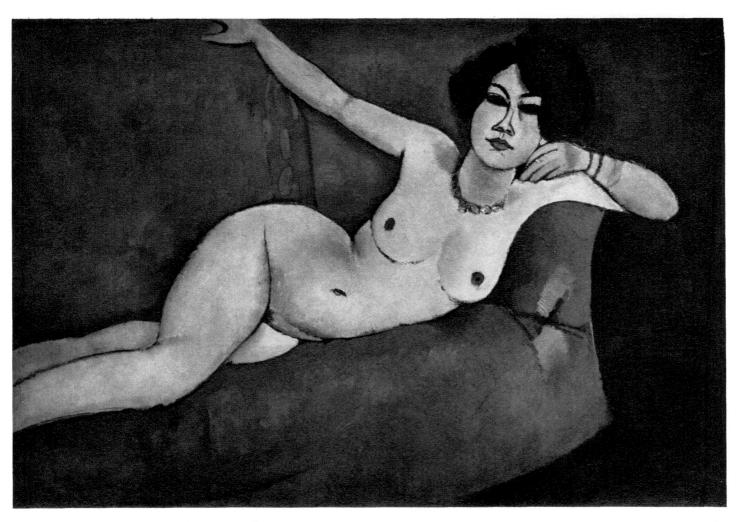

42. NU AU DIVAN (ALMAISA). 1917. Oil on canvas, 31 3/4 × 45 1/2".
Collection Mr. and Mrs. Paul D. Wurzburger, Cleveland, Ohio

35

teristic flat, masklike face—the almond-shaped eyes, the spatulate or slightly twisted nose, the small pursed mouth, all of it in a head narrowed to the extreme—the neck, either overlong or virtually nonexistent; the calculated disproportion between head, torso, and leg; the sculptural approach; and finally, the resonant and intensely luminous though uncomplicated color applied with a restraint that is totally absent in most other Expressionists. Yet if one looks longer, more comes to the surface. The tiresome complaint that all Modiglianis look alike is silenced upon study of his work. The men and women he painted—the poet Jean Cocteau, the sculptor Henri Laurens, the artist's companions Beatrice Hastings and Jeanne Hébuterne, and others about whom we know less, or even nothing, including some who belong to the lowest level of society—are characterized in the most subtle ways: by a stronger tilting of the head, a variation of the angle of the nose, an ironical, surly, or sensitive mouth, the position of arms and hands, or by hot or cold pigment to provide mood. His sitters are elegant or slovenly, sensuous or dispassionate, intellectual or dull.

His work contains pity for man and man's condition, yet it has that amazing poise so often absent in the works of other members of the École Juive. Modigliani's work is full of melody, one of tenderness and calm beauty. It is delicate, yet it also has strength. This is particularly evident in the drawings, mostly done with a thin pencil, where the undulating sharp line reaches an im-

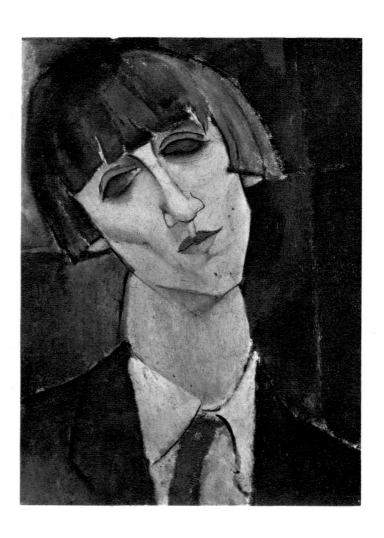

Above:

43. WOMAN WITH NECKLACE (JEANNE HÉBUTERNE). 1917. Oil on canvas, 21 3/4 × 15″. *Collection Robert Eichholz, Washington, D.C.*

Right:

44. MADAME KISLING. C. 1917. Oil on canvas, 18 1/8 × 13″. *National Gallery of Art, Washington, D.C. (Chester Dale Collection)*

36

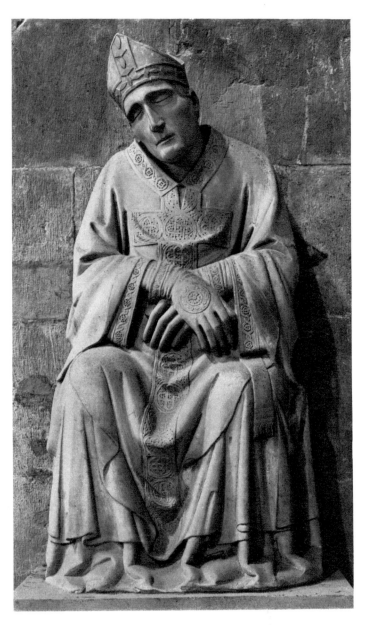

45. Tino di Camaino: BISHOP ANTONIO DEGLI ORSI. 1321. Stone, height 52″. *Cathedral, Florence*

"Such vision is a seeing quite other than the customary seeing of the eye; utterly inward, different for each soul, and therefore incommensurable to the common sights of the common world of nature and men. We can behold it only when, and as, our eyes are shut to that world. Beside that world, our seeing seems 'distorted.' But for the soul it is a way of escape from the civilization which rends it. The inward seeing is a sort of 'eye music,' the opposite of the Impressionist, which degrades man 'to be the gramophone of the world without.'"

46. JUAN GRIS. c. 1918. Oil on canvas, 21 5/8 × 15″. *Collection Miss Adelaide Milton de Groot, New York*

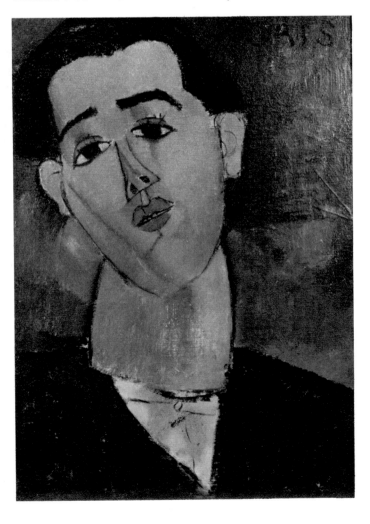

perious assuredness that commands the spectator to complete the omitted contour of the face or body.

In his mature drawings and paintings Modigliani does not resort to faraway, languorous gazes; he often achieves mystery by a simple device, either closing the eye or indicating it with a mere narrow blue or brown slit. Was this to keep out the hostile world? Or did it mean concentration directed inward?

Horace Kallen, in *Art and Freedom*, described Expressionism in a way that fits Modigliani's art:

MODIGLIANI, MASTER DRAFTSMAN

Several great draftsmen—Derain, Picasso, Dunoyer de Segonzac, Pascin, Gris, and Chagall, in addition to Amedeo Modigliani—were among the École de Paris artists born in that fruitful decade, the 1880s. All received thorough training in draftsmanship from their academic teachers, still under the spell of Ingres's theory that one must draw,

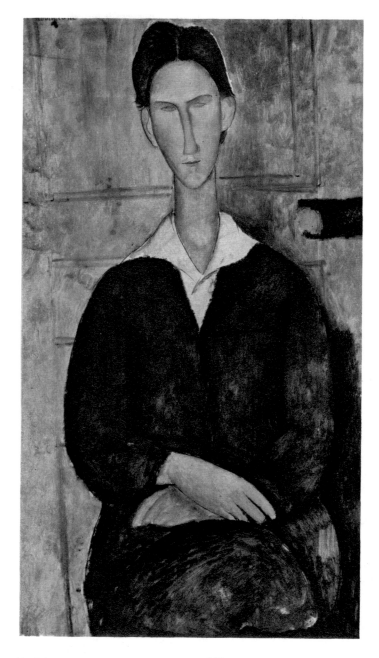

47. BOY WITH RED HAIR. C. 1919. Oil on canvas, 39 1/4 × 25 1/2″. *Collection Mr. and Mrs. Theodore E. Cummings, Beverly Hills, California*

draw, and draw again, even draw with one's eyes when one could not draw with a pencil. Ingres taught that drawing contained everything except the hue. The post-Ingres generation inevitably came to resent what they considered the professorial insistence upon copying without thinking. These post-Ingristes were also the artistic heirs of Delacroix, who held that painters who were not colorists produced illuminations rather than paintings.

None of the seven mentioned cared to do minutely accurate portrait drawings like those of Ingres, yet none was disrespectful of him. Ingres had demanded more than technical proficiency: "Drawing is also expression, the inner form, the plane, modeling." He urged his students to be unafraid of exaggeration ("What you have to fear is lukewarmness"), and to accentuate the striking figures of a model even, if need be, "to the point of caricature."

The young Delacroix had believed—as did the post-Ingristes also, Modigliani included—that the teaching at the École des Beaux-Arts, that bulwark of Ingristes, made students preoccupy themselves with the perfect description of facts at the expense of the inner coherence of form. Modigliani's teachers in the Italian academies, timid heirs of the Renaissance tradition, unquestionably thought that they must demonstrate their knowledge of anatomical facts, not realizing that their drawings showed no personal, spontaneous reaction to the sitter. Hence, Modigliani's remarkable indifference to the anatomical data held sacred at the academies did not mean that he was unable to draw in the strict academic sense. He could ignore the rules because he had mastered them.

So little is known about the early years of Modigliani's career—the years from 1900 to 1908—that his activity as a draftsman can be summed up in a paragraph or two. At Livorno, the city's grand old man, Giovanni Fattori, teacher of Micheli, praised a charcoal drawing by Modigliani—a still life with drapery behind it, with the charred areas of partly burned paper used to produce half-tints. He seems to have drawn a

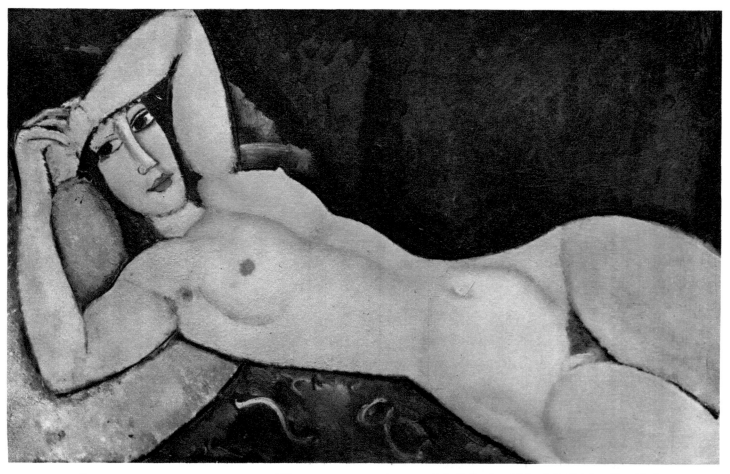

48. NUDE WITH RAISED ARMS. 1917. Oil on canvas, 25 1/4 × 39 1/4″. *Collection Richard S. Zeisler, New York*

great deal, both as a pupil of Micheli and as a student at the academies in Florence and Venice.

Surviving friends of that period in Modigliani's life can remember many early drawings, all academic, without the swan necks and other characteristic distortions of later years. Apparently these were timid and unoriginal, and Jeanne Modigliani quotes a friend as saying, "It was only in his nudes that he showed a certain independence, giving free expression to his interest in line." Hardly any drawings of his first two French years are likely to be found. One day in 1907 the artist, in a fury of dissatisfaction, destroyed everything within reach except a portrait of a young actress, and devoted himself exclusively to sculpture.

There is preserved, however, a large enough body of drawings from the years 1908 to 1920 to give us insight into the workings of a nimble and sensitive mind. There must be thousands of drawings. In addition, unfortunately, there are countless outright fakes (some in famous collections) and many "improved" Modiglianis, where the thin, all too thin, line of the original was reinforced to make sales easier. The drawings range from an early charcoal profile of a friend, Mario Buggelli, clearly an imitation of the Toulouse-Lautrec style, to works done shortly before the artist's death, all unmistakably Modigliani's. These are usually done in graphite pencil on thin paper (occasionally the pencil was so sharply pointed as to nearly cut the page). Others, far less numerous, are done with blue pencil, purple crayon, or ink. Some are touched with watercolor. Many of the extant drawings are signed (some signatures, however, were added by later hands), and are thereby characterized as finished works, though others, equally perfected, lack the signature. A few are also dated by the artist. Some carry titles, such as *La Française* or *Les Deux Orphelines* ("The Two Orphans"), or the name of the sitter.

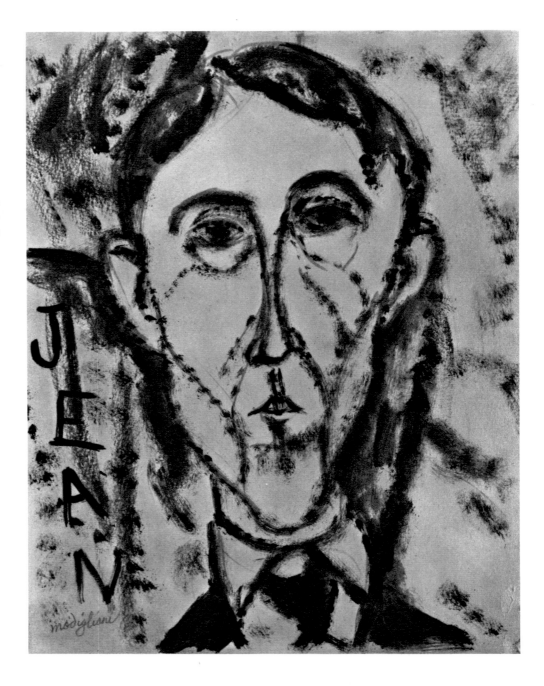

49. PORTRAIT OF JEAN COCTEAU. 1917.
Oil on paper, 13 7/8 × 10 3/4″.
Collection Richard A. Loeb, Santiago, Chile

Modigliani's drawings can be divided into two categories: the portrait studies and the caryatids. Friends of the artist and others who sat for him have described the pale, dark-haired man in the corduroy jacket sitting on the terrace of the Rotonde or the Dôme, a glass of absinthe before him, and drawing likenesses in acute, rapid strokes. He would offer the drawings with a gracious smile to the sitter, for a few francs, or even for a drink. When he had a sheaf of drawings, he would try to sell them to a dealer. One dealer, thinking that

the price was too high, offered a smaller sum, whereupon the artist said he could have them all for nothing: instead of handing them over, he hung them on a nail in the toilet, having pierced a hole through the bundle and run a string through.

Anecdotes of this sort are plentiful and may well be true. But while they tell us something about the proud and often insolent nature of the artist, they say little about the value, the significance of the works, their elegance of execution, their subtle and discreet psychological penetration

40

of the sitter's personality. Ingres comes to mind, but also some of the early Renaissance masters Modigliani knew from his journeys in Italy. Half a century ago the public did not yet appreciate drawings as the spontaneous, personal expressions of a creative personality, but were wont to see them mainly as preparations for a finished painting. Only the artists and intellectuals who belonged to Modigliani's circle—men like Cocteau, Lipchitz, and Zborowski—knew enough to appreciate the precision of line, the firmness of continuous contour, and the rhythmical movement of pencil.

The artist's hand became firmer and bolder as the years went by. In his last years, sick and impoverished, he attained such sureness as to be able to create, in a dozen swift lines, an image as complete as a more elaborate oil painting. By 1914 Modigliani had acquired a manner, even a mannerism, of his own—the bent heads on swan necks, the almond-shaped eyes, and so on. But he also emphasized Kisling's square, strong-boned features, the Anglo-Saxon aspect of Beatrice Hastings, the Gothic look of slender Jeanne Hébuterne. Each of the innumerable girls he sketched has retained her individuality, looking serene or dull, coquettish or standoffish, mannish or feminine, and it is often only a subtle gesture of the hand, a lifting or lowering of an eyelid, a minor detail in the garment worn that creates the crucial difference.

Quite distinct are the caryatids, many in blue or red crayon, aquarelle, or gouache. We know that Modigliani, the frustrated sculptor, dreamed of producing a great series of stone caryatids—possibly hundreds—which he called *colonnes de tendresse* ("pillars of tenderness"). They were to surround his "Temple of Beauty," dedicated to the glory of Man rather than God. But except for the one stone *Caryatid* now in New York's Museum of Modern Art, all that he managed to create, it seems, was a large number of preliminary sketches.

These sketches differ from his portrait drawings. They occupy a nichelike, defined space. There is often more than just a contour; there are inflections suggesting disappearing planes and three-dimensional solidity. There is no psychological depth in them, as there is in most portraits by his hand; instead, we have quiet, hieratic anonymity, appropriate to the purpose of supporting entablatures and roofs.

These caryatids, each crouching on a base, the legs flexed, the head turned to one side, the eyes cast down, are all that remains of an ambitious and unrealized dream. To us they are as dear as the portraits, for in them, as in everything else he did, the elegance of mind and enthusiasm for beauty are revealed.

The French critic Claude Roy said: "If some cataclysm had deprived the world of all Modigliani's paintings and spared the drawings, the latter would certainly have assured him a front rank as a superb interpreter of human bodies and faces Modigliani is one of the supremely gifted few who seem to say everything with next to nothing; in whose works a simple line, a brief allusion, a faintly indicated gesture suffice to bring before us the infinite, incredible profusion of human life."

MODIGLIANI AS A SCULPTOR

The number of Modigliani's sculptures that have come to us is tiny compared with the number of preserved oils, drawings, watercolors, and works in mixed media. As a young art student, Modigliani had a burning desire to create sculpture, but he never studied sculpture at an academy or under a master. A meeting with Constantin Brancusi, an awakening of interest in African Negro art, the exhibition of sculptures by Elie Nadelman, and an encounter with Alexander Archipenko influenced him, in 1909, to give up painting and to express himself wholly in stone.

Modigliani and Archipenko did not like each other, and Modigliani created his sculptures as a reaction against the sensual, demoniac vivacity of Archipenko's work. The German painter Curt Stoermer has written that "Modigliani had a tremendous urge to make sculptures himself. Having ordered a large piece of sandstone to be placed in his studio, he cut directly into the stone.

Just as there were times when he loved idleness and indulged in it with the greatest sophistication, there were also times when he plunged himself deep into work. He started using the chisel when the sun's first rays began to light the studio. He cut all his sculptures directly into the stone, never touching clay or plaster. He felt destined to be a sculptor. There were certain periods when this urge started, and impetuously shoving all painting tools aside, he snatched the hammer."

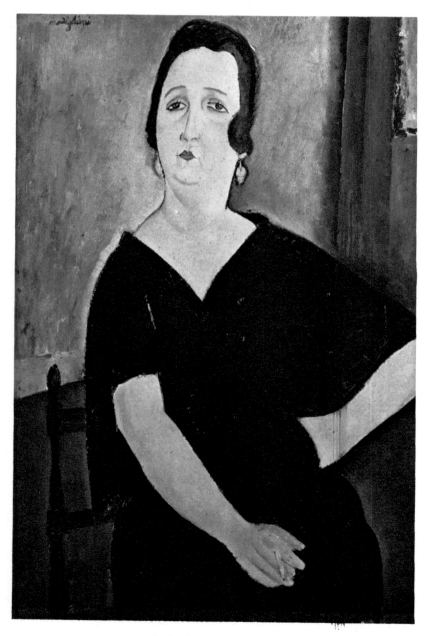

50. MADAME AMÉDÉE (WOMAN WITH CIGARETTE). 1918. Oil on canvas, 39 1/2 × 25 1/2″. *National Gallery of Art, Washington, D.C. (Chester Dale Collection)*

Fellow sculptors admired his talent but were not blind to his foibles. One was Ossip Zadkine, who said that Modigliani allowed himself to be too sketchy. His statues were "never finished, as though for shame, not for a mysterious reason." Jacques Lipchitz reported: "I found him working outdoors. A few heads in stone—maybe five—were standing on the cement floor of the court in front of the studio. He was adjusting them one next to the other

"Modigliani, like some others at the time, was very taken with the notion that sculpture was sick, that it had become very sick with Rodin and his influence. There was too much modeling in clay, too much 'mud.' The only way to save sculpture was to begin carving again, directly in stone. We had many very heated discussions about this. But Modigliani could not be budged; he held firmly to his deep conviction. He had been seeing a good deal of Brancusi, who lived nearby, and he had come under his influence. Then we talked of different kinds of stone, hard and soft. Modigliani said that the stone itself made very little difference; the important thing was to give the carved stone the feeling of hardness"

In the spring and summer of 1909 Modigliani worked feverishly on a series of busts and figures. Overwork, alcohol, and lack of food undermined his health, and he collapsed in his studio. He returned home to recuperate and was urged by his family to stay permanently in Italy. But the lure of the great city of Paris was too strong to resist, and his family's attempts to rescue him came to naught.

Modigliani returned to Paris, to his work as well as to his old habits. He seems to have continued sculpting until early in 1915.

Why did he finally abandon sculpture? Nina Hamnet answers this question succinctly: "He always regarded sculpture as his real métier and it was probably only lack of money, the difficulty of obtaining materials, and the amount of time required to complete a work in stone that made him return to painting during the last five years of his life." Another reason was his poor health: his

throat and lungs, delicate since the attack of tuberculosis suffered in his teens, were affected by the constant inhalation of stone dust and tiny particles chipped off by his tools; also, painting required less physical strength. Shortly after having begun to paint again, Modigliani met Leopold Zborowski, who encouraged him as a painter and somewhat eased his struggle for existence.

The twenty-five sculptures that have been identified undoubtedly constitute no more than a fraction of Modigliani's output, for he was given to destroying or discarding all that he considered below his standards. The *Caryatid* now in the Museum of Modern Art survived by a near-miracle. It had been carved from a building stone, but fell into neglect, and was pushed over and broken. The architect Pierre Chareau had it mended by Lipchitz, and it remained in the architect's garden until 1939. It was acquired by the Museum in 1951.

The statues that have survived are of uneven value and in various stages of completion. They are chiefly of limestone and range in height from small heads, 20 inches or less, to the large standing figure, 63 inches high. For the chronology of these works we must rely upon the vague recollections of visitors who saw the statues in Modigliani's studio.

Modigliani does not fit into any of the schools of modern sculpture that flourished around 1910, especially Cubism and Futurism. He was slightly influenced by Brancusi, but he never followed him into utter abstraction. We also know that he was bitterly opposed to Rodin, though he lived in Paris during the last eleven years of the master's life, when Rodin was a demigod to most Frenchmen.

While none of his sculptural work can be dated earlier than 1909, Modigliani's sculptural talent was manifested even before his meetings with Brancusi, to judge by early drawings and paintings. In these we find a high degree of plastic feeling, a solidity of form, and a tendency toward rhythm and simplification which is a sculptor's trademark.

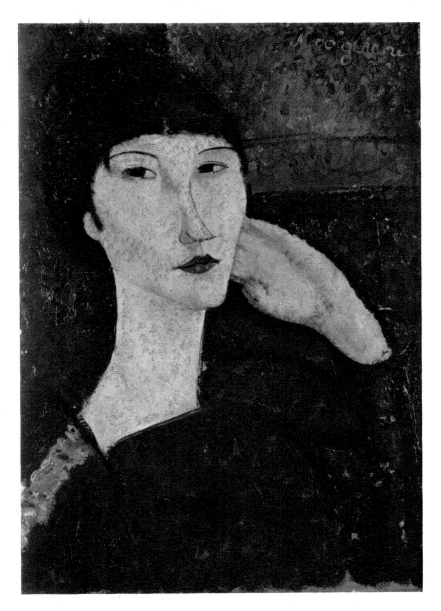

51. ADRIENNE (WOMAN WITH BANGS). 1917. Oil on canvas, 21 3/4 × 15″. *National Gallery of Art, Washington, D.C. (Chester Dale Collection)*

The belief that Modigliani's plastic ideas grew predominantly out of his contacts with African Negro art must be rejected as vastly exaggerated. The contact with non-European art served only to free artists from a dominant school—in the case of Modigliani, from Impressionism. Negro sculpture aided the generation born around 1880—including Archipenko, Brancusi, and Picasso—to throw off Rodin's Impressionism, which was, in the last analysis, three-dimensional painting. The young men who began to fulfill their talents between 1900 and 1910 admired the primitives'

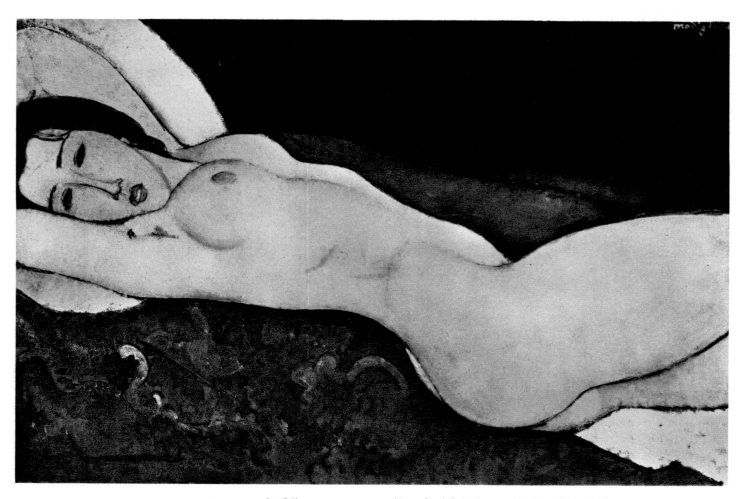

52. RECLINING NUDE. 1918. Oil on canvas, 23 5/8 × 36 1/4". *Private collection, New York*

faculty of expressing feeling through purely sculptural means, with a minimum of naturalistic descriptive elements and a maximum of emotional pitch produced by omissions, distortions, and exaggerations.

Only Picasso actually incorporated African forms into some of his works. Modigliani was different. Robert J. Goldwater has demonstrated in detail why, whatever inspirations Modigliani may have gotten by looking at African sculptures, his work was quite original:

"In his flat forms Modigliani never achieves any of the effect of cubic mass that is supposed to be the main influence of Negro art, and even his sentimental linear rhythms are far removed from the repetitions of design on which African sculpture is built. In accordance with the decorative character of his whole art his deformations of form are elongations adding to grace and sentiment, and so are directly opposed to the thickening of mass characteristic of Negro sculpture."

We should not overlook his Italian origin and the fact that he was exposed to Greek and Roman as well as Italian Renaissance works, plentifully exhibited in Florence, Rome, Naples, and Venice. To escape the influence of Rodin, many sculptors in the period between 1900 and 1910 sought fresh inspiration from the world of antiquity. Modigliani's work has affinities with the Archaic period of Greek art, which was not concerned with naturalistic representation but with formal patterns. Like the Greek sculptors (and early Egyptian masters), Modigliani never forgot the affinity between architecture and sculpture, and his works have retained the strength of figures that were part of an ancient temple. This is particularly

44

evident if one looks at the large standing female figure and at the somewhat smaller *Caryatid*.

The lessons Modigliani learned while concentrating on sculpture were not wasted, and clearly enhanced the formal strength and structural solidity of his painting, as if to echo Michelangelo: "It seems to me that the nearer painting approaches sculpture, the better it is"

EPILOGUE

What remains of Modigliani nearly five decades after his death? There is, first, the work, yet to be studied thoroughly, and second, the legend, now known to millions.

The legend has been created by the reminiscences of those who knew the artist during his tragic life in Paris, and even more by books based on sometimes fascinating but not always reliable second- and third-hand information. Several mediocre novels and one movie based on Modigliani's adventures have appeared.

Alcohol and drugs may have been necessary to the frail, unsuccessful, and lonely foreigner in Paris, suffering from shyness and frustration, but these neither produced nor released his genius. Modigliani was desperately poor most of the time, more because his "frightful disposition" alienated potential patrons than because of total indifference on the part of collectors. Debunking the "romantic legend of a death due to hunger, alcohol, and Heaven knows what metaphysical torments," the artist's daughter Jeanne Modigliani puts the blame squarely on the tuberculosis from which the artist suffered all his life.

Difficult and irresponsible though the artist may have been at times, he was—all his friends agree—basically a man of aristocratic bearing, brilliant and well informed, who could be kind and compassionate. Considering the limited span of his thirteen-year career and the circumstances of his life, his production was amazing, not only qualitatively but also quantitatively. In the volume *Modigliani et son oeuvre* (1956), Arthur Pfannstiel lists and describes 372 oils the artist painted after

his arrival in Paris in 1906. In his preface to *Amedeo Modigliani, dessins et sculptures* (1965), Ambrogio Ceroni maintains that the number of authentic Modigliani oil paintings is exactly 222, a very conservative estimate. A few paintings of Modigliani's youth in Italy have turned up in recent years, and a number of very convincing Parisian paintings that are not mentioned by either Pfannstiel or Ceroni have recently been offered for sale. The market is unfortunately flooded with fake Modiglianis, some of them, *les bons faux*, done with enough skill to deceive an expert and collector. Since prices for first-rate Modiglianis have risen above $100,000, it is not surprising that forgers have been active. The result is a crop of "Modiglianis" that try to reduce

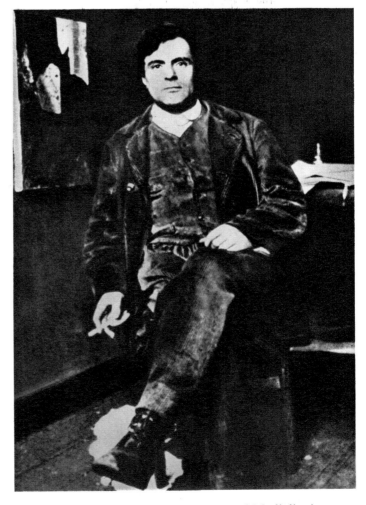

53. One of the last photographs taken of Modigliani. In the background is a portrait of Beatrice Hastings

the master's original inventions to pat formulas.

How many works were lost either because the artist destroyed them or because they were neglected will never be known. No systematic attempt has yet been made to list and describe his extant drawings. There must be thousands upon thousands of them, since Modigliani drew rapidly and incessantly; but again, there exists an avalanche of forged drawings, including replicas of authentic works. There are twenty-five sculptures that have survived. There are also three short poems (in French, though one of them starts with a few lines in Italian).

Had the artist lived a few more years, he would have witnessed a growing interest in his work. In 1921 Zborowski organized a memorial exhibition in Paris, and for the first time the work received general acclaim. The first foreign collector to demonstrate a considerable interest in Modigliani was Dr. Albert C. Barnes, of Merion, Pennsylvania, who in 1922 bought a large number of his works. In the artist's native country recognition came late. At the 1922 Biennale in Venice little attention was given to the Modiglianis shown there; a critic dismissed them as "twelve ugly misshapen heads that a child of five might have drawn." But when, eight years later, Modiglianis were seen again in Venice, the attitude had changed and the master's efforts received their due. In the 1920s Modiglianis were also shown in Zurich, London, New York, and Geneva. In 1922 a portrait of Madame Czechowska was bought by the museum at Grenoble, his first work to enter a public collection. In the 1950s and '60s major museums in Italy, the United States, England, France, and Germany showed his work in large-scale exhibitions.

Modigliani was born three years later than Picasso, and three years before Chagall. Would he have surpassed the great promise of his youth if he, like them, had been given a long life? However that may be, his achievement is enough to make him immortal. While many who started out with him in the early years of this century are completely forgotten by now, Modigliani's name still gleams in the annals of modern art.

46

BIOGRAPHICAL OUTLINE

1884 Amedeo Clemente Modigliani, born July 12 in Livorno (Leghorn), Italy, fourth child of Flaminio Modigliani, owner of a small *banco* (broker's office), and Eugenia, née Garsin. Both the Modiglianis and the Garsins were Sephardic Jews, the former from Rome, the latter from Marseilles.

1895 Amedeo, pupil at the *liceo* (secondary school) in Livorno, falls ill with pleurisy.

1898 Despite an attack of typhoid fever that is followed by pulmonary complications, Modigliani qualifies for his diploma at the *liceo*. Begins his study of drawing and painting under the guidance of Guglielmo Micheli, an artist of Livorno and former pupil of Giovanni Fattori.

1901 After an attack of tuberculosis, he is sent on a tour of convalescence and visits Capri, Naples, Rome, and Florence.

1902 In May enrolls at the Scuola Libera di Nudo of the Accademia di Belle Arti, Florence.

1903 In March enrolls at the Istituto di Belle Arti, Venice.

Late 1905 or early 1906. Arrives in Paris where he finds quarters in the Rue Caulaincourt, near the "Bateau-Lavoir," in Montmartre.

1907 Becomes a member of the Société des Artistes Indépendants. In the fall he meets the young physician Dr. Paul Alexandre, who buys several of his paintings.

1908 Lives at 7 Place J.-B. Clément. Exhibits five paintings and a drawing at the Salon des Artistes Indépendants.

1909 Takes a studio at 14 Cité Falguière. The sculptor Constantin Brancusi, to whom he was introduced by Dr. Alexandre, becomes his friend and guides his first steps in sculpture. Spends the summer and fall in Livorno, where he occupies himself with sculpture.

1910 Exhibits *The Cellist* (both versions) and four other paintings at the Salon des Artistes Indépendants.

1912 Exhibits seven sculptures at the Salon d'Automne.

1913 Probably spends the summer at Livorno.

1914 Love affair with the English poetess Beatrice Hastings, with whom he lives for two years. Meets the dealers Paul Guillaume and Leopold Zborowski.

1916 Zborowski becomes his sole dealer.

1917 Meets Jeanne Hébuterne, then a pupil at an art school in Paris. Has his first and only major one-man show, at the Galerie Berthe Weill, in December. The police order the five pictures of nudes to be removed.

1918 Stays on the Riviera from April until the spring of 1919, trying to regain his health. Jeanne Hébuterne bears him a daughter, also named Jeanne.

1919 Lives at 8 Rue de la Grande Chaumière. Under the sponsorship of Osbert and Sacheverell Sitwell some of his works are shown, in London, at a group show of contemporary French art.

1920 Modigliani dies at the Hôpital de la Charité on January 24. On January 25, at dawn, Jeanne Hébuterne commits suicide by flinging herself from a window of her parents' home. On January 27, the artist is buried at Père Lachaise cemetery.

MODIGLIANI'S
DRAWINGS

54. LA DOMPTEUSE. C. 1914. Pencil and colored crayons,
17 × 10 1/4". *Collection Merrick Lewis, Alliance, Ohio*

55. THE HARLEQUIN. Blue crayon,
17 38/ × 10 7/8″. *Private collection*

56. PROFILE STUDY OF A NUDE. C. 1914. Pencil, 16 1/2 × 9 7/8″.
Collection Madame Denise Lévi Lasser, New York

57. PORTRAIT OF MADAME BERTHE LIPCHITZ. 1916.
Pencil, 23 × 16″. *Collection Lolya Lipchitz*

58. MOTHERHOOD. 1916. Pencil, 14 1/8 × 10 3/8″.
Private collection

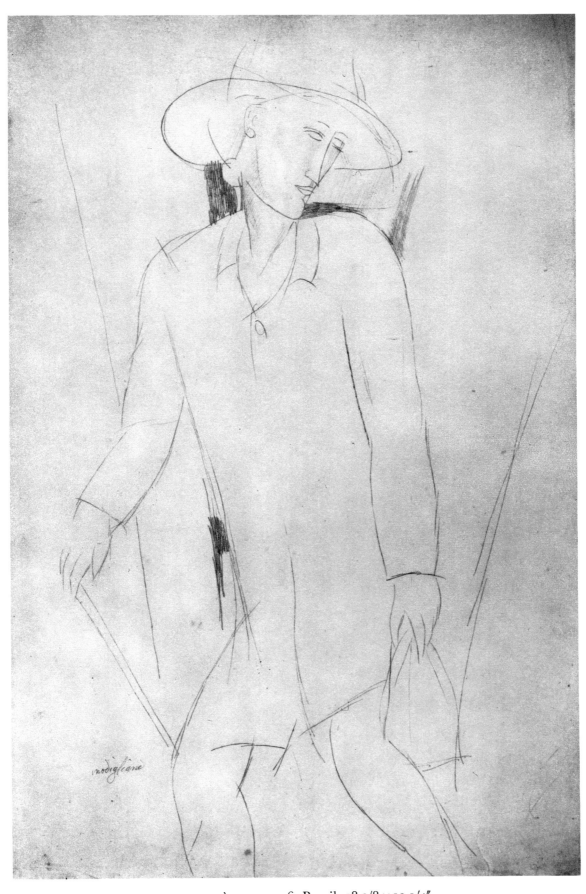

59. LE JEUNE PÈLERIN. 1916. Pencil, 18 3/8 × 12 1/4".
Collection Crozer F. Martin, Philadelphia

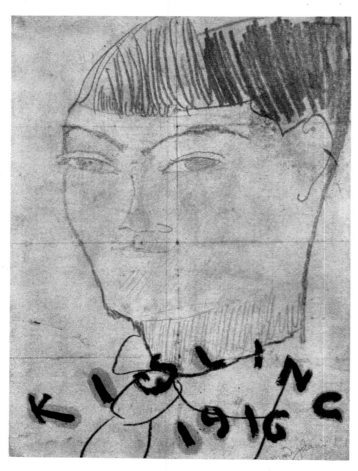

60. PORTRAIT OF KISLING. C. 1916. Wax pencil,
10 5/8 × 8 3/8″. *Private collection*

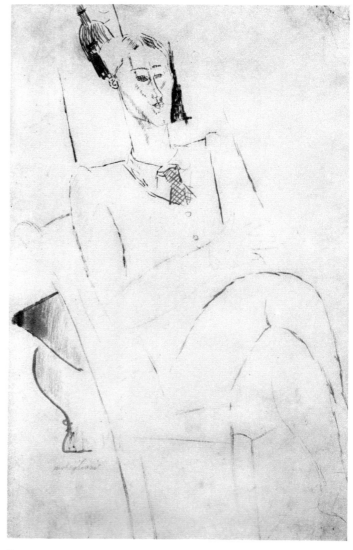

61. PORTRAIT OF JEAN COCTEAU. 1917. Blue ink, 17 × 10 1/2″.
Collection Richard S. Davis, Wayzata, Minnesota

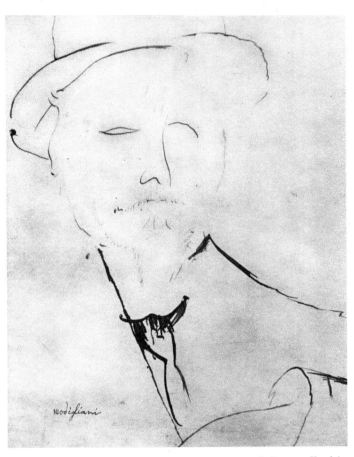

62. PORTRAIT OF A MAN WITH HAT. C. 1917. Ink on off-white paper. *The Abrams Family Collection, New York*

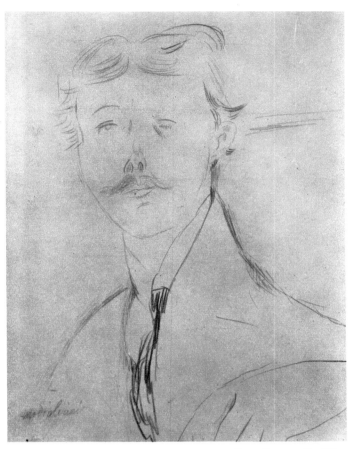

63. PORTRAIT OF A YOUNG MAN. 1917. Pencil, 12 × 8 7/8″. *Perls Galleries, New York*

64. CIRCUS ACROBAT (inscribed in French and Italian).
Pencil, 20 5/8 × 14 3/4″. *Galerie Marcel Bernheim, Paris*

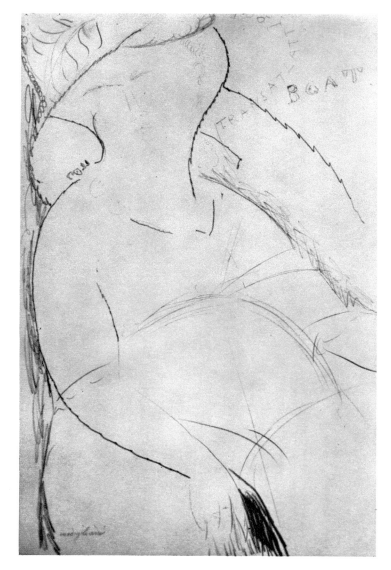

65. "TRANSATLANTIQUE BOAT."
Pencil, 16 3/4 × 10 1/4″.
*Collection Mr. and Mrs. James W. Alsdorf,
Winnetka, Illinois*

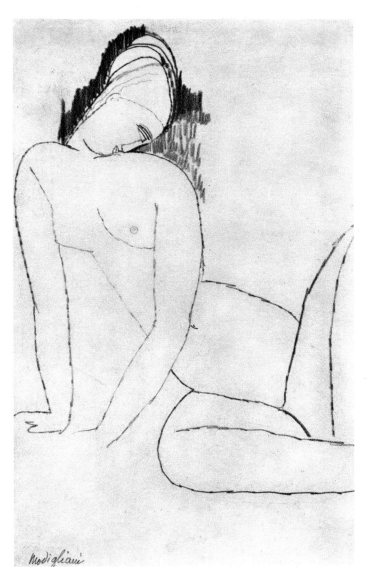

66. FEMALE NUDE, HEAD INCLINED.
Black crayon, 16 1/2 × 18 1/8″.
Collection Mrs. Sydney G. Biddle, Philadelphia

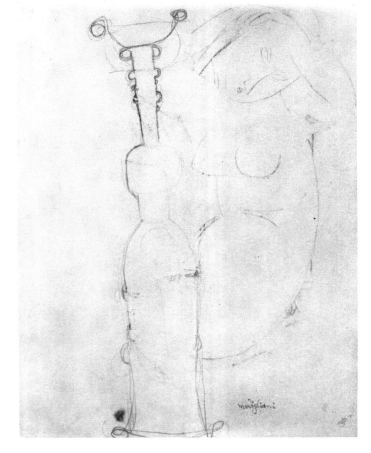

67. CARYATID WITH AFRICAN SCULPTURE.
Pencil, 10 1/2 × 8 1/4″.
Collection Mr. and Mrs. James W. Alsdorf,
Winnetka, Illinois

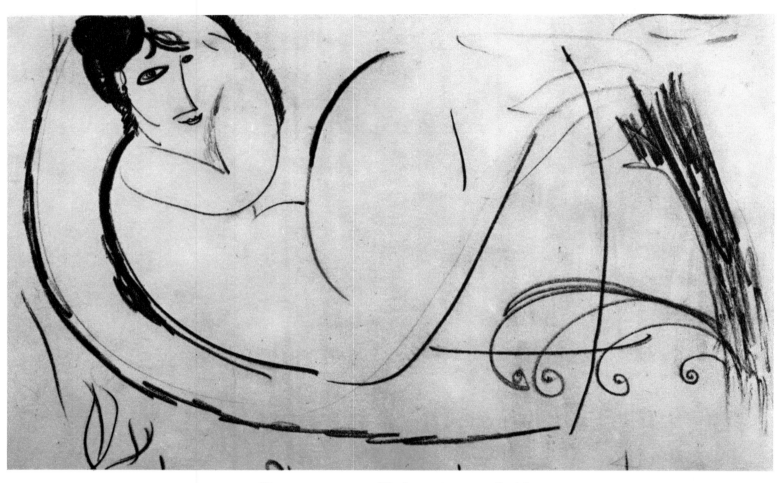

68. RECLINING NUDE. Black crayon, 10 × 16 3/4″.
Collection Mrs. Sydney G. Biddle, Philadelphia

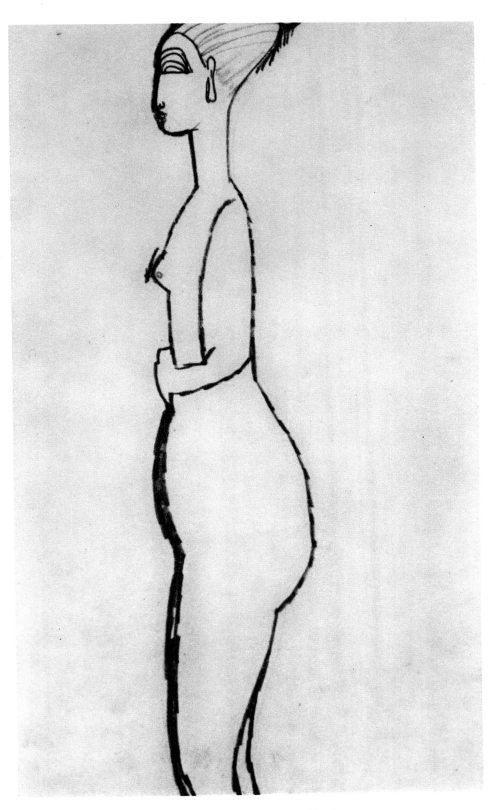

69. STANDING FEMALE NUDE IN PROFILE. Black crayon,
16 1/2 × 9 7/8″. *Collection Mrs. Sydney G. Biddle, Philadelphia*

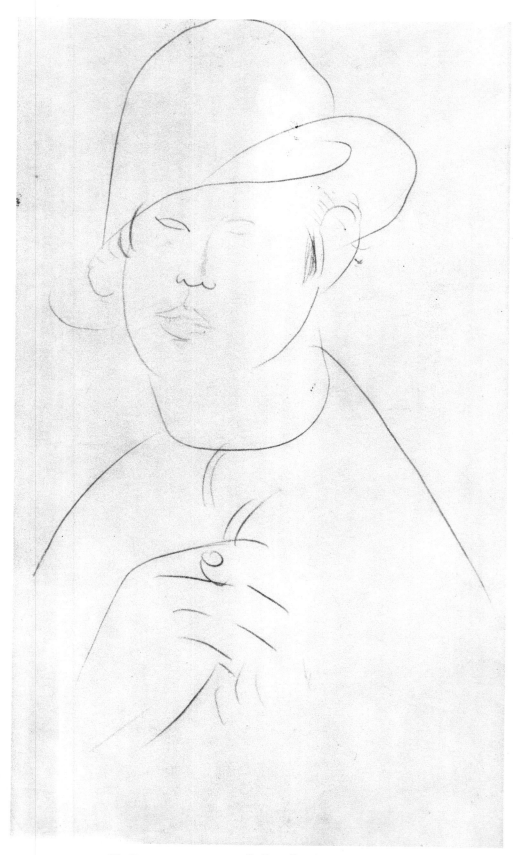

70. SWEDISH GIRL. C. 1918. Pencil, 16 × 9 1/2″.
Collection Mr. and Mrs. Jack Resnick, New York

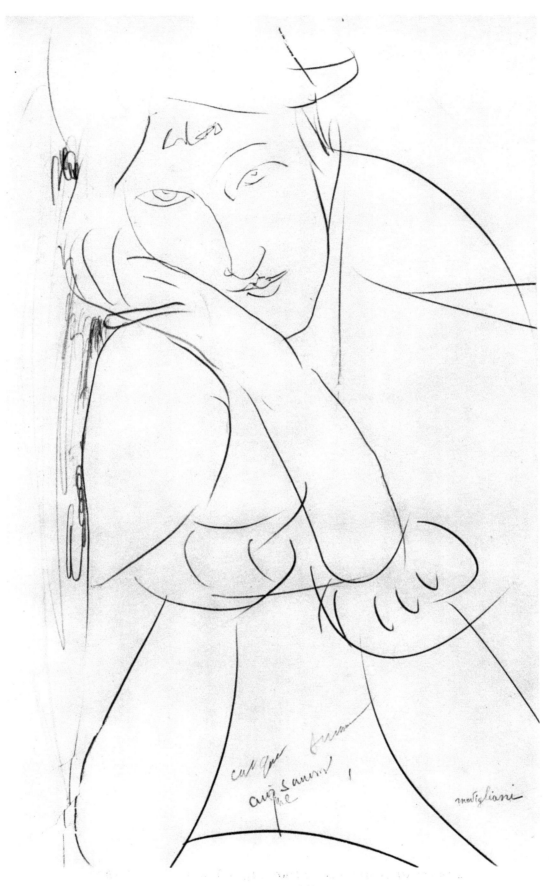

71. WOMAN, HEAD ON HAND. 1919. Pencil, 19 3/8 × 11 7/8".
The Museum of Modern Art, New York

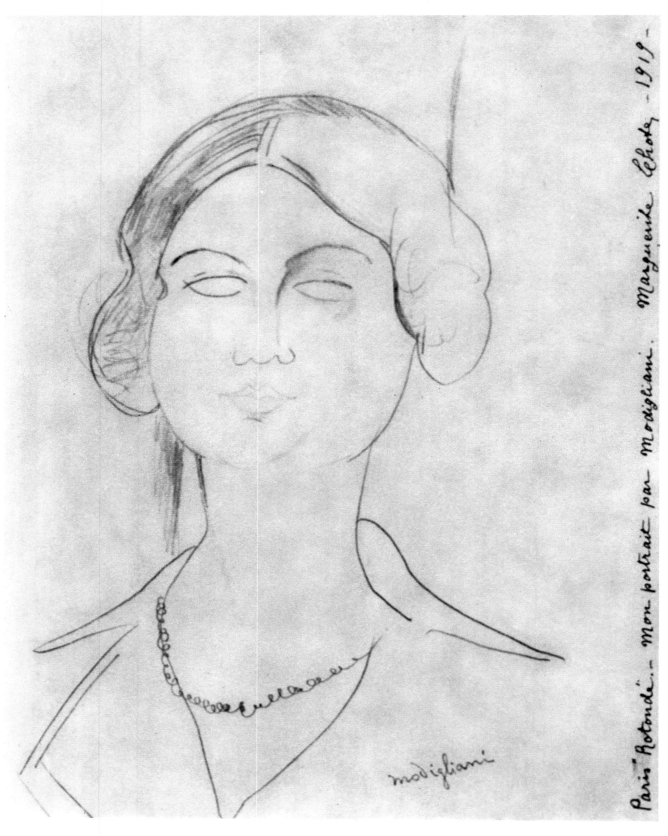

Paris "Rotonde".. Mon portrait par modigliani. Marguerite Lhote - 1919 -

modigliani

72. PORTRAIT OF MARGUERITE LHOTE. 1919. Pencil, 10 1/2 × 8 1/8".
Collection Mrs. J. William Craig, Jr., Dayton, Ohio

73. PORTRAIT OF WOMAN WITH CURLS. Black crayon,
17 1/4 × 10 1/2″. *Perls Galleries, New York*

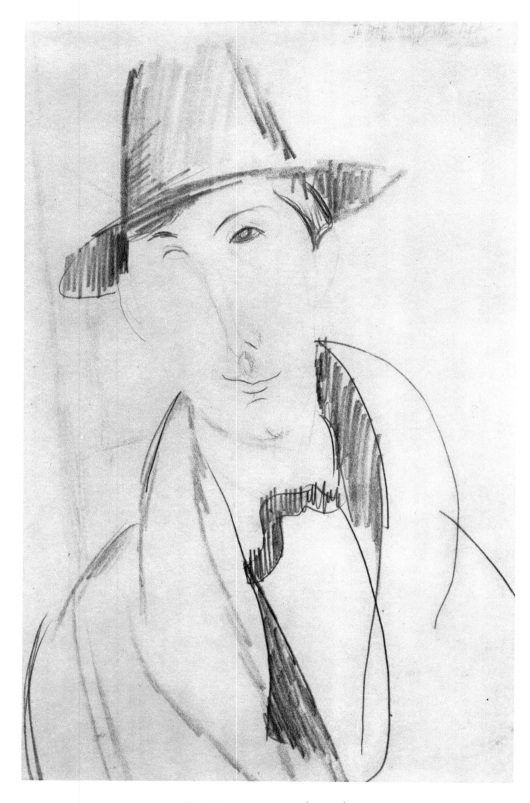

74. MAN WITH A HAT (MARIO). 1920.
Pencil, 19 1/4 × 12″. *The Museum of Modern Art, New York.*
Gift of Abby Aldrich Rockefeller

COLORPLATES

Painted 1908

HEAD OF A YOUNG WOMAN

Oil on canvas, 22 × 21 5/8"

Collection Jean Masurel, Mouvaux (Nord), France

This is one of the few paintings surviving from Modigliani's first Parisian period, between his arrival in Paris in 1906 and his self-immersion in sculpture in 1909. It is quite clear that the artist had seen and admired the work of Toulouse-Lautrec. Here Modigliani is still groping for a style of his own, and has not yet achieved his originality (for "typical" Modiglianis one must look for works done after 1914). This picture, with its thick black outlines, the strongly accentuated red of the lips, and the unruly brush-work, is also somewhat reminiscent of the work of the German Expressionists, such as the members of the *Brücke*, although any direct influence is impossible (few German Expressionist works were exhibited in Paris in Modigliani's lifetime). For a young man of twenty-four, this is quite a strong painting. It has none of the sweetness and slickness of academic portraits of *La Belle Époque*.

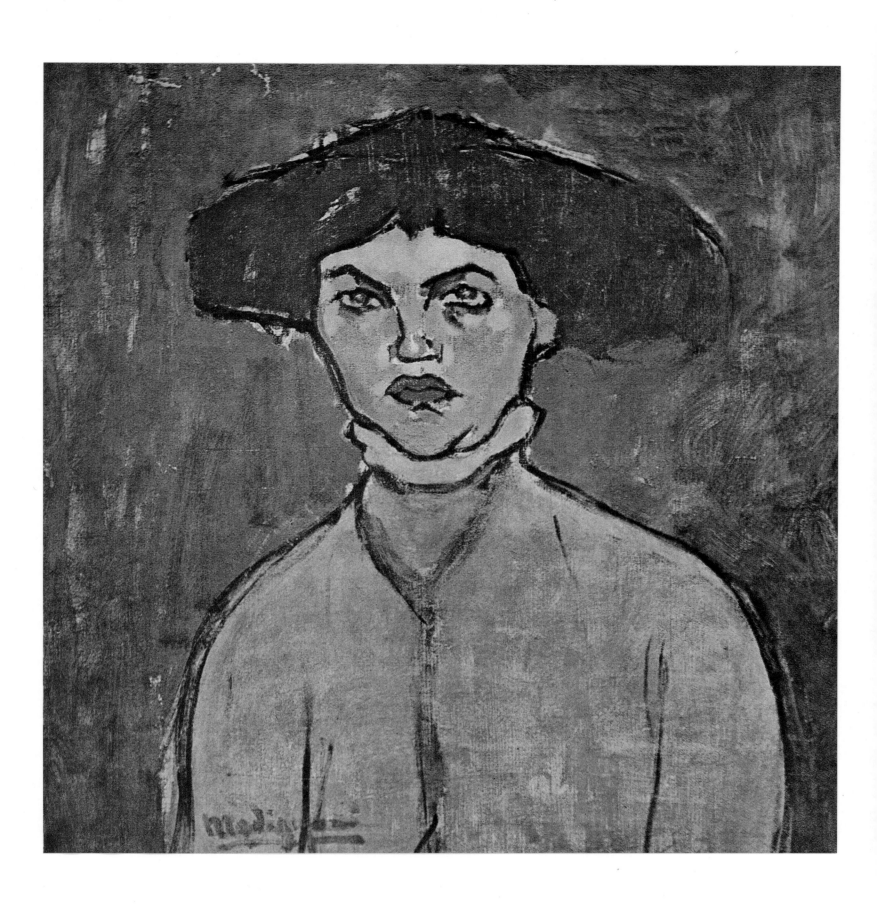

Painted 1908

THE JEWESS

Oil on canvas, 21 1/4 × 18 1/8"
Private collection, Paris

According to the artist's daughter, Dr. Paul Alexandre saw this picture when he first met Modigliani in November, 1907. Under the title *La Juive*, it was one of the six pictures Modigliani selected in 1908 for his first appearance in a group show in Paris. This extremely untraditional portrait of an unknown woman has a haunting quality. In its vehement striving for expression, its feverish unrest, it is related to the *Brücke* rebels even more than the preceding picture, though one can also find affinities to the turbulent early work of Rouault, and to the melancholy of Picasso's Blue Period pictures. The overriding dark-blue pigment, sensitively modulated, has the mysterious nuances observed in Grünewald's *Isenheim Altarpiece* or in El Greco's *View of Toledo*. The woman's hair, torso, and arm are indicated only in rough outline so that attention can be focused on the face, with the firmly drawn eyes and eyebrows, the slightly curved nose, the determined lips, and the powerful chin.

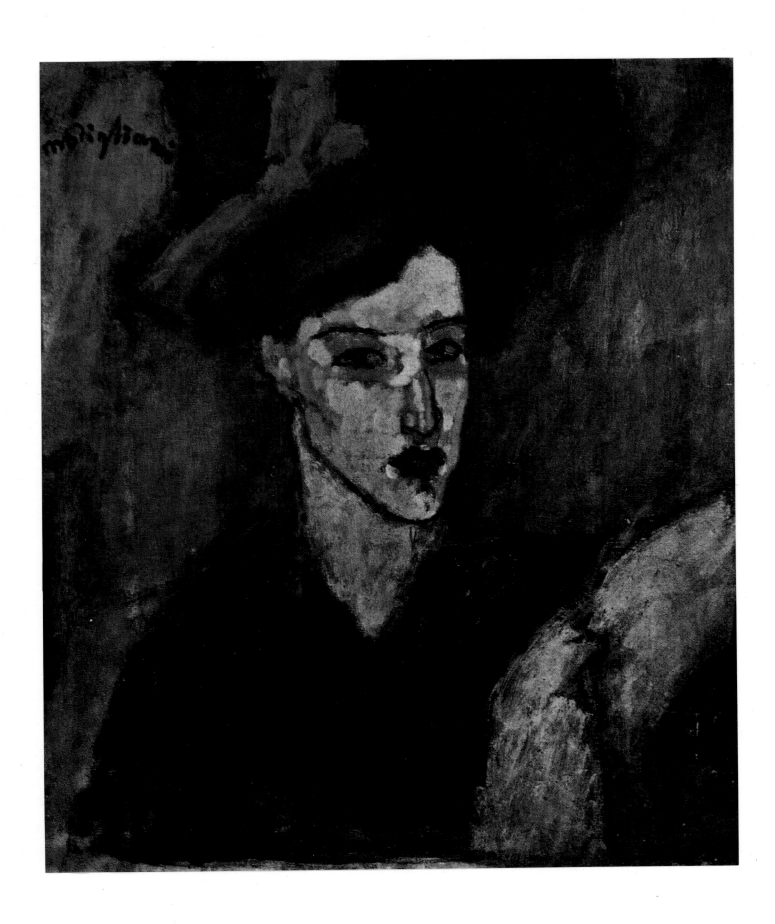

Painted 1909

PORTRAIT OF JEAN ALEXANDRE

Oil canvas, 31 7/8 × 23 5/8"

Collection Mme. Jeanne Brefort, Paris

Jean Alexandre (1886–1913) was a student of pharmacy, a son of the pharmacist Jean-Baptiste Alexandre (1848–1916) and the brother of Modigliani's friend and enthusiastic patron, Dr. Paul Alexandre (page 73). Modigliani and Jean Alexandre, two years his junior, were close friends; the picture *The Beggarwoman* (collection Dr. Paul Alexandre) in its upper left corner carries the dedication "à Jean Alexandre."

Like many of Modigliani's works, especially those of his earlier years, this painting is unsigned. On the back is an earlier work, an oil sketch of a young seated nude.

The portrait, of a thoughtful young man—the sitter was only twenty-three—is still conventional in both pose and color; the artist had not yet achieved the clear palette of his later work. However, it reveals the beginner Modigliani as a searcher for character who concentrated on the essentials of face and hand, giving only summary treatment to the sitter's torso.

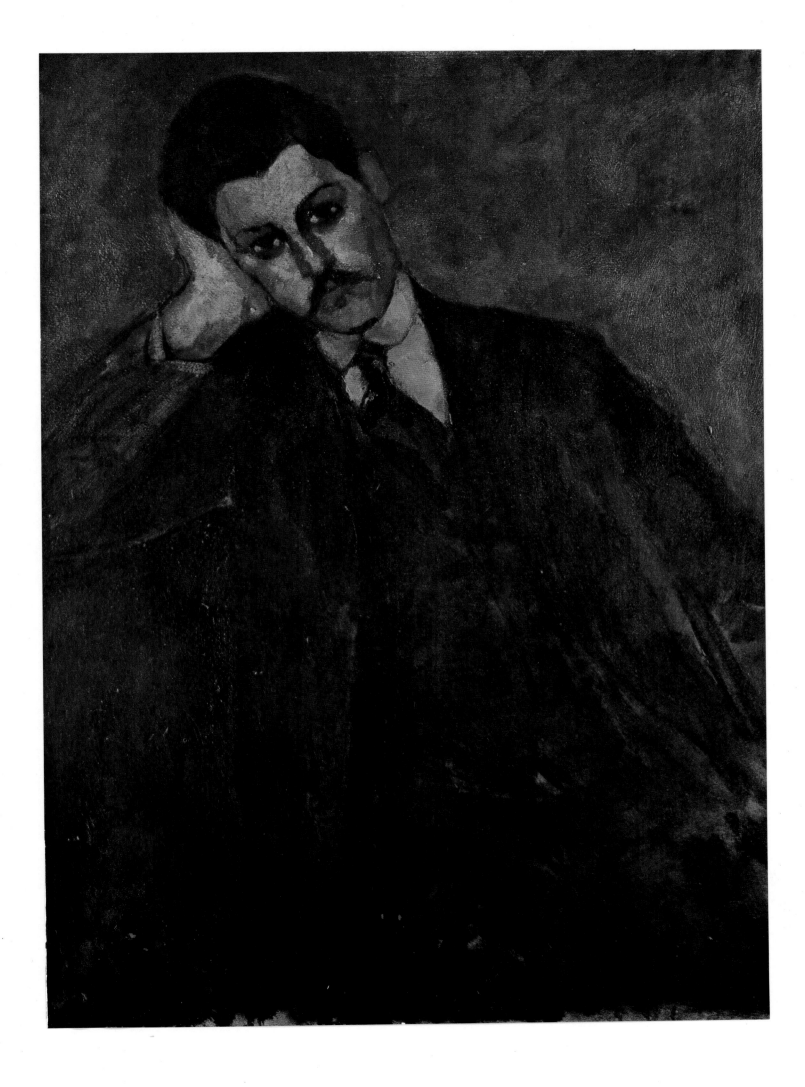

Painted 1909

PORTRAIT OF DR. PAUL ALEXANDRE

Oil on canvas, 39 3/8 × 31 7/8"

Collection Blaise Alexandre, Paris

Dr. Paul Alexandre as a young physician in Paris befriended Modigliani and bought his paintings when the artist very much needed encouragement. This patronage was particularly remarkable because Dr. Alexandre was then still struggling to build up a practice as a dermatologist and also because Modigliani was completely unknown. Here the doctor is posed in front of *The Jewess* (page 69). The large forehead, the bony structure of the face, and the white of his linen are emphasized. One is reminded of the elegant and sophisticated portraits of aristocrats done in Modigliani's native Tuscany during the sixteenth century by Bronzino and other Mannerist painters. While most early works by Modigliani have disappeared, more than a dozen of the finest paintings he did in his mid-twenties are still in the Alexandre family collection.

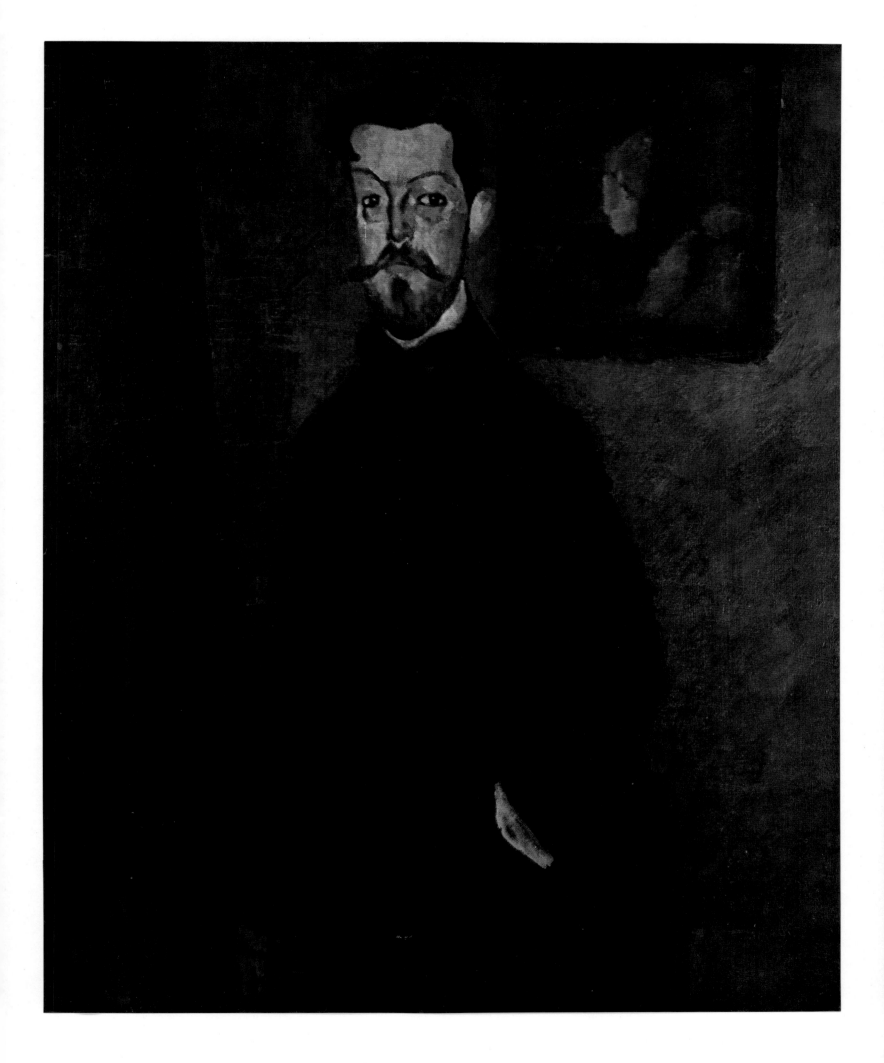

Painted 1909

THE EQUESTRIENNE (*L'Amazone*)

Oil on canvas, 36 1/4 × 25 1/2″

Collection Mr. and Mrs. Alexander Lewyt, New York

There is something very determined in the expression of this young energetic lady who glances at us in a cautious, almost supercilious manner. The face, the high collar, and the perfectly cut jacket stand out strongly against the surrounding darkness, uninterrupted by any trace of detail. For this picture of a horsewoman Toulouse-Lautrec was undoubtedly Modigliani's guide.

The lady was a "Baronne de H." This is probably the only case where the Socialist and Bohemian Modigliani painted a member of the aristocracy (while Zborowski and his wife came from Polish nobility, they wholly identified with artists and writers of the Left Bank). Modigliani, genteelly reared, could have, had he so wished, become a portraitist of French high society and earned a fortune, as did another immigrant, Kees van Dongen (whose formula—to make women appear slimmer and their jewels fatter— assured him a big success). But he refused to prostitute his talents; like Rembrandt he kept company "mostly with common people and such as practiced art" (as one of Rembrandt's biographers complained).

74

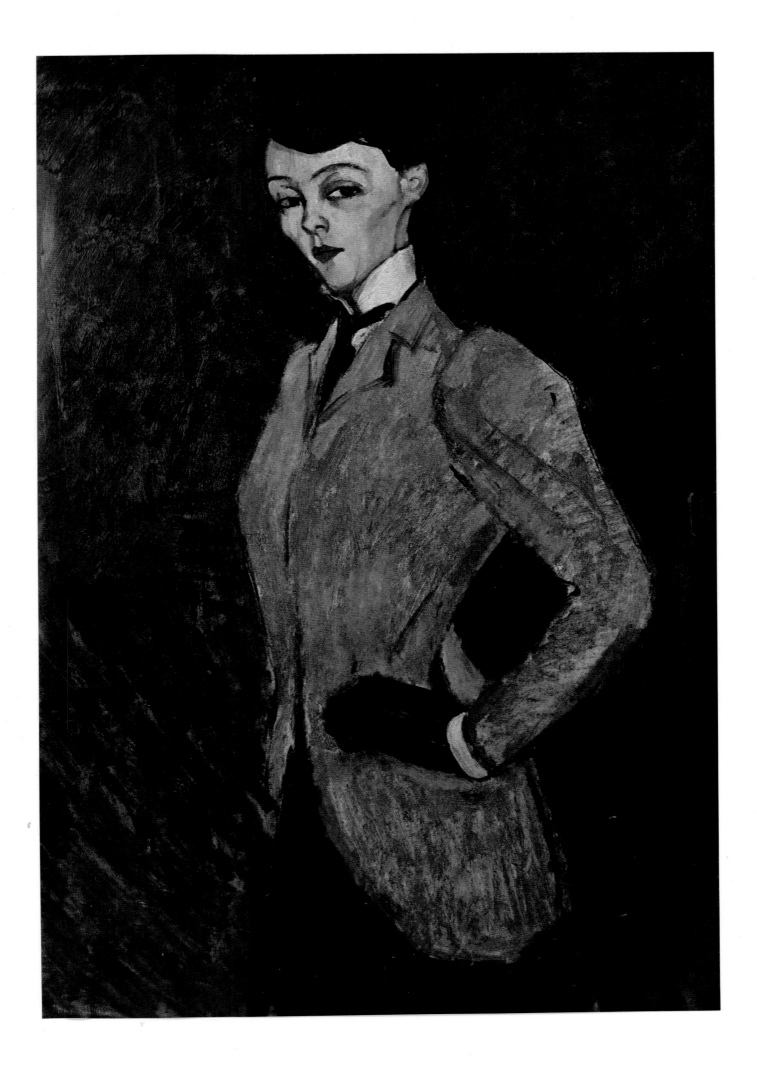

Painted 1909

THE CELLIST

Oil on canvas, 29 × 23 1/2"
Private collection, Paris

When somebody pointed out to Max Liebermann that one arm in Cézanne's *Boy in a Red Vest* was much too long, the German master replied, in Cézanne's defense, "Such a superbly painted arm can't be long enough!" In this picture, which clearly reveals Cézanne's influence, several "unnatural" elongations can be noted; yet, far from disturbing the beholder, they increase his feeling for the picture's inwardness. The bearded young cellist does not look at us; he is too deeply involved in making music to pay attention to anything but his instrument. Incidentally, the cello player—whose instrument has the leading role in the picture—was a poor devil who lived at the Cité Falguière when Modigliani had a studio there; the posing gave him a chance to keep warm at Modigliani's stove.

Though this majestic picture is listed as a "study" (*étude*), one feels that it is complete, even if certain areas of the canvas have remained without pigment and the bow is barely indicated. There also exists a somehow more "finished" version. Both versions were first shown in 1910 when Modigliani participated with six pictures in a group show of the Salon des Artistes Indépendants, for the second and last time. In 1926, the more finished version was seen again in the show Trente Ans d'un Art Indépendant, given by the Société des Artistes Indépendants, which also included, among others, *The Jewess* (page 69) and the portraits of Paul Guillaume (page 101) and Jean Cocteau (page 115). On the back of the canvas reproduced here is sketched a portrait of Modigliani's friend and mentor, the sculptor Constantin Brancusi.

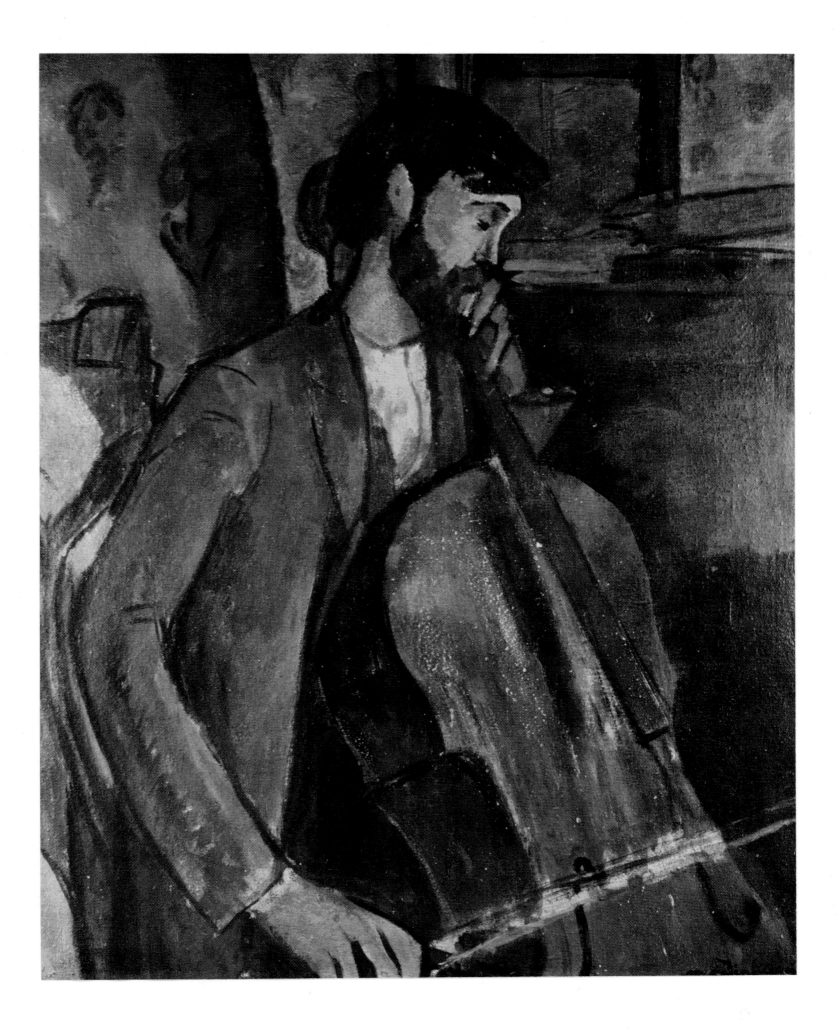

Painted 1909

THE BEGGAR (*Peasant from Livorno*)

Oil on canvas, 26 × 21"

Collection Blaise Alexandre, Paris

This picture is also known as *The Beggar of Livorno* (in 1909 Modigliani revisited his native city). From the same period there is also a canvas titled *The Beggarwoman*. The beggar's eyes appear closed—he may very well have been blind. Modigliani painted this poorly clad man with that profound sympathy he had for all who were burdened and oppressed. Although Modigliani came of a middle-class family, in Montmartre and Montparnasse he lived the life of an outcast.

According to Jeanne Modigliani, this picture was inspired by a seventeenth-century Neapolitan painting of a beggar which the family inherited in 1909. It is not a copy; it is a modern interpretation of an old picture. The painting was one of six by Modigliani included in the 1910 Salon des Artistes Indépendants.

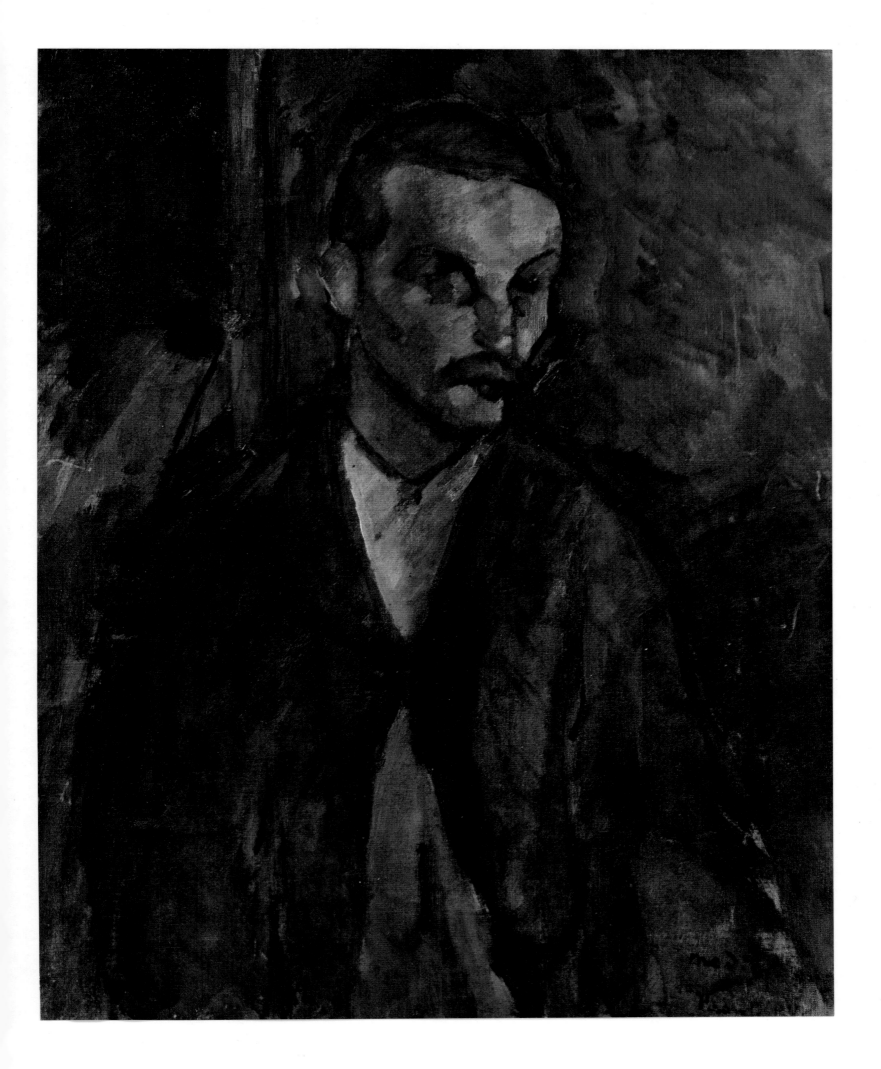

Painted c. 1912

CARYATID

Oil on canvas, 32 1/4 × 18"
Collection Antonino Verdirame, Milan

"Caryatid" is derived from the Greek word for a woman of Caryae in Laconia, Greece, and is applied to the sculpture of partly draped female figures which held up the roofs of ancient Greek temples. Similar figures were used to support the thrones of tribal chieftains of Africa's Ivory Coast. In this painting on the theme of a caryatid, Modigliani combined the influences of the two worlds to produce something witty and delicate. This picture was painted during the period when the artist was concentrating on sculpture. While only one sculptured caryatid by Modigliani has remained, and that in a very unfinished state, he drew and painted caryatids incessantly, in a large variety of poses.

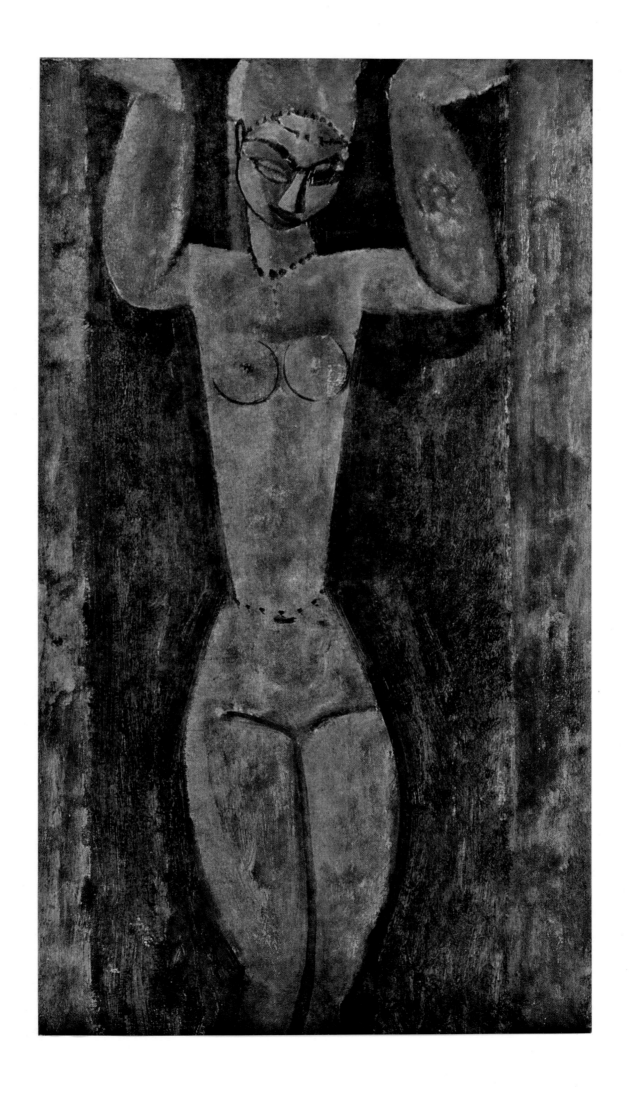

Painted c. 1912

SEATED NUDE

Oil on canvas, 36 1/4 × 23 5/8″
The Courtauld Institute of Art, London

Modigliani loved the motif of the female nude, painting her seated or lying on her back, usually at full length. The female nude has, of course, been a favorite subject for artists throughout civilization. Here the torso is drawn "correctly" in a naturalistic vein, while the rendering of the face alone is typical of the artist's mannerisms. Other artists have surrounded the nude with pieces of furniture, draperies, and flower still lifes, and sometimes struck a dramatic note by the addition of a fully clothed companion figure. Modigliani's nude is generally shown without any distracting accessories. The convention of concealing the pubic hair by a bit of drapery or the casual gesture of a hand was generally spurned by Modigliani. His attitude was that of the ancients who insisted that *naturalia non sunt turpia,* natural things are not bad in themselves.

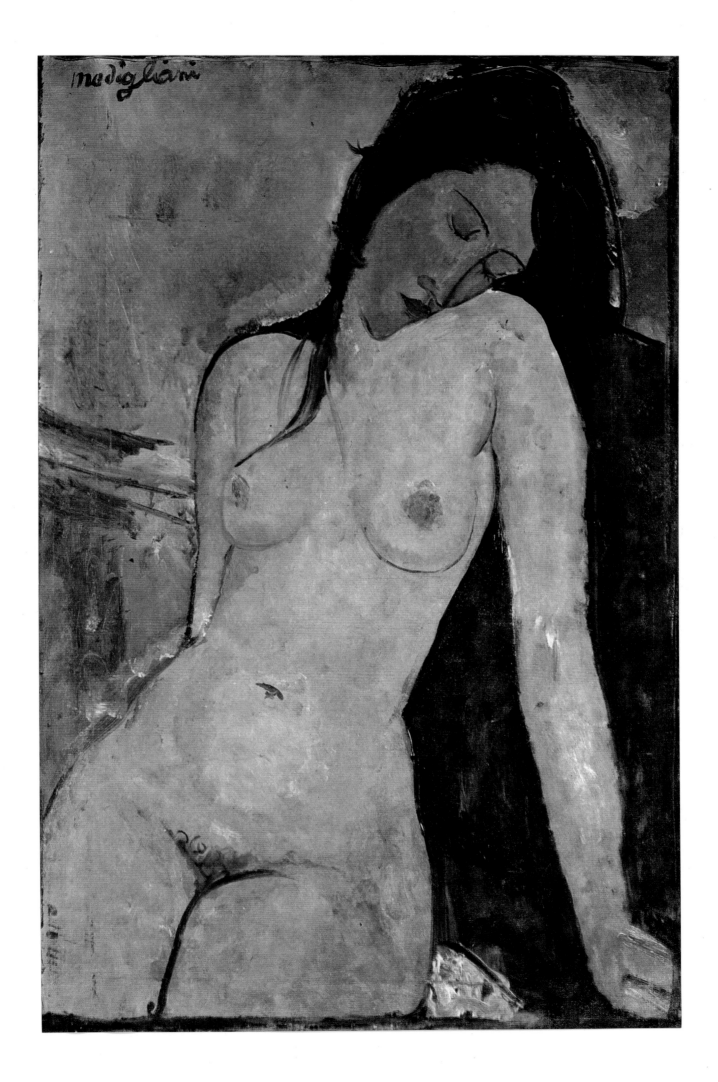

Painted 1914

PORTRAIT OF DIEGO RIVERA

Oil on cardboard, 39 3/8 × 31 1/8″

Museu de Arte, São Paulo, Brazil

The Mexican painter Diego Rivera (1886–1957) in his Paris days often associated with Modigliani; they disputed on art, drank together, and often quarreled violently. In *The Fabulous Life of Diego Rivera*, Bertram D. Wolfe relates that the very industrious Mexican helped Modigliani whenever he and his companion Angela were themselves not starving. Rivera posed for several artists. Mr. Wolfe writes:

"But the best of the Rivera portraits are three attempts by Modigliani, wrestling with the problem of getting into his sketches something of the savagery, smoldering sensuous fire, fantastic imagination and mighty irony for which Diego was famous. His Rivera is large and heavy, savage and overflowing, mocking and bombastic. How strong must have been the impact of Diego's personality so to alter Modigliani's usually simple, lyrical line!"

The swirling spirals in a manner unusual for Modigliani bring out the huge bulk of the enormous Mexican (this is, of course, only an unsigned sketch on cardboard: in an equally large but more finished portrait whose whereabouts is unknown, the swirls disappear under the heavy pigment). Like a sun, the round, insolent face with little eyes and drooping lips shines forth in an outbreak of utter truculence.

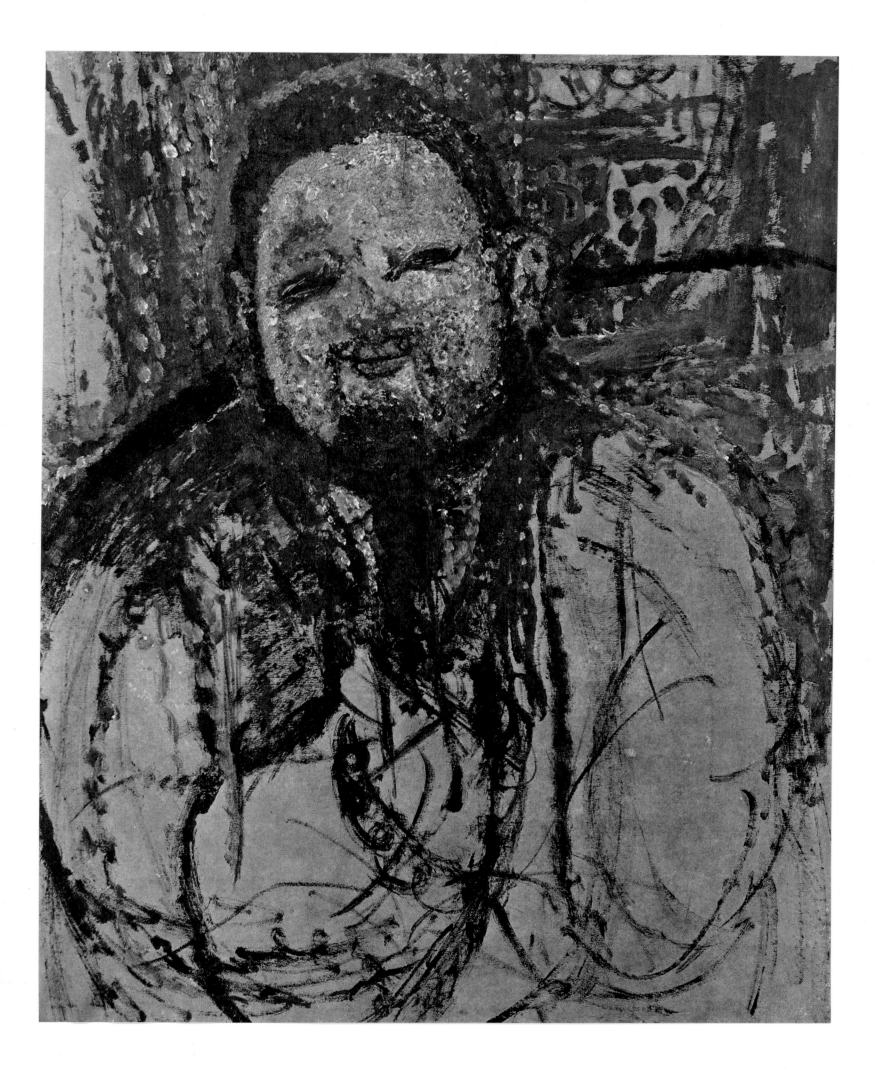

Painted c. 1914

PORTRAIT OF
FRANK BURTY HAVILAND

Oil on cardboard, 28 3/4 × 23 5/8"

Collection Gianni Mattioli, Milan

The subject, a wealthy collector, was well known in the art circles of Paris. His father was an Englishman and his mother was a daughter of the French critic Philip Burty, a staunch defender of Manet. It was in the sitter's house that Modigliani may have first encountered African Negro art. Two qualities make this picture unusual within the production of Modigliani. The head here is seen in flat, exaggeratedly long profile rather than in full or three-quarter face. The artist made use, for once, of the Neo-Impressionist method of Pointillism, although in no way adhering strictly to the theories of Seurat and Signac. The face, in particular, is composed of dozens of tiny strokes of arbitrary color. Almost a decade earlier Matisse, in *Luxe, Calme et Volupté*, had also briefly fallen under the spell of Neo-Impressionism. But neither artist ever repeated the experiment.

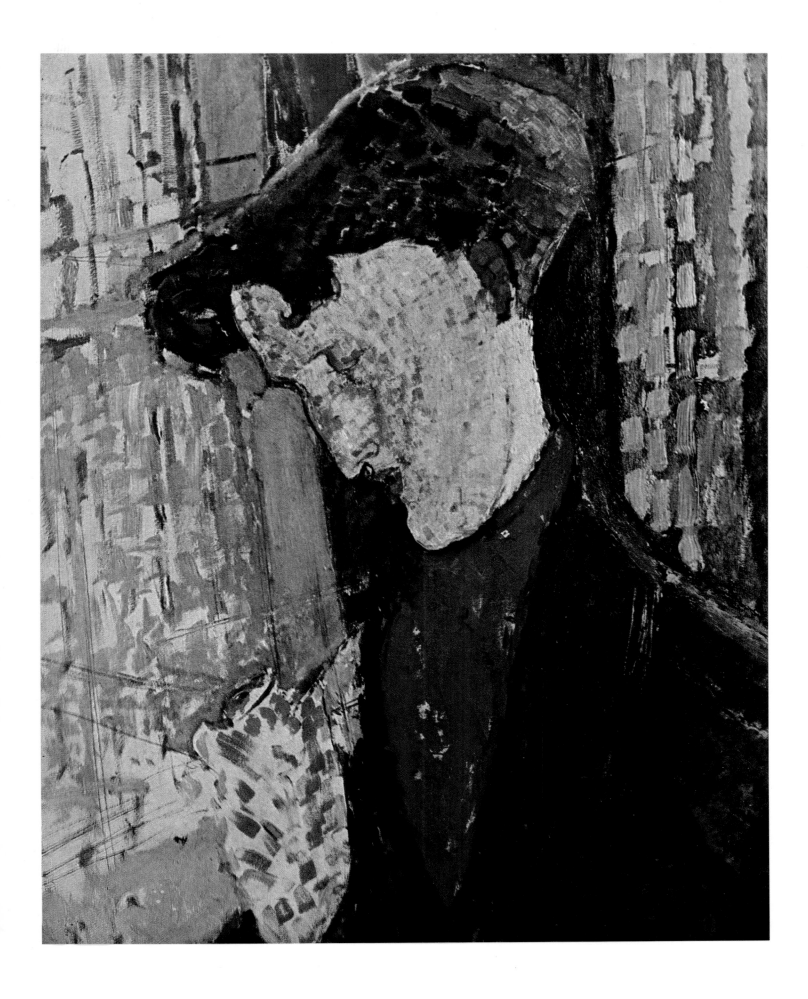

Painted 1915

PORTRAIT OF HENRI LAURENS

Oil on canvas, 21 5/8 × 18 1/8"
Private collection, Paris

Henri Laurens (1885–1954) was a Cubist sculptor who, among other things, made constructions in colored sheet iron. The reddish object flanking the artist's head may be a reference to his work. In this powerfully composed picture little is left of Modigliani's earlier concessions to realism. However, he never went as far in the destruction of reality as did the Cubist painters—Picasso, Braque, Gris, and others—whose sitters almost disappear in a maze of fragmented geometric details. Modigliani seems here rather to have taken to heart the admonitions of the aged Cézanne. The geometrical simplification skillfully held together is as unnaturalistic as the strong red applied without regard for the actual color. But while Modigliani was, of course, a deft patternmaker, he never neglected a sitter's personality. One may speculate as to the magnificent series of portrait busts he might have hewn from stone, had he remained a sculptor.

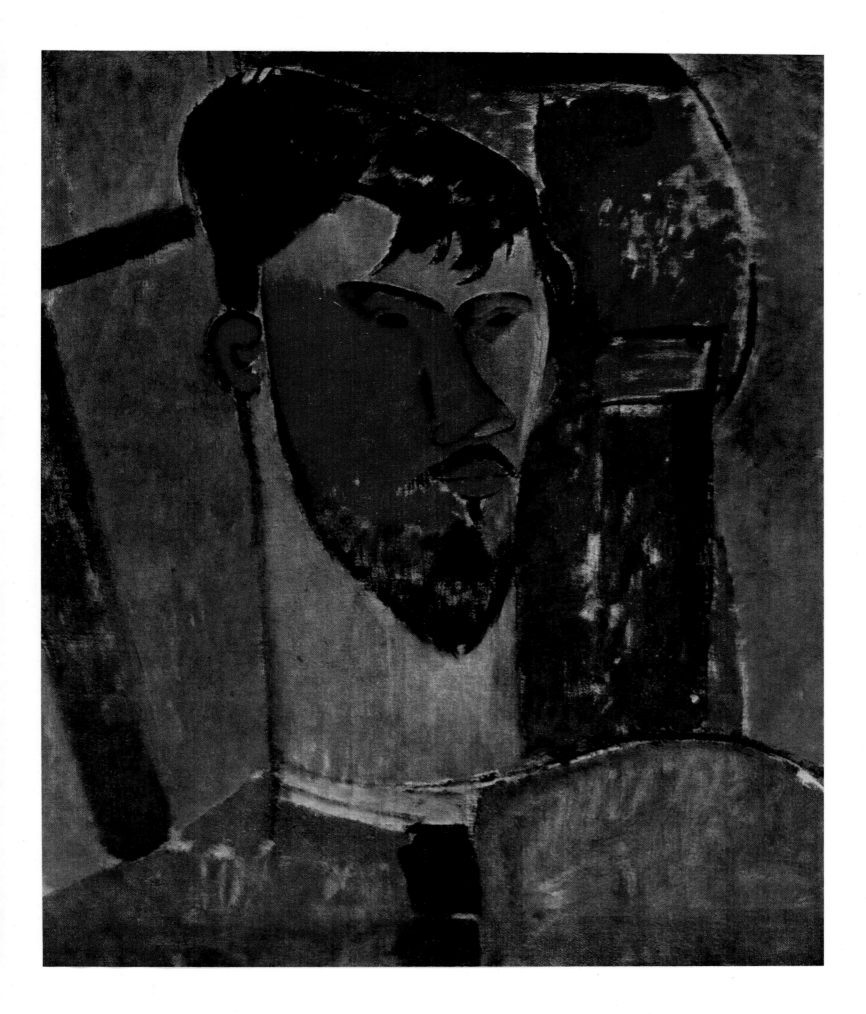

Painted 1915–16

BRIDE AND GROOM (*Les Mariés*)

Oil on canvas, 21 3/4 × 18 1/4″

The Museum of Modern Art, New York, Gift of Frederick Clay Bartlett

Modigliani specialized in single-figure studies; this picture is one of the rare exceptions, as is the double portrait of the sculptor Lipchitz and his wife (page 109). The poet Jean Cocteau has suggested that this picture may have been inspired by two social climbers Modigliani had noticed on the boulevards. Unlike most of Modigliani's subjects, who are very informally dressed, these two are well groomed and seem to be out for a night on the town (note the man's opera hat and stiff collar, the woman's large earrings). Undoubtedly Modigliani viewed the two, from a world very different from his own, with mildly ironic eyes. Echoes of Cubism, by 1915 several years old, can be detected in the faceting of the faces and figures.

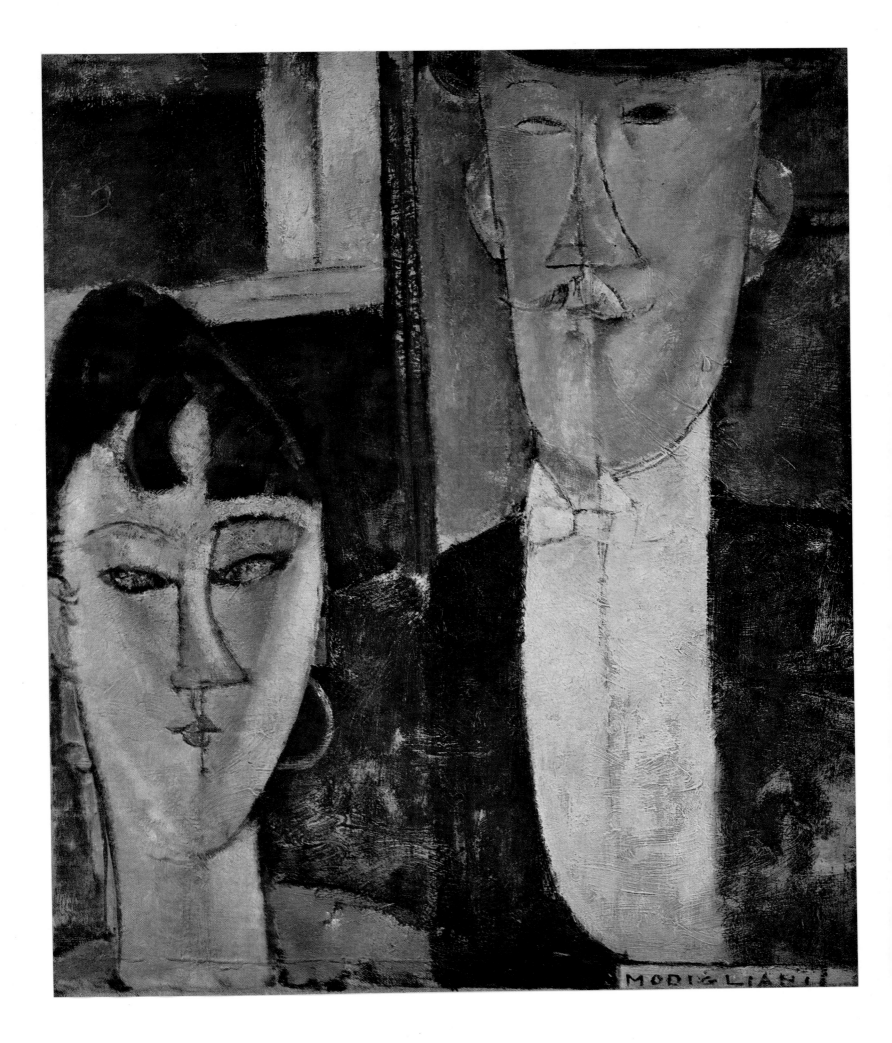

Painted 1915

PORTRAIT OF BEATRICE HASTINGS

Oil on canvas, 32 × 18 1/2"

Collection The Ritter Foundation, Inc.

For two years Modigliani lived with Beatrice Hastings, an English woman of South African origin, often referred to by his biographers as "*la poétesse anglaise*" (he had been introduced to her by the sculptor Zadkine). Whatever poetry she may have written, she became known eventually through her ardent espousal of the theories of the theosophist Madame Blavatsky. Opinion is divided about the influence she exerted upon Modigliani; according to some it was she who introduced him to whisky, while others report that she actually restrained him and made him work. Modigliani drew and painted her repeatedly. To judge by this rendering of her face, she did not have the beauty of her successor, Jeanne Hébuterne. Jeanne appears to have been submissive, unlike Beatrice, whose strong and cold personality is hinted at in the decisive willfulness of her mouth. Here more than in other more fluent, more lyrical portraits is a basically angular design, with sharp intersections of planes and the dominance of straight lines. Although she was very much of a Bohemian, Beatrice is seen here wearing a fashionable hat: no lady would be seen in a public place without one at that time.

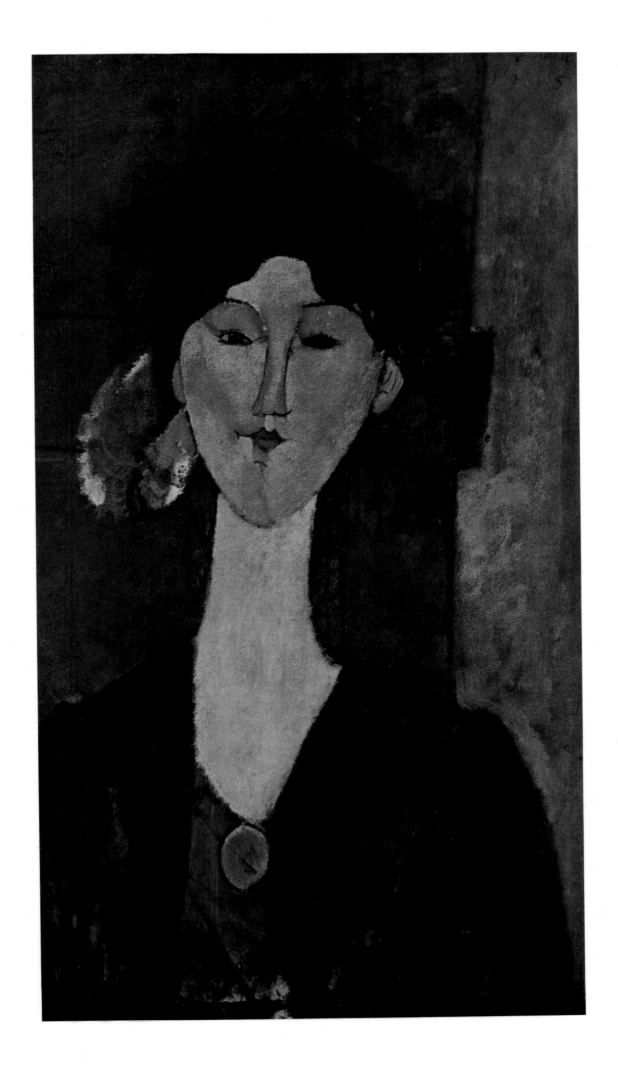

Painted 1915

THE FAT CHILD

Oil on canvas, 18 1/2 × 15"
Private collection, Milan

In the upper left corner, the title *L'Enfant gras* is written in large characters. Modigliani occasionally painted the title on the canvas to identify the sitter or to convey an informal message. His friend and drinking companion Utrillo liked to use words like *vins* or *liqueurs* in signs on the old houses he painted. Picasso and Braque used words, or parts of words, as formal elements in their Cubist compositions. Although by 1915 Modigliani had abandoned his own sculpture, there is much sculpturesque simplicity in the pictures he painted in his last four or five years. The almost perfect oval of the face is reminiscent of the head of Mademoiselle Pogany done by Modigliani's mentor, the sculptor Constantin Brancusi. Salmon claims that *The Fat Child* "on closer inspection turns out to be a study of a beautiful young woman."

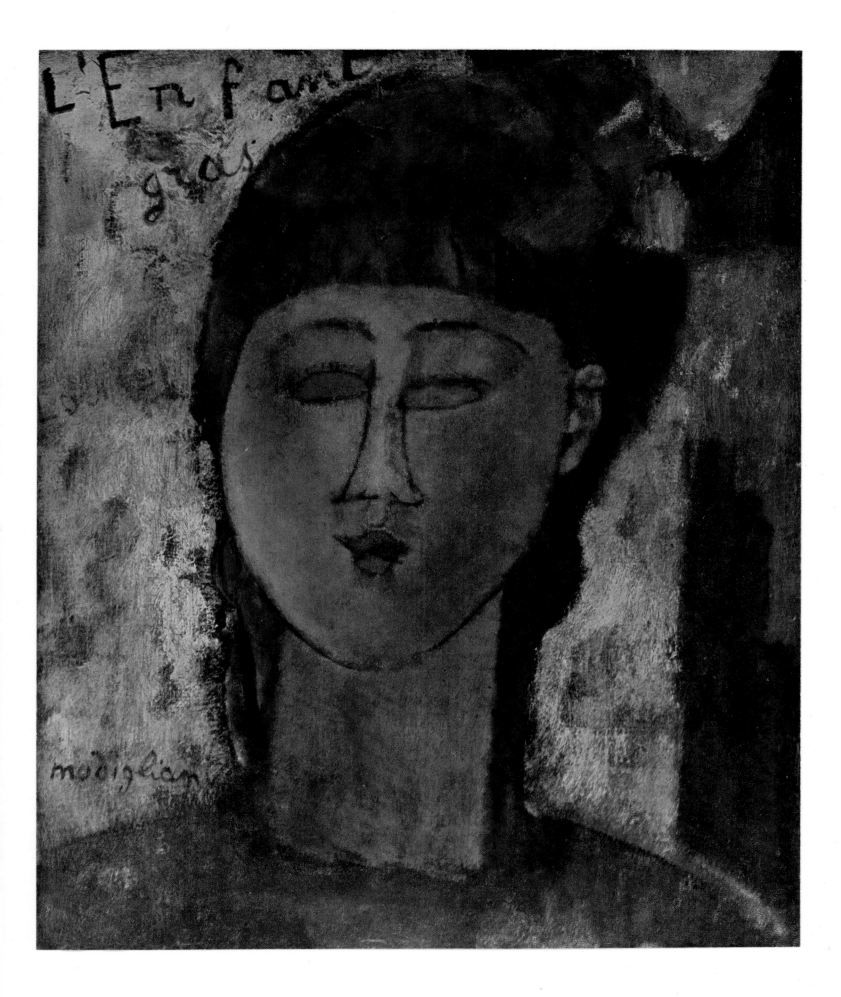

Painted 1915

PORTRAIT OF PABLO PICASSO

Oil on canvas, 13 3/4 × 10 1/4"

Collection Georges Moos, Geneva

While still under Brancusi's influence, Modigliani would say that the example of Picasso and his "contrivances" should be avoided. Later, however, he remarked that "Picasso has always been two years ahead of the rest of us." Of his contemporaries, Picasso and Matisse were clearly the artists Modigliani most admired. Picasso is not known to have returned the compliment. He accused Modigliani of exhibitionism, saying, "You may find Utrillo drunk anywhere...but Modigliani is always drunk right in front of the Rotonde or the Dôme" (where he would be most conspicuous). To judge by an episode recorded by Roland Penrose in his *Picasso: His Life and Work*, one may assume he did not think too highly of Modigliani's work:

"On one occasion [in 1918, it seems] ... he searched the house for a canvas on which to work, and finding none he picked on a painting by Modigliani which he had acquired. Setting to work on it with thick paint which allowed nothing to show through, he produced a still-life with a guitar and a bottle of port."

In 1915, however, relations between the two so utterly different men were friendly enough to allow Picasso to pose for Modigliani (in addition to this hastily done portrait, two portrait drawings are known). Note the Art Nouveau-style "Picasso" lettered above the head, and over the shoulder, the single word *savoir* (to know) which might be interpreted as a tribute to the wisdom of Picasso, though here he is made to look like a dark-skinned, wide-eyed faun.

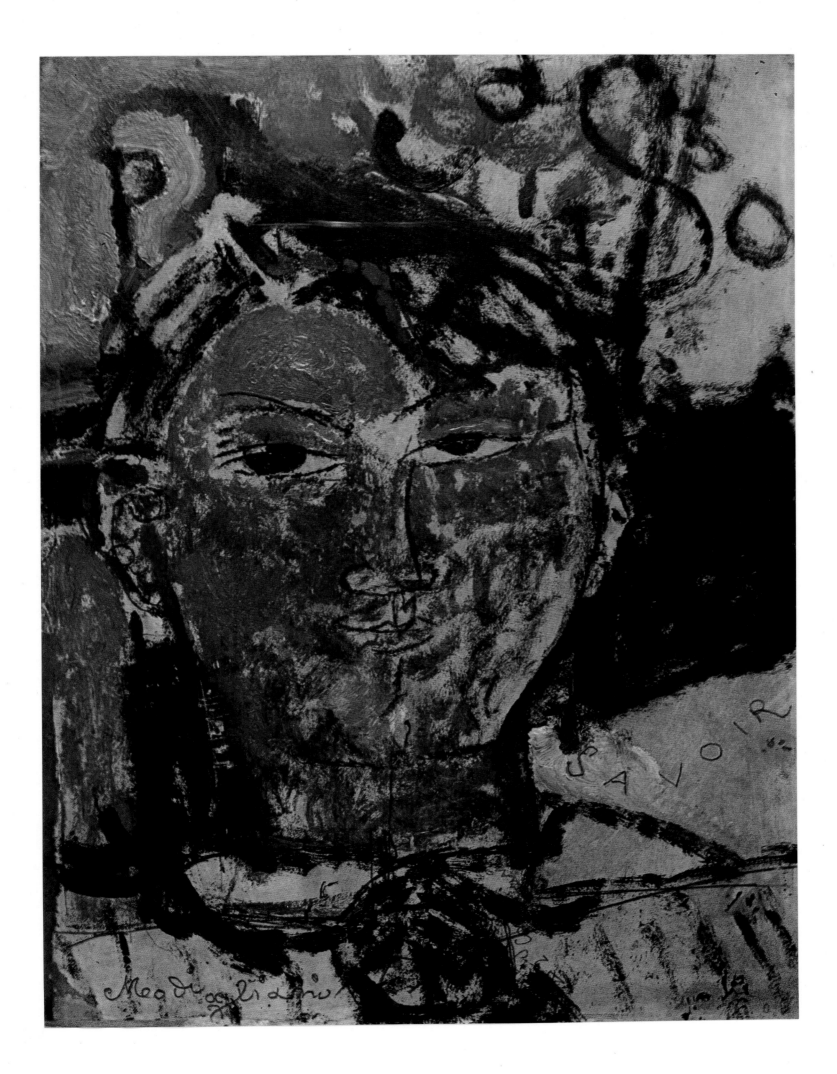

Painted 1915

HEAD OF KISLING

Oil on canvas, 14 1/2 × 10 3/4"

Collection Emilio Jesi, Milan

The sitter, the painter Moïse Kisling (1891–1953), has a four-square, strong-boned face and is portrayed in an uncompromisingly direct manner. Kisling studied at the academy of art at his native city of Cracow (now in Poland) where his well-informed teacher, Joseph Pankiewicz, strongly urged him to go to France: "He drew my attention to Paris where the unhappy but ingenious Italian Jew, Amedeo Modigliani, had just started his ill-fated career, in reckless opposition to the *académiciens*." Kisling arrived in Paris in 1910. He and his wife Renée often posed for Modigliani and tried to help him in many ways. When Modigliani had no studio, Kisling offered him his, in the Rue Joseph Bara. There Modigliani painted some of his masterpieces, among them the portrait of Jean Cocteau (page 115) and the double portrait of Lipchitz and his wife (page 109). Kisling assisted Lipchitz in making Modigliani's death mask.

Unlike Modigliani, who could be childishly rude to a prospective patron if he felt the slightest antipathy, Kisling was amiable in his dealings with collectors. He summed up his philosophy: "One works, eats, drinks, works, one lives very well and marries, that's all." His own portraits, strongly outlined and painted carefully in cool, restrained colors, have an affinity to those of Modigliani, but in them there is only a hint of melancholy, only a scent of sadness.

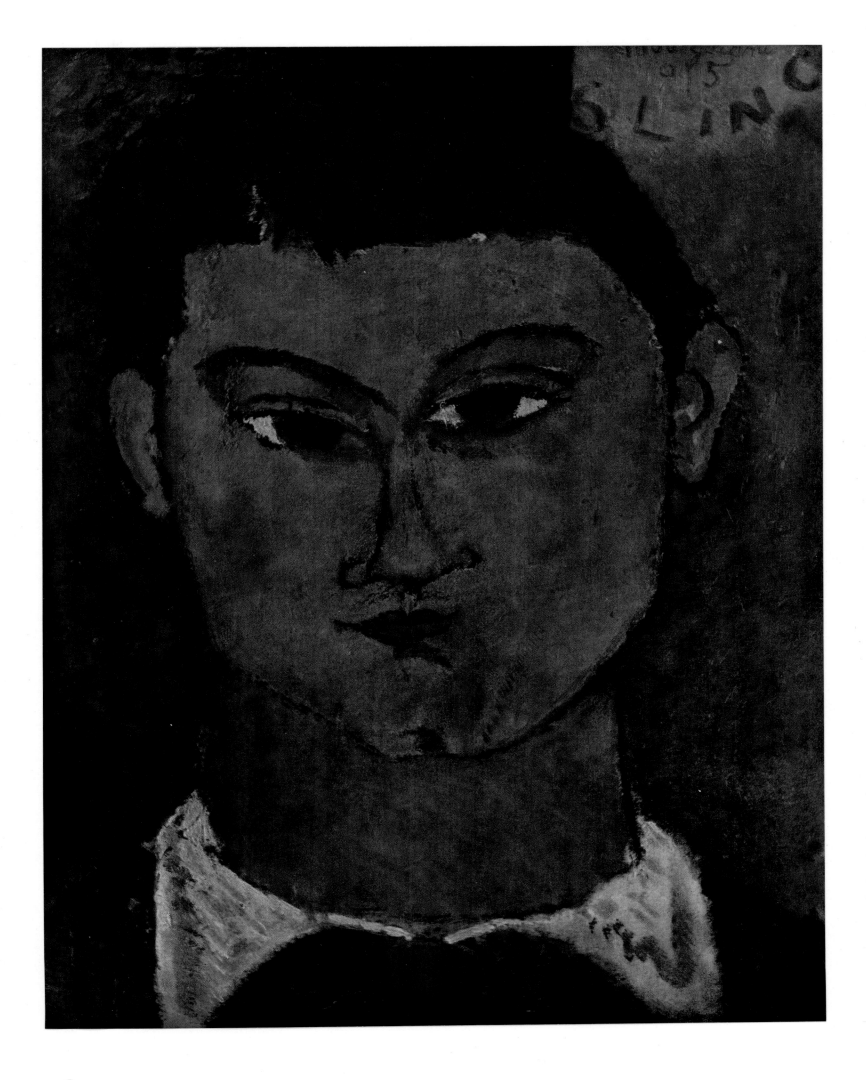

Painted 1916

PORTRAIT OF PAUL GUILLAUME

Oil on canvas, 31 1/2 × 21 1/4″

Civica Galleria d'Arte Moderna, Milan

The poet Max Jacob introduced Modigliani to the dealer Paul Guillaume in 1914. (Guillaume opened his own gallery on the Rue du Faubourg St. Honoré in 1915). He bought and sold some of Modigliani's paintings, yet did not devote himself to the young artist with the self-forgetting fervor that was to characterize the next and last dealer, Leopold Zborowski. Modigliani drew and painted Guillaume several times. In another portrait, now in a private collection in Paris, the words "NOVO PILOTA" appear in the lower left corner. They were meant as a compliment, a comparison of the *avant-garde* dealer with pioneer aviators. In pose this picture is reminiscent of Venetian Renaissance portraits the artist must have seen in his student days. By little details—the tilt of the hat and the necktie slightly off center—Modigliani characterizes his dealer as easygoing and informal, as he assuredly was. But there is also something detached and subtly arrogant in the posture and facial expression of this businessman who later committed suicide by shooting himself.

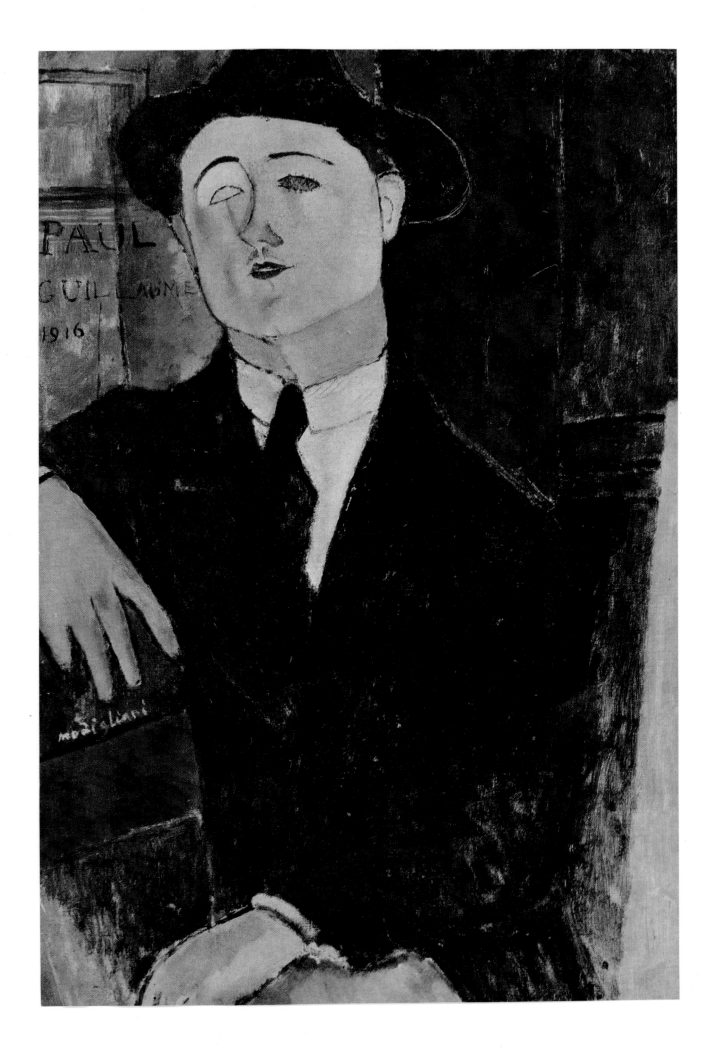

Painted 1917–18

PORTRAIT OF MARGUERITE

Oil on canvas, 31 1/2 × 17 3/4″

The Abrams Family Collection, New York

The same model in the same mauve dress posed in strict frontality for another picture, now in a private collection in Italy. The room is barely indicated by what looks like a door, and space is suggested only by the perspective of the chair. While many of Modigliani's male sitters are known to us, and include individuals who achieved high fame in art or literature, this is less true of the female sitters, often identified by first name only— such as Louise, Almaisa, or Renée—or not identified at all. Marguerite was one of the thousands who frequented Montmartre and Montparnasse trying to eke out a living. The artist gave her a strength of character she may not have possessed. Note the exaggerated size of the vivid eyes and the uninterrupted elegant line that encompasses the outline of the nose and eyebrow.

Carrieri observes: "Men and women repeat the same natural gesture; sitting down is the simplest thing in the world; but when they stand up again, they have unknowingly left their soul there. The chair, the plaster, the atmosphere is pregnant with them. . . ."

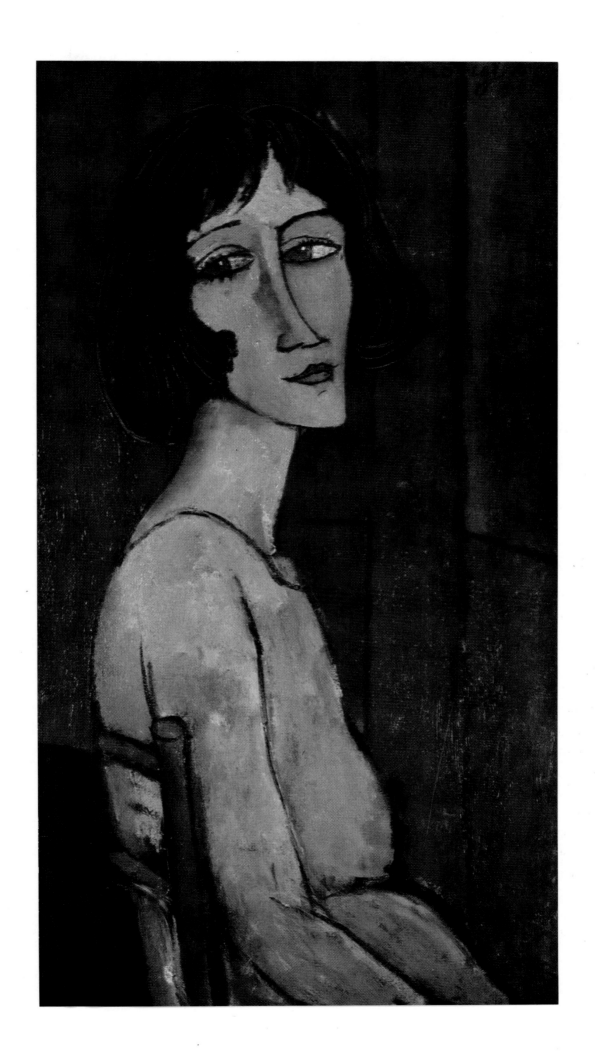

Painted c. 1916

PORTRAIT OF MAX JACOB

Oil on canvas, 36 5/8 × 23 5/8"

Collection Pierre Roche, Paris

Max Jacob (1876–1944), poet, painter, and art critic, was born in Brittany of Jewish parents but, as a young man, embraced Catholicism. Coming of a family of tailors, he was able, despite his poverty, to keep his wardrobe in good repair, and in another picture painted by Modigliani appears as a perfect top-hatted dandy. Note the dome of a mighty forehead. Although Jacob was only forty, his sparse hair was already white. Modigliani's intuition encompassed his sitter's complicated character, described by another friend:

"Malice, ingenuity, covetousness, melancholy, irony, sweetness, goodness, cruelty, salaciousness: all that you will, except innocence, simplicity, lightheartedness, true gaiety, severity, incapacity to understand. Except saintliness. . . ."

In this reticent face, the poet's sensitivity and intelligence are intensely felt. Jacob perished in a Nazi concentration camp.

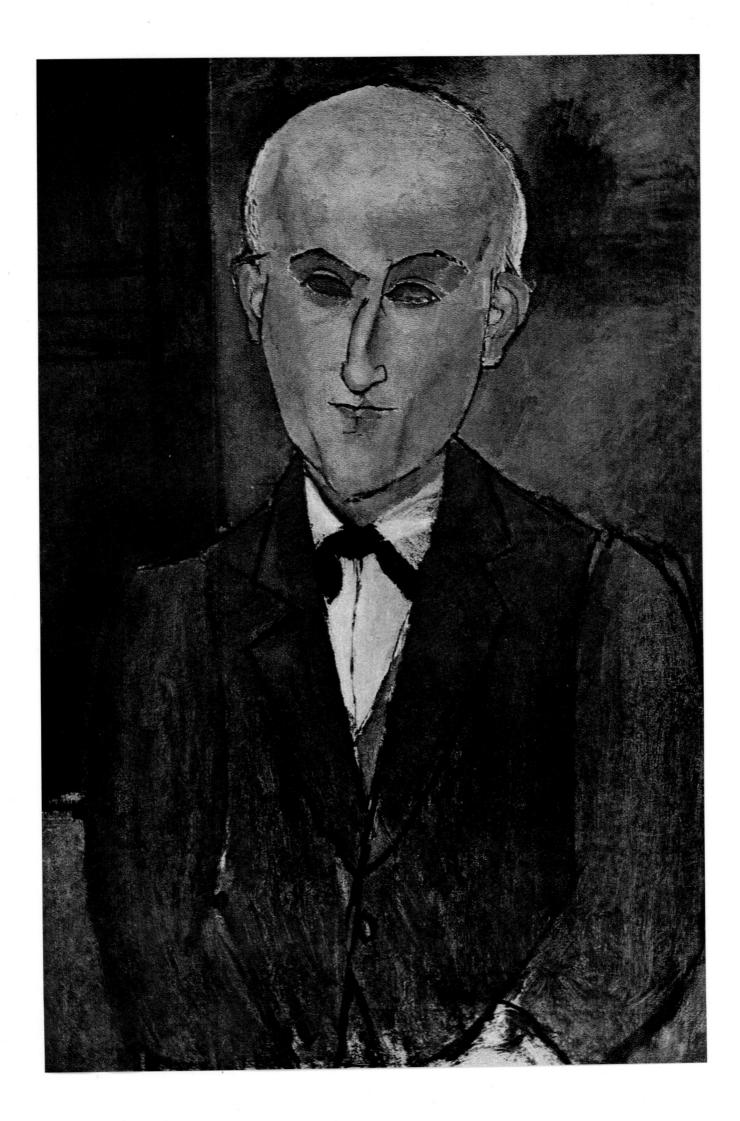

Painted c. 1916

HEAD OF A WOMAN IN A HAT (*Lolotte*)

Oil on canvas, 20 7/8 × 13 3/4″

Musée National d'Art Moderne, Paris

Lolotte was one of the countless girls, mostly from rural districts, who flocked to the artists' quarter in search of excitement and new ways of life. Viewing his sitter in the solitude of his studio (unlike Pascin who did not mind crowds in his studio, Modigliani tolerated no visitors while he was at work), the artist carefully studied every detail. Whereas he gave to most female sitters some of the spiritual beauty that rested in his soul, there is a cheapness about this model. Was she a prostitute, catering to an undiscriminating clientele? Will she sink lower and lower? Or will she be rescued by a neighborhood grocer, to end up as his plump and prim little wife?

Note the flowers in the right corner. What wonderful flower still lifes might Modigliani have produced, had he put himself to this task!

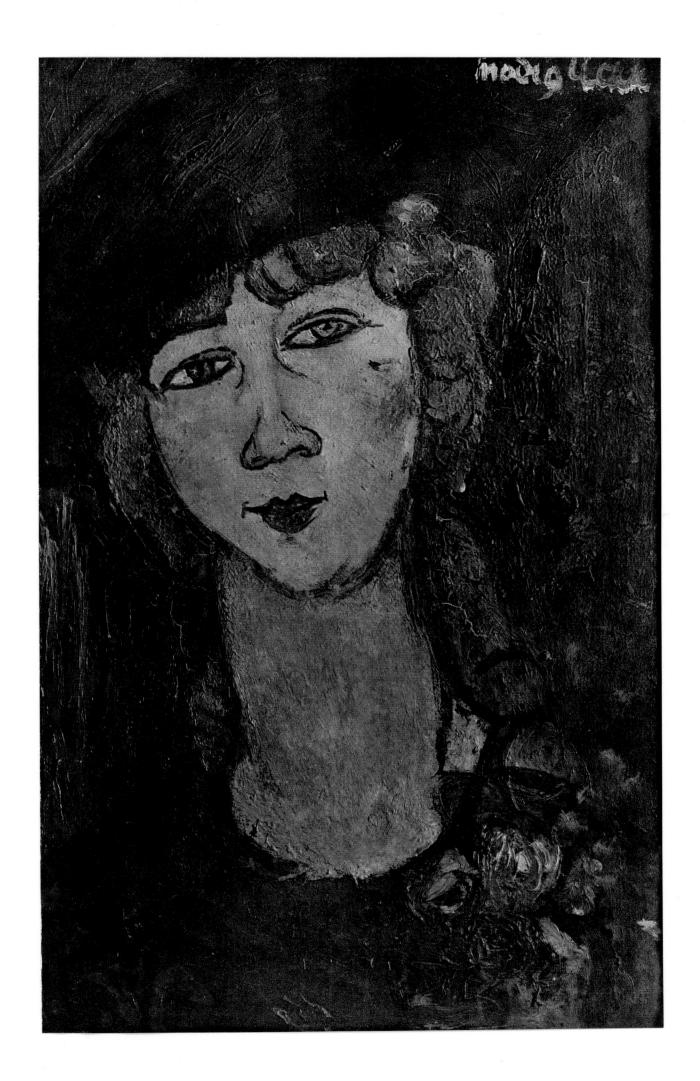

Painted 1916–17

PORTRAIT OF JACQUES LIPCHITZ AND HIS WIFE

Oil on canvas, 31 1/2 × 21"

The Art Institute of Chicago (Helen Birch Bartlett Memorial Collection)

Lipchitz and his wife approached Modigliani in 1916 to ask him to do their portraits.

"'My price is ten francs a sitting and a little alcohol, you know,' he replied when I asked him to do it. He came the next day and made a lot of preliminary drawings, one right after the other, with tremendous speed and precision Finally a pose was decided upon—a pose inspired by our wedding photograph.

"The following day at one o'clock, Modigliani came with an old canvas and his box of painting materials, and we began to pose. I see him so clearly even now—sitting in front of his canvas which he had put on a chair, working quietly, interrupting only now and then to take a gulp of alcohol from the bottle standing nearby. From time to time he would get up and glance critically over his work and look at his models. By the end of the day he said, 'Well, I guess it's finished.' We looked at our double portrait which, in effect, was finished. But then I felt some scruples at having the painting at the modest price of ten francs; it had not occurred to me that he could do two portraits on one canvas in a single session. So I asked him if he could not continue to work a bit more on the canvas, inventing excuses for additional sittings. 'You know,' I said, 'we sculptors like more substance.' 'Well,' he answered, 'if you want me to spoil it, I can continue.'

"As I recall it, it took him almost two weeks to finish our portrait, probably the longest time he ever devoted to working on one painting."

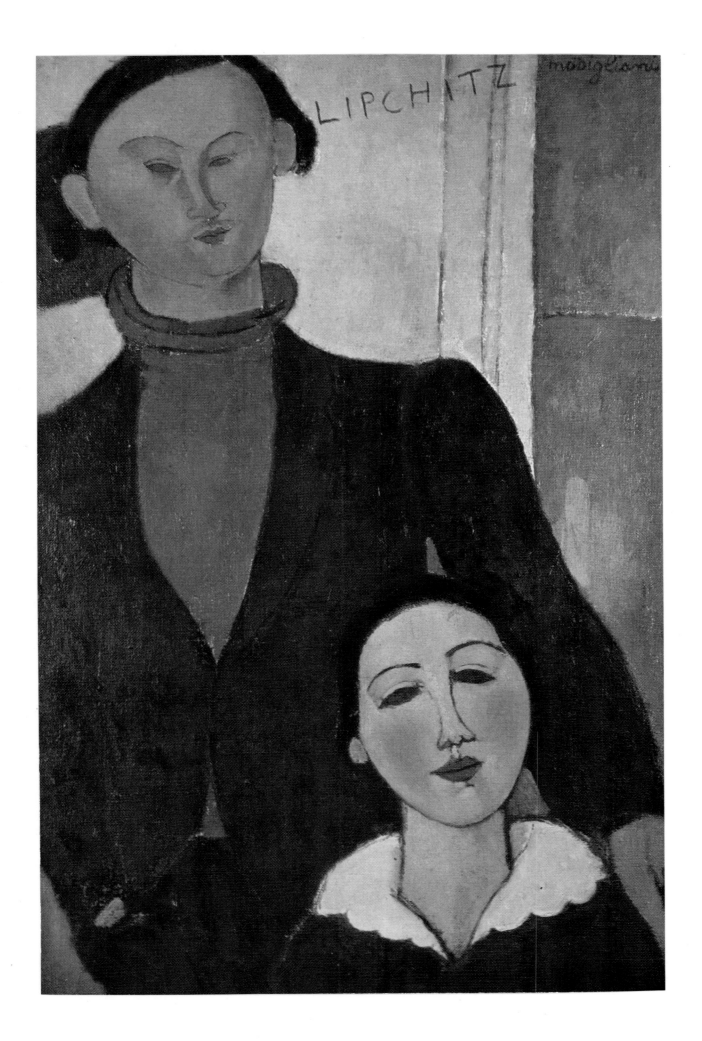

Painted 1917

LE BEAU MAJOR (*Dr. Devaraigne*)

Oil on canvas, 22 × 19"

Collection The Evergreen House Foundation, Baltimore

We know little about the bearded sitter, a physician, except that Modigliani consulted him several times. He seems to have been an army surgeon, to judge by the title, the blue uniform, and the decoration he wears on the left breast. The ruddy complexion is set off by the russet colors of the wall. The general treatment recalls Van Gogh's portrait of the postman Roulin. In all likelihood, Modigliani owned reproductions of Van Gogh's work: the Dutch painter was very popular with the younger artists of Paris. Another portrait of Dr. Devaraigne by Modigliani is in the famous collection of Emil G. Bührle, Zurich.

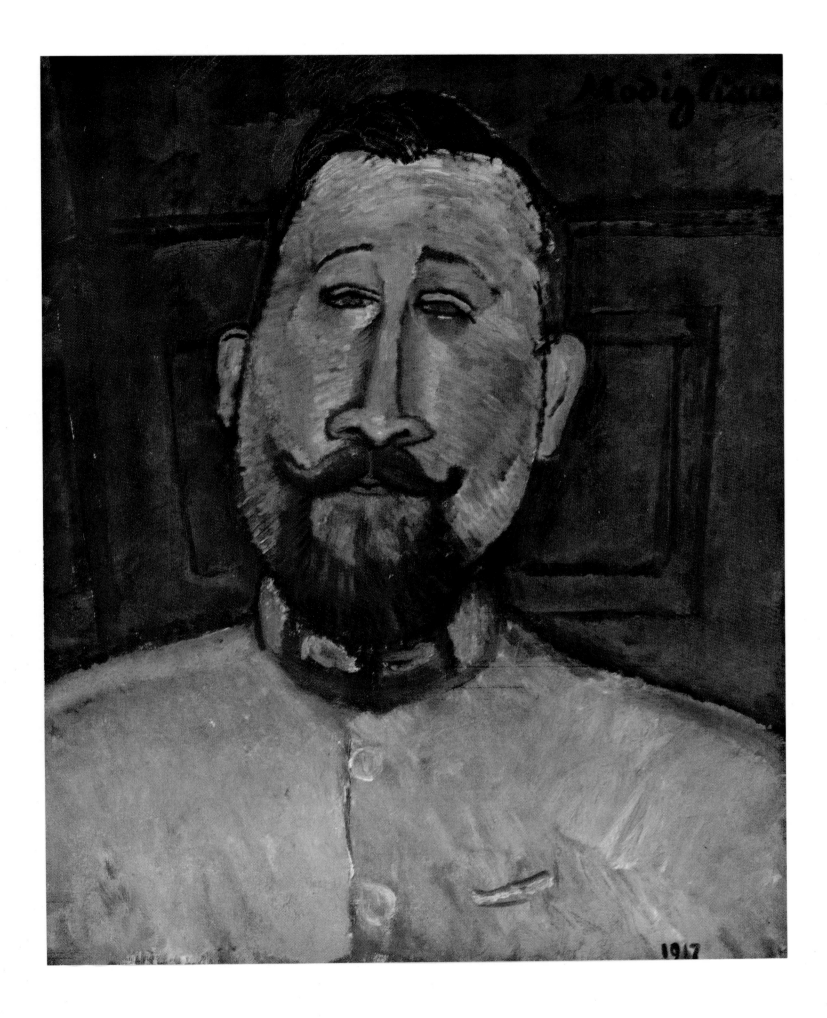

Painted 1917

GIRL WITH BRAIDS

Oil on canvas, 23 1/4 × 17 1/4"

Collection Dr. and Mrs. Ernest Kahn, Cambridge, Massachusetts

This is one of Modigliani's most popular paintings. Here "distortions" and "exaggerations" are less noticeable. The geometric patterns are carefully balanced. While the pretty face is more naturalistically drawn and painted than in other portraits—even to the light reflected in the pupils—the shoulders droop rather unnaturally and the torso becomes a sort of stele for neck and head. Like his contemporary Jules Pascin, Modigliani seems to have been fond of children, for he painted quite a few schoolgirls and boys. This gay little girl in pigtails, with raised eyebrows, whose white teeth repeat the stark whites of her eyes, is as yet untinged by the sordidness of the milieu in which she lives. The door in the background is a favorite motif.

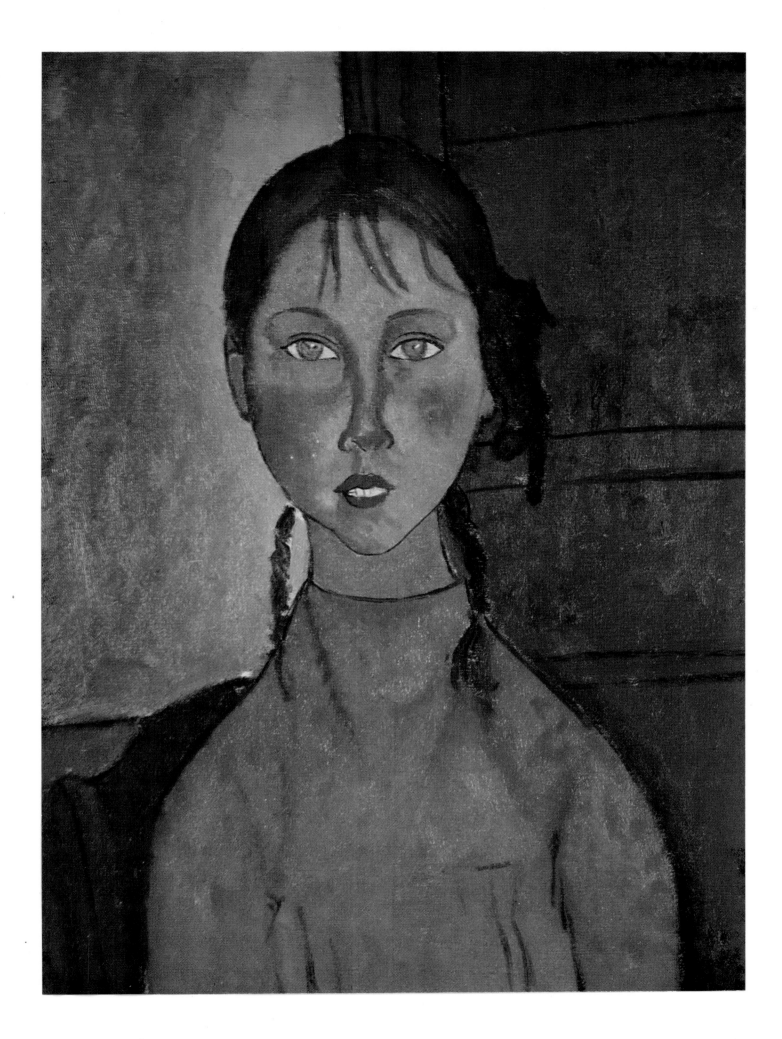

Painted 1917

PORTRAIT OF JEAN COCTEAU

Oil on canvas, 39 1/2 × 32"

Collection Henry Pearlman, New York

Clouet and the French school of portraiture come to mind in this delicate portrait of the elegant young poet Jean Cocteau (1889–1963), then well known for his association with the Russian Ballet. Cocteau sits here as a perfect dandy—note the carefully arranged white handkerchief in his breast pocket. The high hoop of the chair, reminiscent of a throne, might have been chosen by the artist to indicate the leadership the poet, despite his youth, exerted over the literati of Paris.

In the introduction to a small volume on Modigliani, Cocteau called him "our aristocrat." The two became close friends during the painting of this portrait: "I had a sitting every day at three o'clock in Kisling's studio Modigliani's portrait (his prices were between five and fifteen francs) has traveled widely, and enjoyed an immense success; but we were not then concerned with the results of our actions; none of us saw things from the historical viewpoint—we merely tried to live, and to live together."

In this angular, quasi-Cubist portrait Modigliani proved again how well he could, through subtle observations, point out important character traits.

114

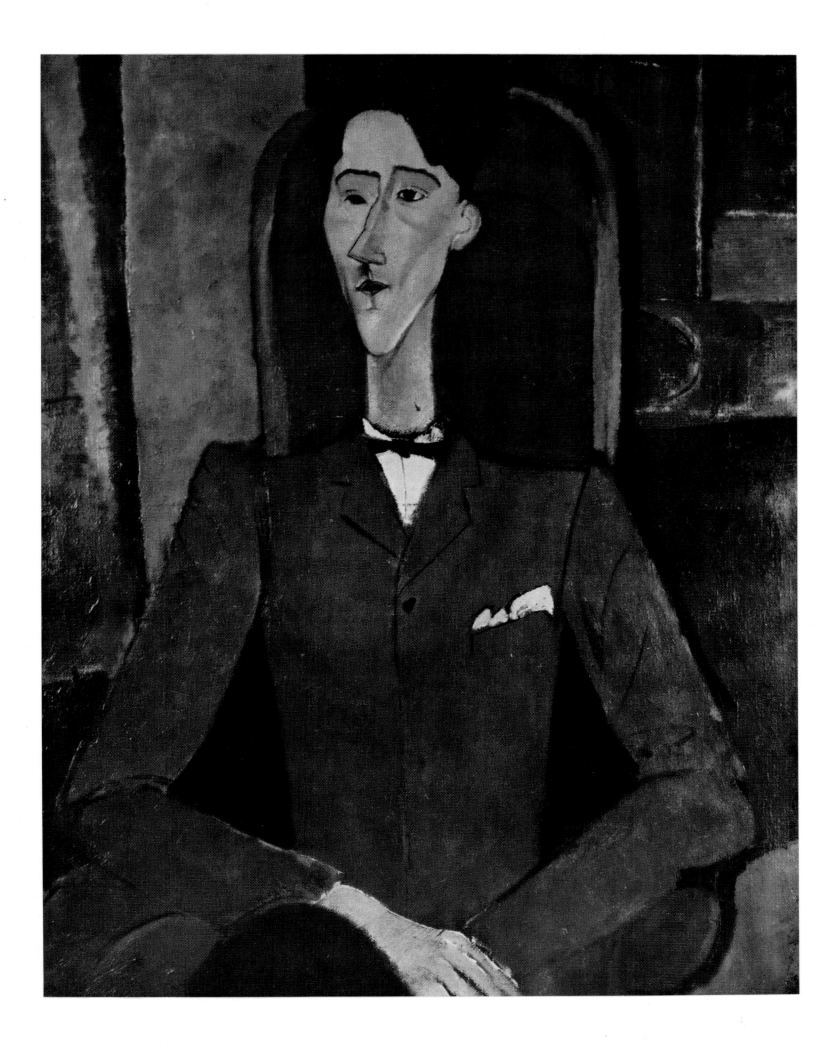

Painted 1917

PORTRAIT OF CHAIM SOUTINE

Oil on canvas, 36 1/4 × 23 1/4"

National Gallery of Art, Washington, D. C. (Chester Dale Collection)

In a self-portrait which Soutine painted around 1917 (collection Henry Pearlman, New York), the artist honestly presents himself as he is also known from photographs: an uncouth, sulky young man with an anguished yet also truculent "ugly" face (his features have been described as resembling those of Kalmuks or Tartars, although by origin he was a Jew from Lithuania). Modigliani, who introduced him to his own dealer, Zborowski, painted him several times (one painting was done on the door separating Soutine's atelier from that of Modigliani at 3, Rue Joseph Bara, and is now in a private collection in Paris). Soutine is shown here in a peaceful, meditative mood, unusual in this uneasy young man. For a change, accessories—a table and a glass—have been introduced, as much for compositional needs as for suggestion of milieu.

Soutine's unruly, wild manner of painting was alien to his Italian friend who, to describe his own state of drunkenness, once quipped: "Everything dances around me as in a landscape by Soutine." Nevertheless, he admired his friend. Mortally sick, he remarked to Zborowski: "Don't worry, in Soutine I am leaving you a man of genius."

116

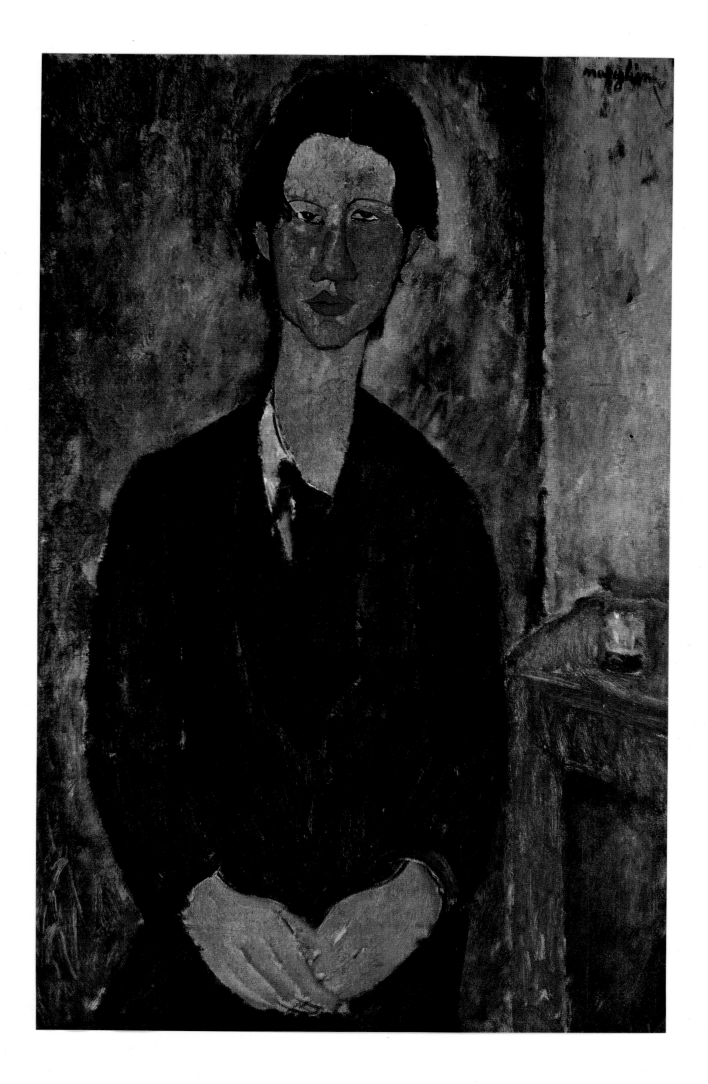

Painted 1917

PORTRAIT OF JEANNE HÉBUTERNE

Oil on canvas, 39 3/8 × 25 5/8"
Private collection, Paris

Jeanne Hébuterne was born in Paris in 1898. She was a student in the sketching class at an art school in the Rue de la Grande Chaumière, and here she met Modigliani. To judge by whatever little of her own work has survived, she had considerable gifts. From 1917 until her suicide in 1920 (right after Modigliani's death), she repeatedly posed for him. Jeanne was small and slim. She was nicknamed *Haricot Rouge* (Kidney Bean), perhaps because of her hair, which was chestnut with reddish lights, and usually done up in a high chignon. Another nickname, *Noix de Coco* (Coconut), was a reference to the paleness of her complexion. In all the portraits she appears sweet, delicate, submissive, in a languid pose. Those who knew her describe her as having been timid, patient, and soft-spoken. Here an interesting pattern is produced through the forms of the oval face and the oval part of the upper body, connected with the head by the typical Modiglianesque cylinder neck. Note the way the fingers of the right hand curl. Note also the eyes. Here as elsewhere she has about her something of a Madonna by Botticelli.

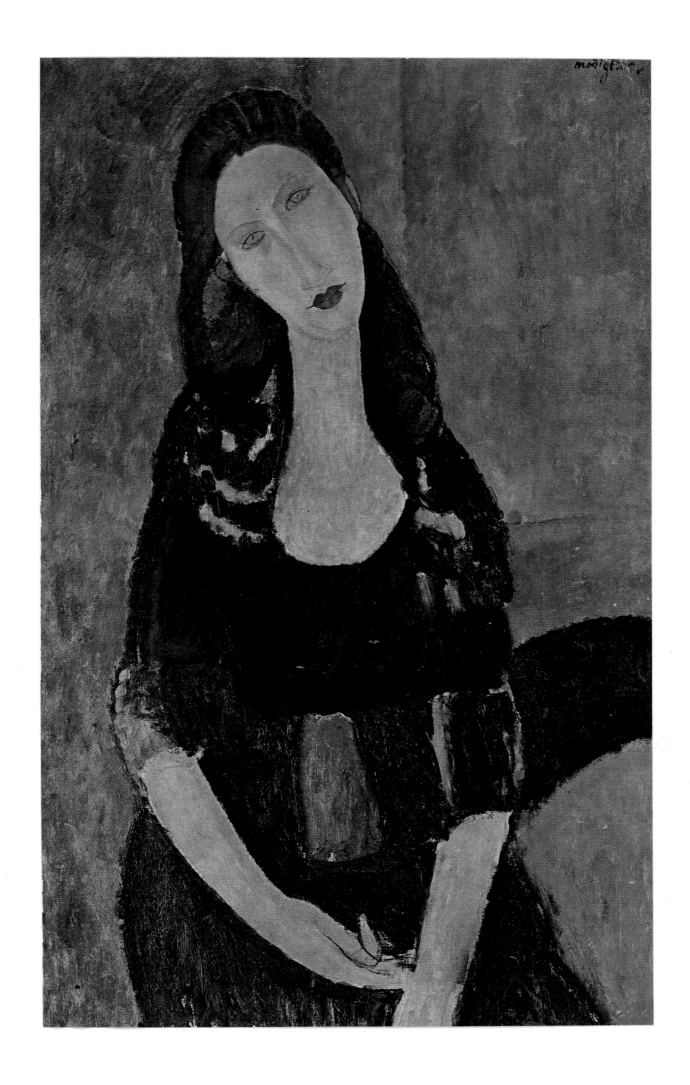

Painted 1918

PORTRAIT OF ANNA

Oil on canvas, 21 5/8 × 13 3/4"

Galleria Nazionale d'Arte Moderna, Rome

Anna (in Polish, Hanka) Cirowska was the daughter of an old and wealthy Polish aristocratic family. She met her future husband, the poet and dealer Leopold Zborowski, soon after his arrival in Paris in 1914. She often fed Modigliani, she nursed him in his last illness, and took care of his infant daughter, Jeanne. "Anna" is written at the upper right of the picture in large yet barely discernible block letters against the brown background. Her face, in enamel-like tones, grows out of the swan neck in rigid articulation of hard volumes. The dark brown of the hair is balanced by the black of the dress. An interesting pattern is made by the large white collar.

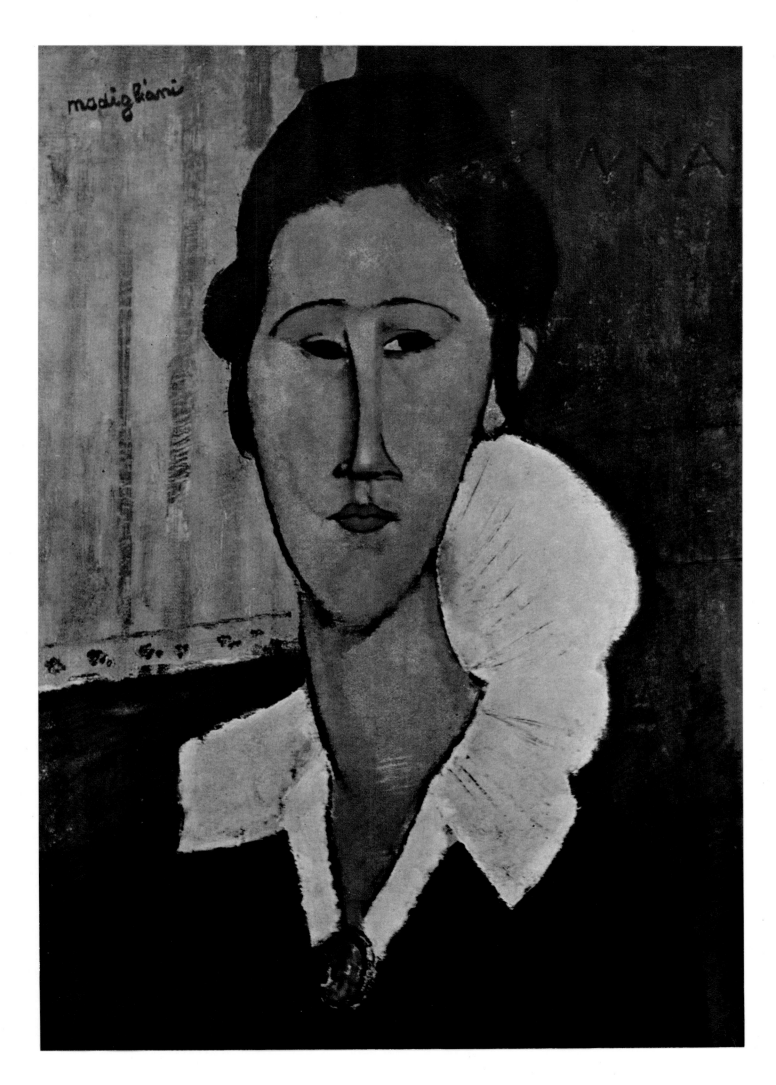

Painted 1917

PORTRAIT OF BLAISE CENDRARS

Oil on cardboard, 24 × 19 5/8″

Collection Riccardo Gualino, Rome

The poet Blaise Cendrars (1887–1961) was a friend of many artists of Paris, and in particular, Chagall, who, in *My Life*, called him a "flame, light, and clear-toned." In a magazine article in 1927, Cendrars reminisced about his late friend Modigliani. When, in 1930, the artist's friends, in a small volume, *Omaggio a Modigliani*, commemorated the tenth anniversary of the painter's death, Cendrars wrote, "*Je l'ai beaucoup aimé*," and the poet's wife, Félicie, expressed "*mon admiration pour le grand Modigliani*."

A fine thumbnail description of Cendrars was given by Ilya Ehrenburg: "A remarkable man, Blaise Cendrars. One could call him a romantic adventurer if the word 'adventurer' had not lost its real meaning. The son of a Scotsman and a Swiss woman, an outstanding French poet who influenced Apollinaire, a man who knew every trade and had traveled all over the world, he was the yeast of his generation. At sixteen he went to Russia, then to China and India, returned to Russia, went on to America and Canada, he served as a volunteer in the Foreign Legion and lost his right arm in the war; he went to the Argentine, to Brazil and Paraguay; he was a boilerman in Peking, a wandering juggler in France, made the film *La Rouée* with Abel Gance, bought lapis lazuli in Persia, was a beekeeper, a tractor driver, and wrote a book on Rimsky-Korsakov. I have never seen him depressed, unnerved, or without hope" (*People and Life, 1891–1921*, 1962).

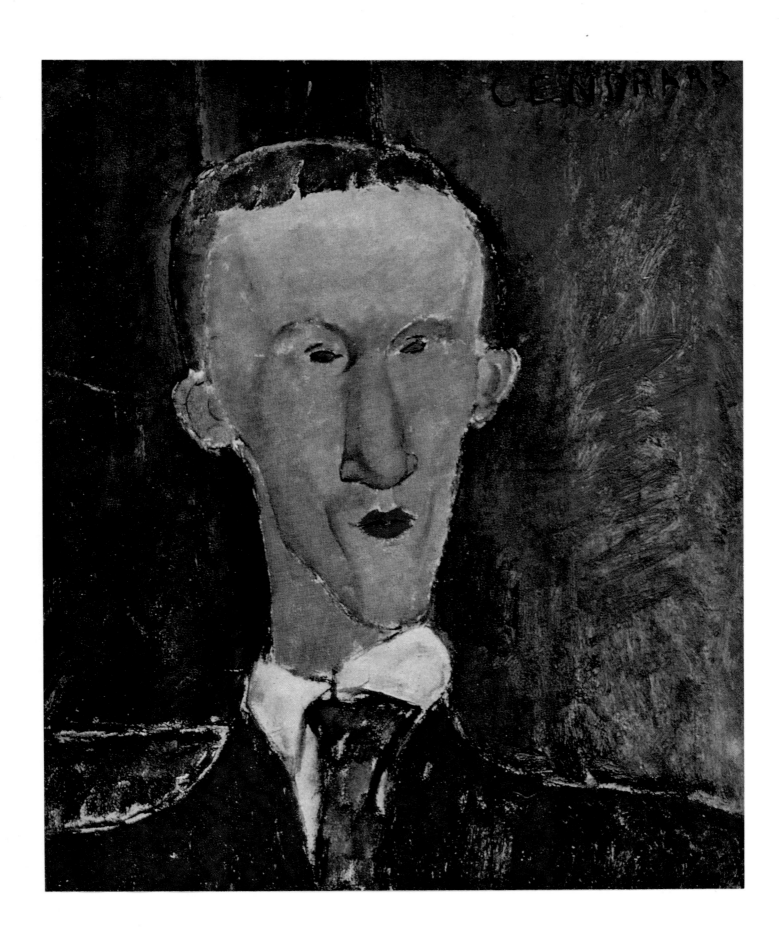

Painted 1917

NUDE WITH NECKLACE

Oil on canvas, 36 1/4 × 24"

Collection Mr. and Mrs. Ralph F. Colin, New York

The model seems to be the same as the one (also wearing a string of beads) who posed for the reclining *Nude* in The Solomon R. Guggenheim Museum. The necklace introduces a note of civilization into what otherwise would be a picture of animal splendor, and so does the hand which—unusual in Modigliani—is directed in the classic gesture of modesty. The face has much of the austere quality of an African mask. Earlier studies of the female nude, such as the one in London's Courtauld Institute (page 83), render the flesh tones in their natural colors. Here as in the other nudes of Modigliani's last years, the form is covered uniformly and flatly, without any attempts at modeling through light and shade, in one high-keyed orange-red hue.

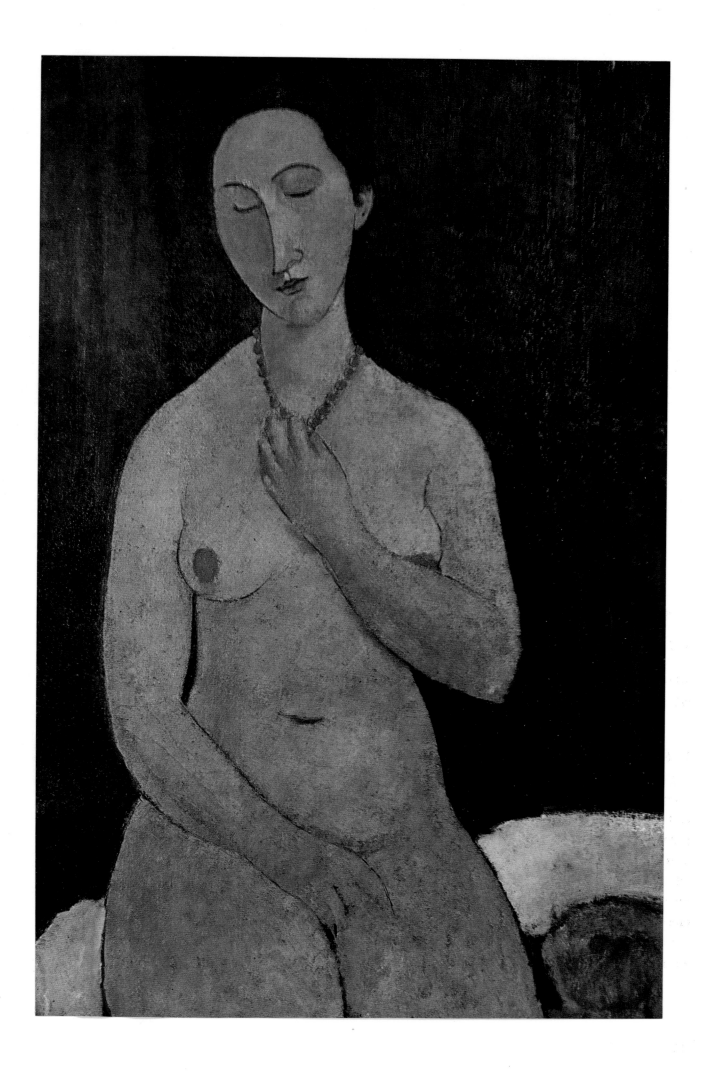

Painted 1918

LITTLE GIRL IN BLUE

Oil on canvas, 46 1/8 × 28 1/2"

Private collection, Paris

In Modigliani's work, "realistic" studies alternate with more formalized, "abstract" work. This small, awkward model, placed in the corner of a room, is painted with as much fidelity to nature—including the shadow cast on the floor and wall—as Modigliani, in his final years, would permit himself. The detail of the pupils is noteworthy, since very often the eyes are reduced to blue or black slits. Modigliani was fond of the proletarian children of his Montparnasse neighborhood, and he painted them repeatedly. This little one wears a pretty dress—perhaps the only good one she owns. There is no gaiety, no cheerfulness in her face. The expression is as forlorn, even resigned, as those of his much older models. Modigliani's pictures of children evoke a genuine feeling of tenderness.

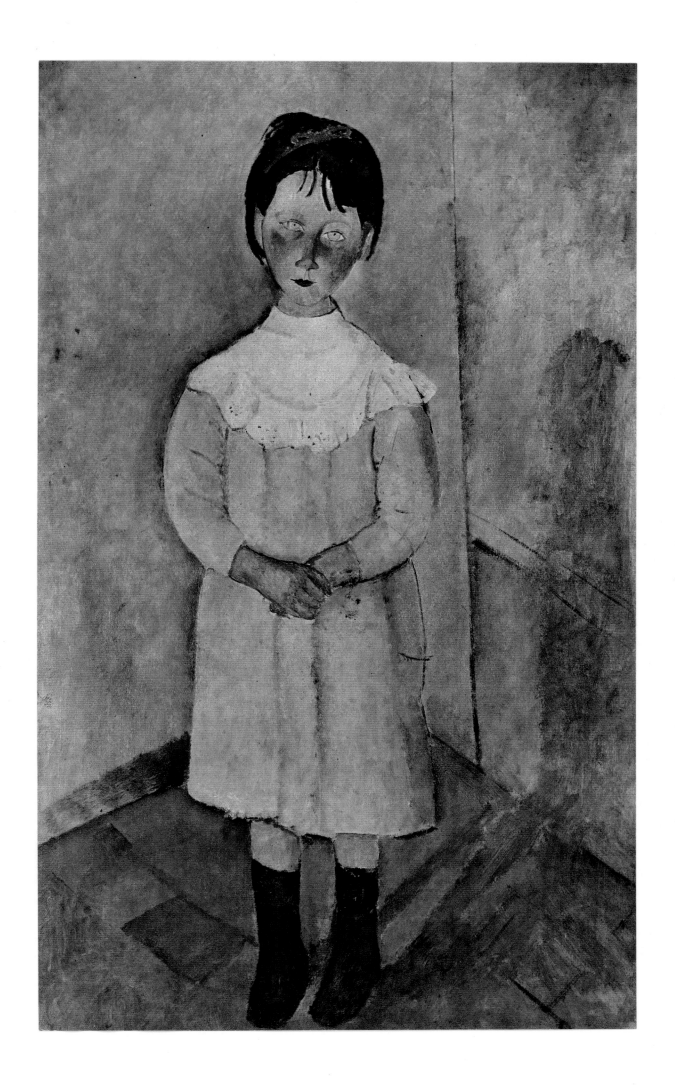

Painted 1918

LANDSCAPE IN THE MIDI

Oil on canvas, 21 5/8 × 18 1/8"

Private collection, Paris

Under the influence of his first teacher, Guglielmo Micheli, at Livorno, Modigliani practiced landscape painting (in the city's museum there is a picture of a country road thought to have been painted by Modigliani when he was about seventeen). Later in life, he paid very little attention to anything but the human figure. He even pretended to loathe landscape. One night, at the bar of the Café de la Rotonde in Montparnasse, Diego Rivera and Modigliani had a furious discussion: the latter shouted, "Landscape doesn't exist," to which his Mexican friend retorted, "Landscape does exist!" As a rule, Modigliani showed people within a room, unlike the Impressionists, who liked to set figures in the midst of nature. (*La Belle Épicière* is an exception; she is seen sitting on a Montparnasse street, near a tree trunk, with two leafless trees and a house in the background.) It is of interest that only a few years after Modigliani painted this *Landscape*, Henry Moore wrote, in a letter from Florence, ". . . I do not wonder that the Italians have no landscape school—I have a great desire—almost an ache for the sight of a tree that can be called a tree—for a tree with a trunk" (*Modern English Painters*, Vol. 2, by John Rothenstein). In the *catalogue raisonné* issued by Arthur Pfannstiel (1956), only three landscapes by Modigliani are listed, including this one. The artist painted it during the period spent in the south of France, especially in Nice and Cannes. The scene suggests a small village street leading toward the beach. The firmness of drawing and coloring recalls André Derain, while the over-all, dry limpidity may be traced to the clarity of Tuscan tradition.

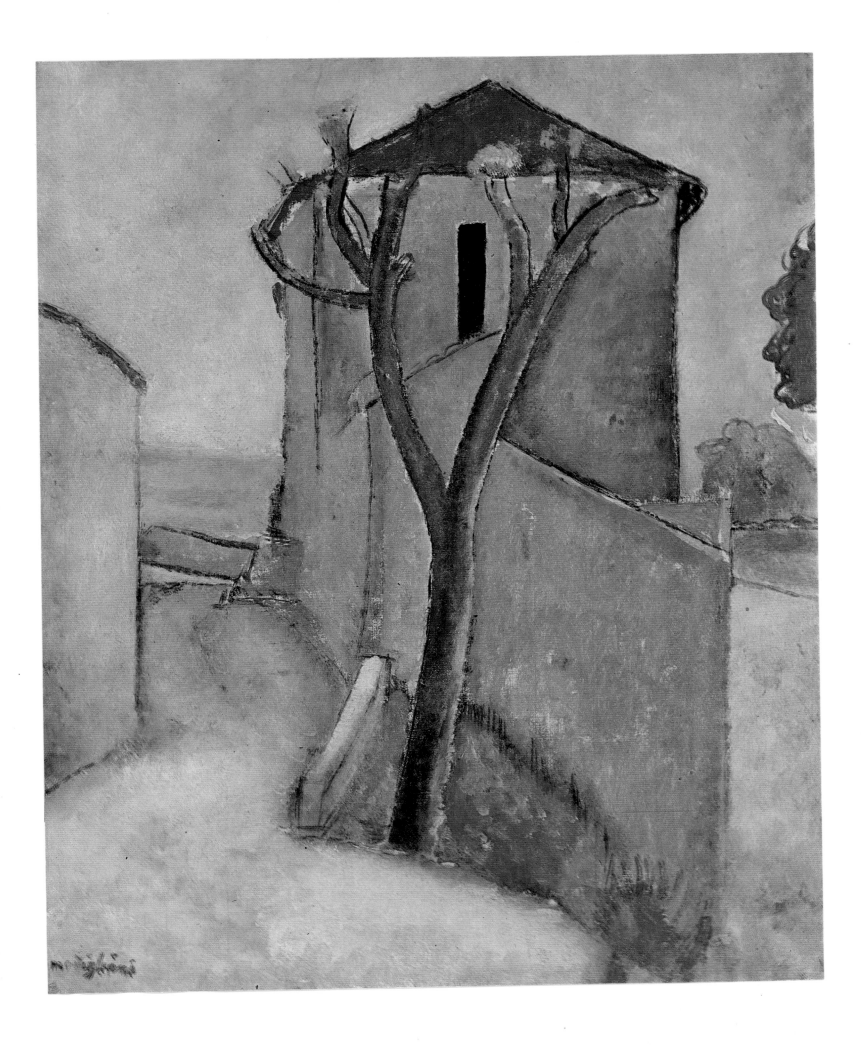

Painted c. 1919

RECLINING NUDE (*Le Grand Nu*)

Oil on canvas, 28 1/2 × 45 7/8"

The Museum of Modern Art, New York (Mrs. Simon Guggenheim Fund)

This picture may have been among several paintings of nudes in the one-man show Modigliani had in December, 1917, at the Galerie Berthe Weill in Paris. The exhibition was visited by a police superintendent who objected to the nudes in the windows, declared the whole thing scandalous, and arrested Mme. Weill and the artist. But Modigliani's nudes are really not sexually provocative. They are far from naturalistic and have something unreal about them. In this they are closer to Giorgione than to Titian. Giorgione's *Sleeping Venus* (in Dresden) has something dreamlike about her, an impression which is enhanced by the idyllic landscape in the background. Titian's *Venus of Urbino* (in the Uffizi) is no longer a goddess; she is a woman, very much a part of the world of reality. Modigliani's nudes are neither goddesses nor young Parisiennes. In their unnatural colors they are like pieces of sculpture, carved out of some orange stone. It is now difficult to understand the uproar and scandal Modigliani's nudes caused in Paris, a city that had displayed on its walls so many more frankly erotic pictures. Note how the orange-gold is heightened in its effects by the contrasting blue and red.

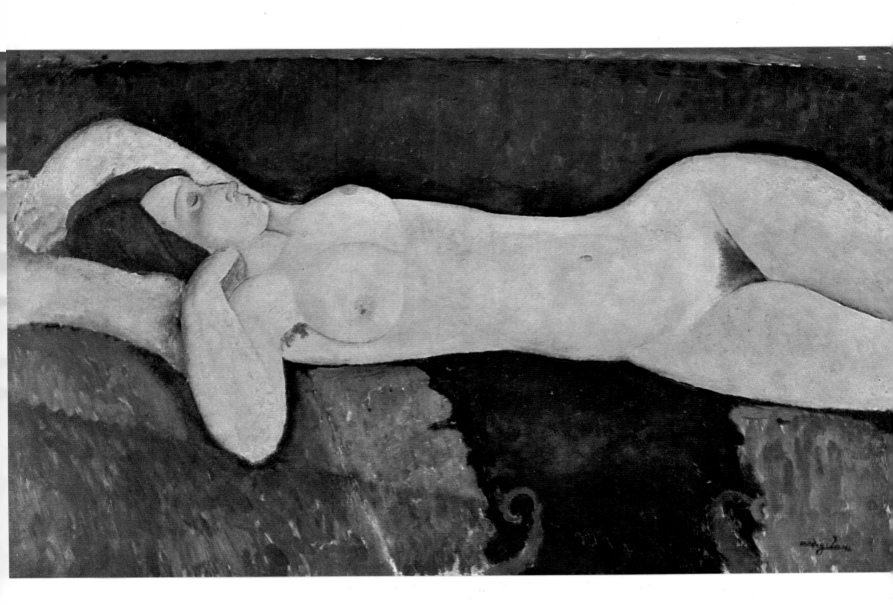

Painted 1917–18

NUDE ON A CUSHION

Oil on canvas, 23 1/2 × 36 1/4″

Collection Gianni Mattioli, Milan

Sleepy and tranquil, the young woman lies stretched out on the sofa, her body forming a long diagonal across the picture. There is no false modesty about Modigliani's anonymous models, who, aware of the artist's presence, display themselves fully to him and to us. Degas, striving to obtain the same unconscious freedom in his work, said that he painted his nudes, bathing and scrubbing themselves, as though he had watched them through a keyhole.

Studying the unrestrained voluptuousness, Modigliani made many pencil sketches, tenderly outlining each limb. He then turned to the canvas on the easel, filling the graceful arabesques which define the form with terra-cotta flesh tones of the most lustrous quality. The elongated body stands out superbly against the subtle combinations of red, blue, black, white, and brown in the background.

The biographer G. Scheiwiller has written:

"One does not know nudes like those of Modigliani's, which can demonstrate such a perfect spiritual communion between the painter and the creature chosen as model."

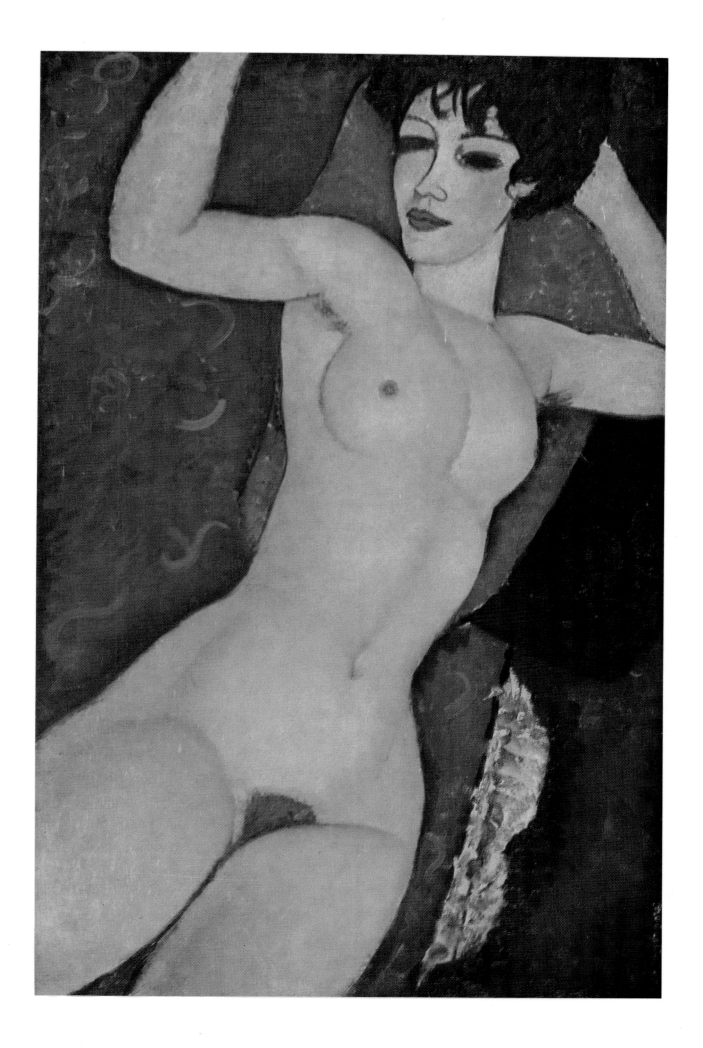

Painted 1917–18

SEATED NUDE

Oil on canvas, 39 3/8 × 25 5/8"

Private collection, Paris

To make the head and large hips balance one another Modigliani suppresses the lower parts of the legs. Even though the body is clearly a combination of elementary stereometric shapes—interlocking cylinders, spheres, ovoids, cones, and cubes—Modigliani's nudes are, on the whole, more realistic, less stylized than his portraits. Here the notion of nudity is enhanced by the bit of white garment that conceals really nothing of this young woman's body. The sensuality of the figure is enhanced by the exaggeratedly large thigh close to the spectator's eye. Yet the voluptuousness is always kept under control. The dignity of immaculate style elevates this frankly erotic nude to a higher level of aesthetic contemplation. Modigliani had no trace of the misogyny of Degas, the lewdness of Bouguereau, the clinical coldness of Toulouse-Lautrec, and the cynicism of Pascin.

He loved women, without reservations, and makes the spectator also love them. In his book *The Nude*, Sir Kenneth Clark wrote that "no nude, however abstract, should fail to arouse in the spectator some vestige of erotic feeling . . . and if it does not do so, it is bad art and false morals."

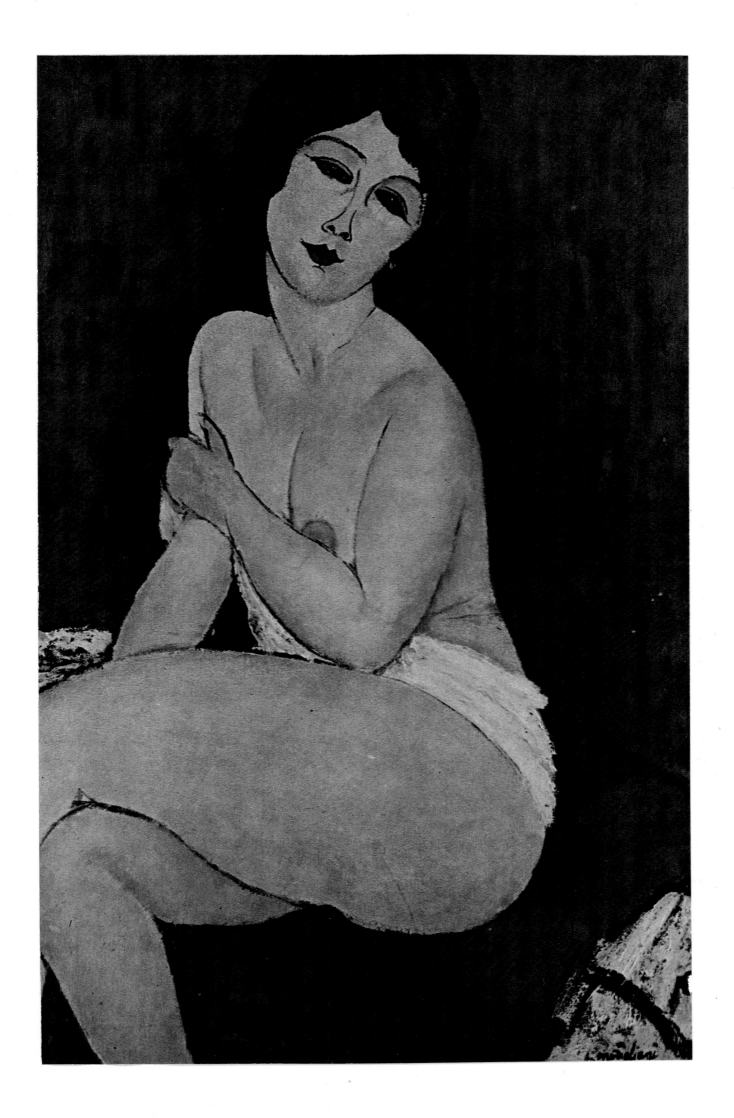

Painted 1918

PORTRAIT OF LEOPOLD ZBOROWSKI

Oil on canvas, 42 1/8 × 26"

Museu de Arte, São Paulo, Brazil

Leopold Zborowski (1889–1932), who was of Polish aristocratic descent, arrived in Paris from Cracow on a scholarship in June, 1914. As a foreigner with an Austrian passport he was interned for a while after the outbreak of World War I. After his release, he started to make a living as a free-lance bookseller. In his reminiscences, Charles Douglas talks about Modigliani's most ardent friend and patron, "Zbo": "From the first, the poet-turned-dealer found the task of selling Modigliani almost as difficult as Modi himself—who had none of the patience and persuasive powers of his friend— had found it. But Zborowski was indefatigable. Nothing discouraged him. Modi must have sufficient food, and above all painting materials.... Zborowski would even deprive himself of tobacco that Modi might drink, recognizing that alcohol to him was a *sine qua non* for work. When things got worse, he went so far as to sell, for Modi's sake, his clothes and the few objects of value he possessed. His wife was as devotedly enthusiastic as he was."

Modigliani repeatedly painted the dealer and his wife. This is one of the artist's most successful works. The sitter is revealed in all the nobility of mind and heart he truly possessed. This picture is a veritable act of friendship. A tall, elegant man, with drooping moustache, a neat pointed beard, and sloping shoulders, he might have been a grandee painted by El Greco.

136

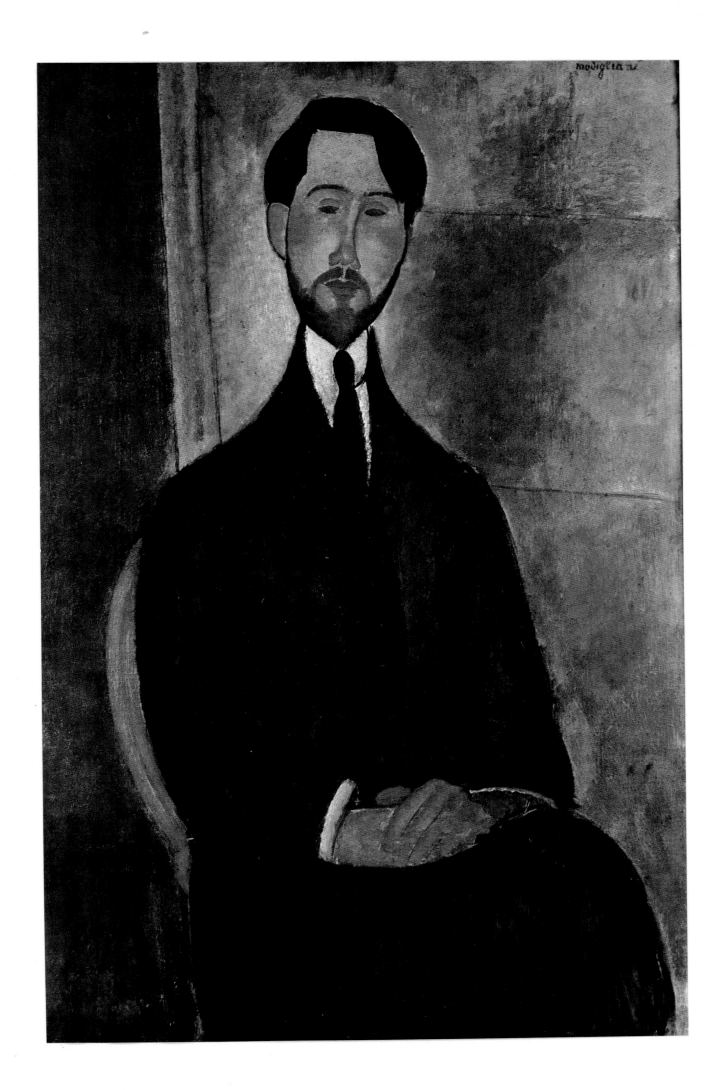

Painted 1918

LE ZOUAVE

Oil on canvas, 24 3/4 × 19″

Collection Mr. and Mrs. Stavros Niarchos, Paris

The Zouaves were members of a French light infantry corps originally recruited solely from a tribe of Berbers. Although in the course of time the corps came to consist purely of Frenchmen, the North African uniform was retained. At Arles, Vincent van Gogh twice painted his friend Second Lieutenant Milliet in that uniform. Modigliani's Zouave, however, wears the uniform of the regular French *poilu*. He has a nondescript, bland face, without particular character—so different from the clearly defined expressions found in the portraits of more distinguished sitters. The military decoration on the soldier's chest tends to relieve the monotony of the large area of brown.

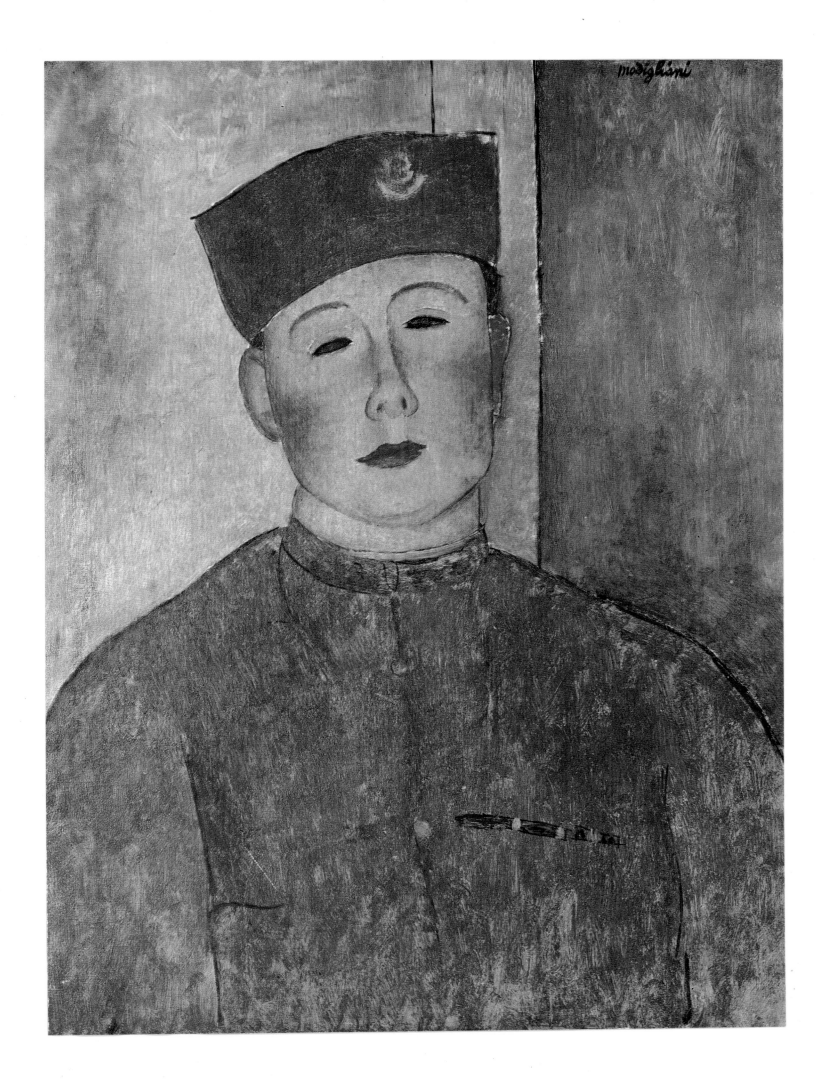

Painted 1918

MAN WITH A PIPE

Oil on canvas, 36 1/4 × 23 5/8″

Private collection, Paris

This picture of a stolid, bearded old man is also known as *Le Niçois*—the man from Nice. It was painted during Modigliani's sojourn in the south of France. For purely aesthetic reasons there is a green stripe on the right, set off against the orange background. To bring out more clearly the whiteness of the collar, a bit of deeper orange is placed to its left.

The sculptor Jacques Lipchitz has said of Modigliani, "He could never forget his interest in people, and he painted them, so to say, with abandon, urged on by the intensity of his feeling and vision. This is why Modigliani, though he admired African Negro and other primitive arts as much as any of us, was never profoundly influenced by them—any more than he was by Cubism. He took from them certain stylistic traits, but he was hardly affected by their spirit." It is indeed a striking achievement that Modigliani could embrace certain elements of primitive art without sacrificing his intense interest in individual personality.

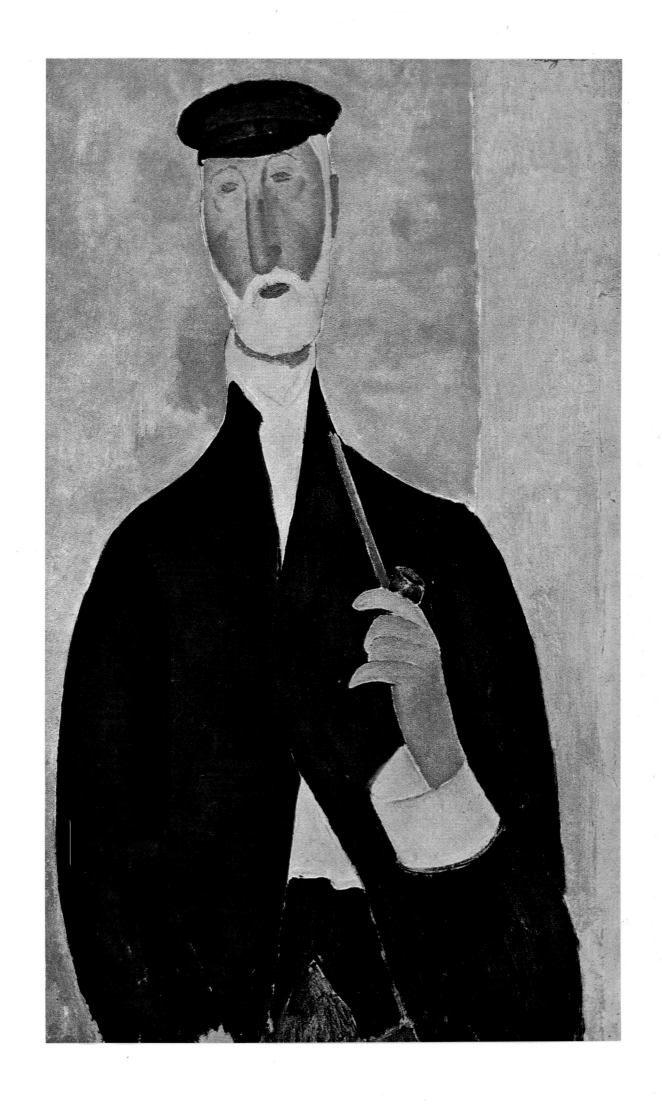

Painted c. 1919

YELLOW SWEATER
(*Portrait of Mademoiselle Hébuterne*)

Oil on canvas, 39 3/8 × 25 5/8"

The Solomon R. Guggenheim Museum, New York

This pose of a woman sitting with her head a little on one side, her hands resting in her lap, often appears in Cézanne. One recalls that his wife, Hortense Cézanne, loathed the countless long sessions to which she was subjected by her irascible husband, who shouted at her, "Sit still—like an apple!" Jeanne Hébuterne does not seem to have objected to her role as a model; unlike Hortense, she never looks tired or bored. While in most cases Modigliani concentrated on the sitter to the exclusion of virtually everything else in the room, here we get a glimpse of some of the simple objects in the couple's household: a chair, a chest, and, in the lower left, what seems to be a small sofa. The sitter is portrayed according to the formula which Modigliani, in his last two years, developed to perfection. The body is shaped in an S curve, and is composed of several rounded forms, gently flowing into melodious lines. Here, the face is thinner, more attenuated than ever before. Modigliani would have agreed with his colleague, Gino Severini: "To distort is to correct nature in terms of the artist's sensibility." Another artist, Lipchitz, has recalled the "very Gothic" appearance of Jeanne, whose blonde hair fell down in long braids (here, the hair is reddish, and is put in an elegant coiffure). Gowned in flowing dresses, she fashioned herself (according to Lipchitz) with a sure "aesthetic sense" for line and color.

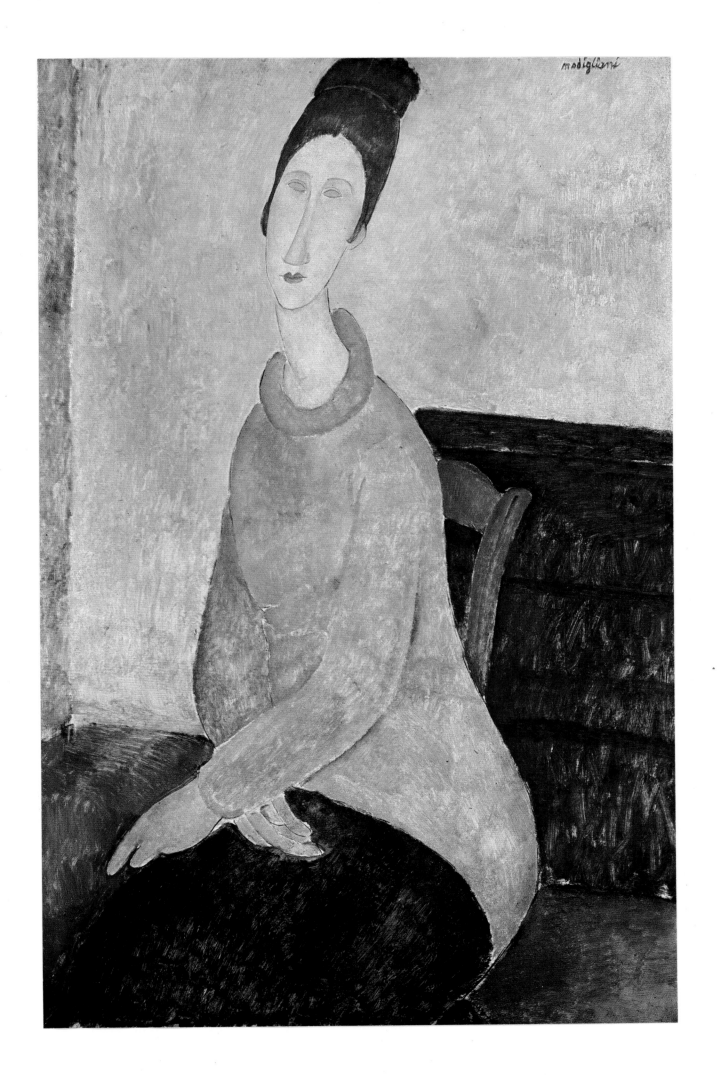

Painted 1918

PORTRAIT OF
MONSIEUR BARANOWSKI

Oil on canvas, 43 3/4 × 21 5/8"

Collection Mr. and Mrs. R. J. Sainsbury, London

Like the preceding one, this picture is painted in sinuous curves (these serpentine compositions are based on an S, or on the treble clef symbol). To avoid a dull symmetry, the head is quite askew, thus acquiring an expression the late Gothic woodcarvers gave to their Madonnas by slightly tilted head, or a hip thrust to one side. Who was Monsieur Baranowski? Supposedly a painter—one of the hundreds of artists and intellectuals who flocked to Paris from Eastern Europe, most of whose talents were to remain unrecognized, their dreams unfulfilled. Modigliani once remarked to a friend: "To do any work, I must have a living person, I must be able to see him opposite me." He liked to be inspired by the originality of the sitter, always stopping well this side of caricature, never allowing malice to enter the portrait. To judge by this portrait, Baranowski must have been a sensitive, introspective man of the type Modigliani liked to associate with. But it must also be borne in mind that Modigliani invariably endowed his sitters with the charm and grace of his own attractive personality. The French critic Christian Zervos once wrote: "We may discern in the thoughtful subtlety of Modigliani's faces something peculiar that the art of Botticelli had brought into Italian painting." The correctness of this observation is borne out by Baranowski's portrait.

144

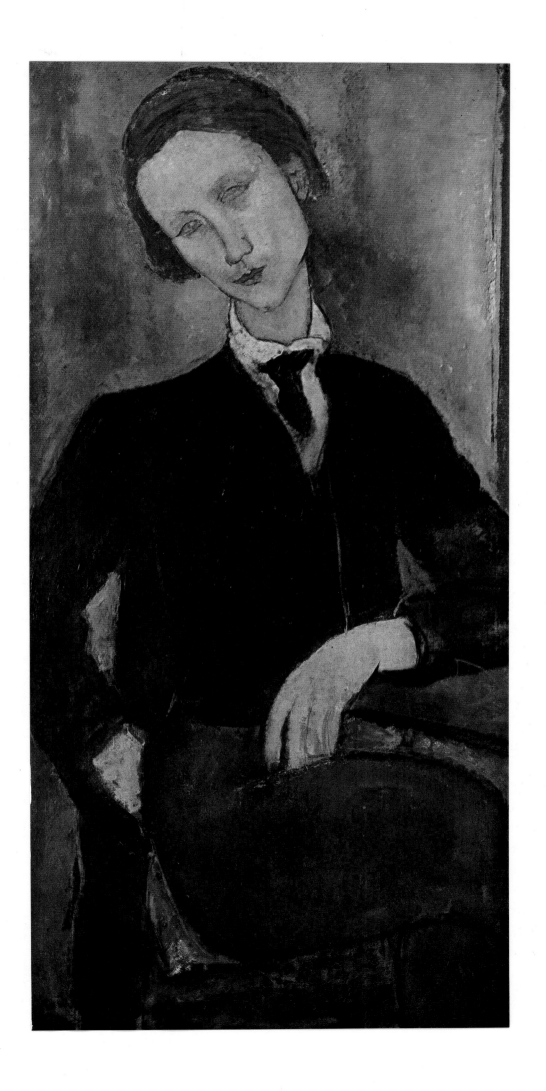

Painted 1918

THE LITTLE PEASANT

Oil on canvas, 39 3/8 × 25 3/8"
The Tate Gallery, London

Painted in the south of France, this engaging picture was one of the first by Modigliani to enter an English collection (it was sold by Zborowski in 1919). We see in this small rustic the same simple dignity that Cézanne gave to the modest folk of Provence. Both artists, despite their middle-class backgrounds, were fond of what is known as the Common Man. In Modigliani, a Socialist tendency may have come into play. The British critic John Russell finds "an echo of the late nineteenth century left in the readiness with which he gave a timeless human grandeur" to a picture like this one. Modigliani was aware of his affinity to Cézanne. But he also re-marked to Soutine: "Cézanne's figures, just like the finest statues of antiq-uity, do not look. Mine, on the contrary, do. They see, even when I have chosen not to draw the pupils; but, like the figures by Cézanne, they do not want to express anything beyond a mute acceptance of life." This statement might be applied to this country lad who is treated here plainly, without ornament or any other embellishment. The sitter may very well still be living—without the slightest awareness that an early portrait of him (probably the only one made by a painter) is now a prized possession of one of the world's major museums.

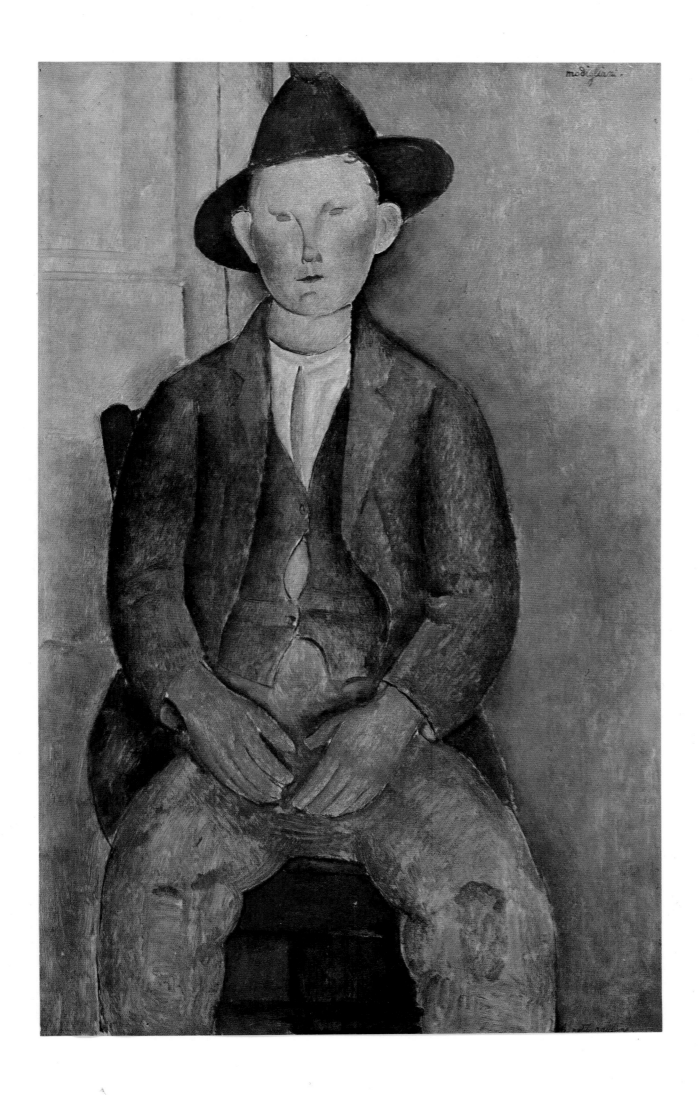

Painted 1919

THE YOUNG SERVANT GIRL

Oil on canvas, 60 × 24"

Albright-Knox Art Gallery, Buffalo, New York, Room of Contemporary Art

The French title is *La Jeune Bonne*. A *bonne* is a nurserymaid or a lady's maid. She is usually a girl from the country who seeks employment in the large cities. She works hard, is on her feet from daybreak till late in the evening, and wears the simple dress and heavy shoes in which she is depicted here. Her chores leave her as fatigued and untidy as she appears in this sympathetic rendering by Modigliani, who does not fail to point out, through the empty slits that are her eyes, that for her there is little in life that she can look forward to. We happen to know the name of this particular model: she was Marie Feret, a peasant girl from Cagnes-sur-Mer.

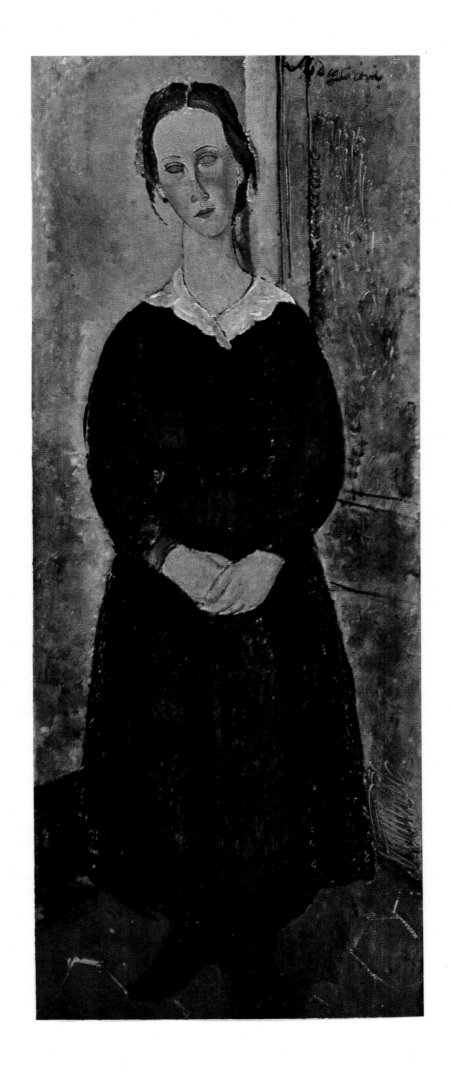

Painted 1918

NUDE RESTING

Oil on canvas, 28 3/4 × 45 5/8"

Private collection

In other paintings the space is clearly indicated, and at least some semblance of shape is given to the bed or sofa upon which the woman is reclining. Here the body is set against several modulated areas of abstract color, designed solely to set off the flesh tones and the black hair that surrounds the face. The model is not known. As a matter of fact, the faces of the nude models do not have any of the psychological complexity with which Modigliani was concerned when faces were the sole subjects of his painting. While his nudes are as earthy as those of Rubens or Renoir, they are more "abstract," pictures rather than color shots of reality. His nudes were not appreciated during the artist's lifetime. Lipchitz reports that after the fiasco of the one-man show of 1917, Modigliani offered him four nudes for the ridiculously low price of 500 francs, that is, about $125, for the lot. Lipchitz did not have room for them and did not buy them. Today, each would sell for more than $100,000!

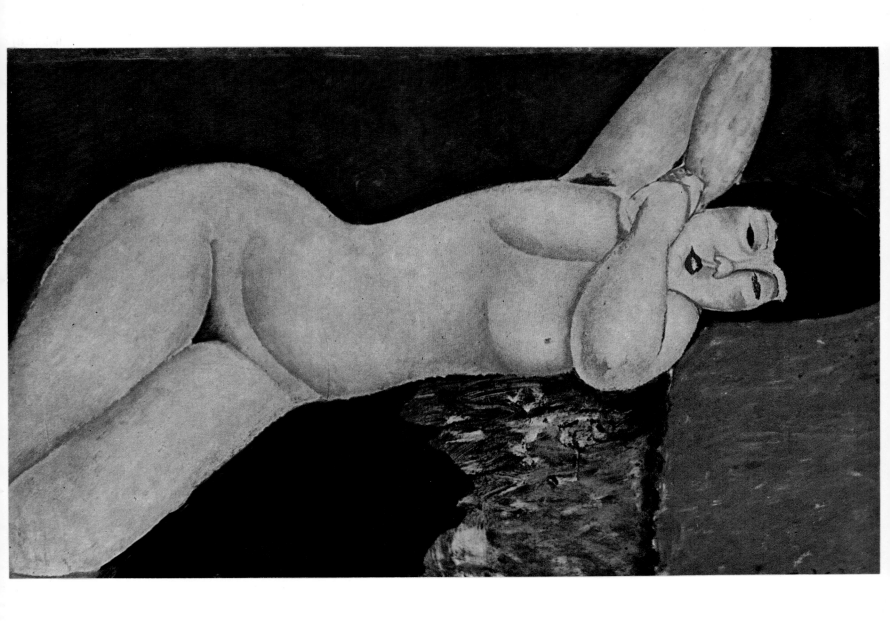

Painted 1918

GYPSY WOMAN WITH BABY

Oil on canvas, 45 × 28 3/4″

National Gallery of Art, Washington, D. C. (Chester Dale Collection)

We know nothing about this woman with a sailor's collar. In the cata-
logues, the picture is called *Motherhood* or simply *Seated Woman with Child*.
In parentheses, she is sometimes characterized as *gitane* or *bohémienne*, both
terms for a gypsy woman. Perhaps her straight black hair, ending in short
braids, is a clue to her racial origin. Modigliani, who often provides us with
inscriptions on the canvas, leaves us guessing here. This picture has been
frequently reproduced, and is the favorite of those who prefer Modigliani
when he leans toward a more conventional treatment: this group, indeed,
is furnished with a great many details. The juxtaposition of warm with cool
colors, a chromatic system which the artist learned from Cézanne, may be
responsible for the apparently arbitrary choice of eye color. The blue eyes
are unexpected in so brunette a model, but the blue echoes the cool color
of the scarf and contrasts with the warmth of the skin tones.

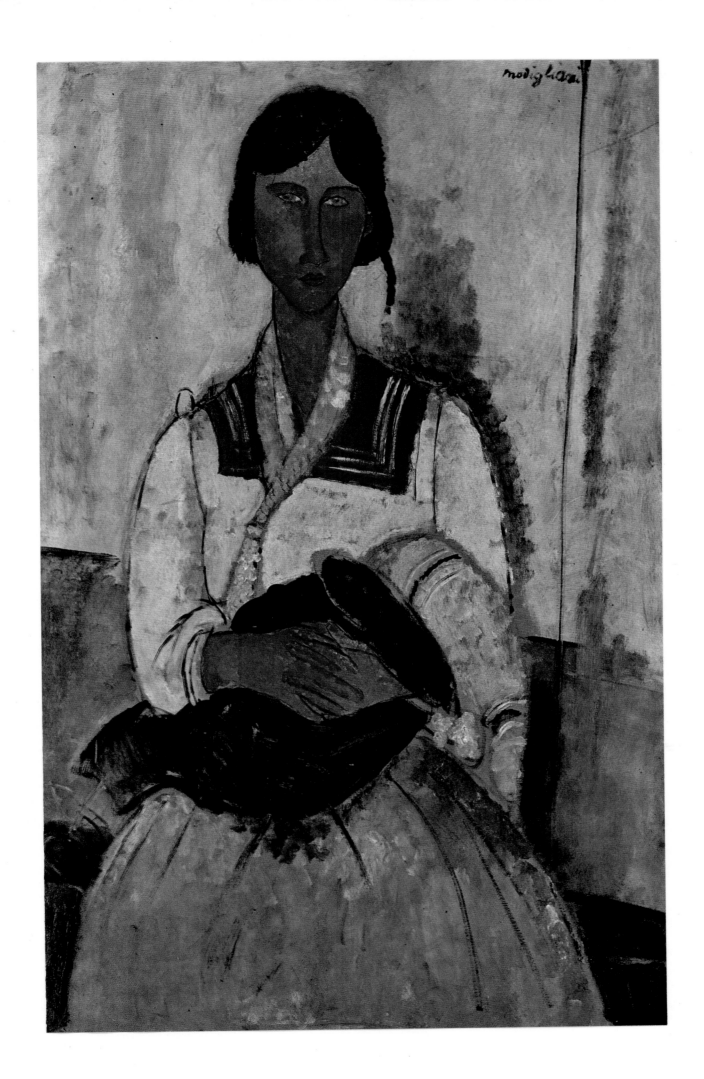

Painted 1918

YOUNG GIRL WITH BROWN HAIR

Oil on canvas, 26 × 18"

Collection Emilio Jesi, Milan

In many cases, Modigliani's sitters are known to us. In other cases, the first name, or the sitter's occupation (e.g., *la belle épicière, la marchande de fleurs*) or only her nationality (*la petite japonaise, la belle polonaise*) has come down to us. Here we know nothing about this young girl, a casual acquaintance whom chance put in the artist's path. Note here, as elsewhere, the decorative design created by the bangs. The darkish green of the dress is picked up by the variations of green in the background. As elsewhere, the eyes are reduced to blue slits which, in some inexplicable way, still manage to exchange regards with us.

The art historian Lionello Venturi, in his *Italian Painting from Caravaggio to Modigliani*, has admirably described the sitter's role and function: "Sitting motionless . . . in relaxed attitudes, daydreaming, their minds void for the moment of the petty anxieties of daily life, they gaze towards the painter. Or, rather, it is the painter who is gazing at them with tender feeling, a sense of intimate communion with beings as forlorn as himself—more so indeed since they have not his consolation, his hope of creating beauty through the medium of his art. The strange thing is that somehow Modigliani seems to communicate that hope to those he painted; their eyes may appear vacant, but in them is a glimmer, a dim reflection, as it were, of the artist's secret dream."

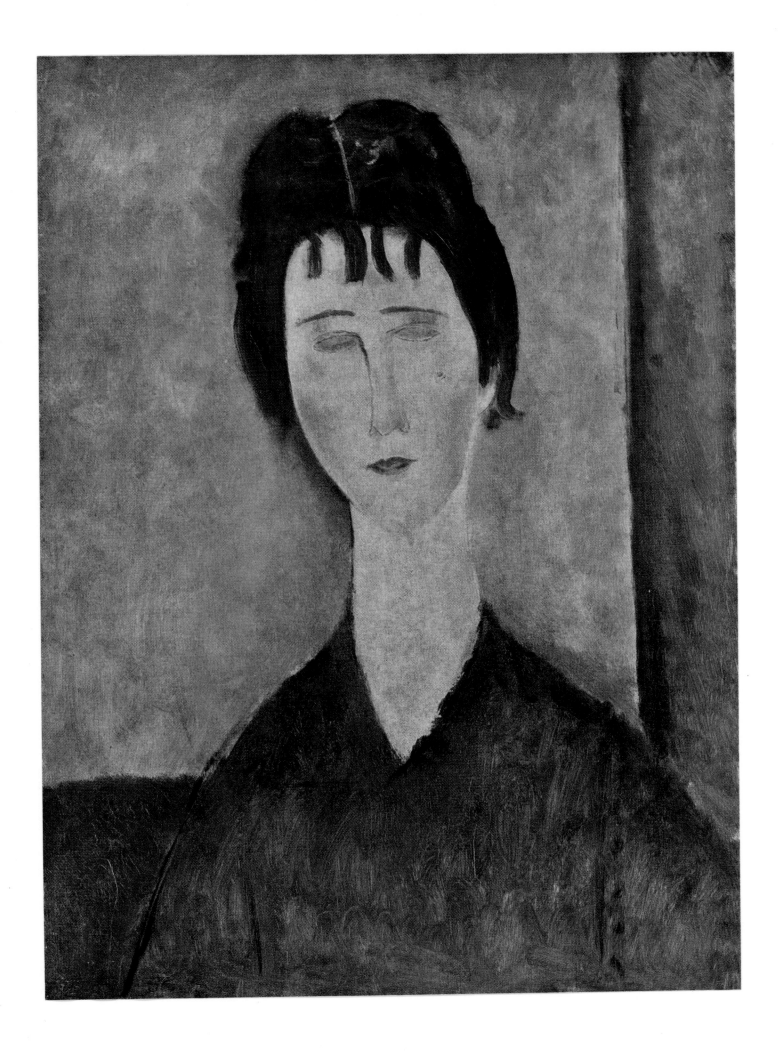

Painted 1919

PORTRAIT OF LUNIA CZECHOWSKA

Oil on canvas, 18 1/2 × 13"
Private collection, Milan

The sitter, a friend of the Zborowskis, first met the artist in June, 1916. In every possible way she tried to assist Modigliani, and subsequently Jeanne Hébuterne as well. The artist drew and painted her aristocratic Slavic features repeatedly; among Modigliani's best-known pictures, now in the Petit Palais, Paris, is one of Madame Czechowska in a yellow dress and holding a fan. Ambrogio Ceroni's *Amedeo Modigliani, Peintre* includes Madame Czechowska's memoirs, written in 1953. She says of Modigliani, "I was struck by his distinctive appearance, his radiance, and the beauty of his eyes.... Modigliani saw only that which was beautiful and pure." Modigliani, she continued, was "determined to capture his or her character and to implant it in his work. As for the model, he or she had the impression of having the soul laid bare and of being in the strange position of being able to do nothing to disguise the feelings."

This is one of Modigliani's most beautiful and most celebrated portraits. The figure is drawn firmly, with incisive strokes, against the bare wall. Like the sixteenth-century Mannerists of his native country, Modigliani here asserts his independence from nature by freely exaggerating and distorting, while maintaining a balance between naturalism and abstraction. His passion for beauty, his desire to avoid the ordinary, and his search for intellectual grandeur did not conflict with his yearning for truth about the sitter. While one admires the spiritual elegance and crystalline perfection of this picture, one becomes fully aware of Madame Czechowska's dignity, her serenity tinged with a touch of sadness.

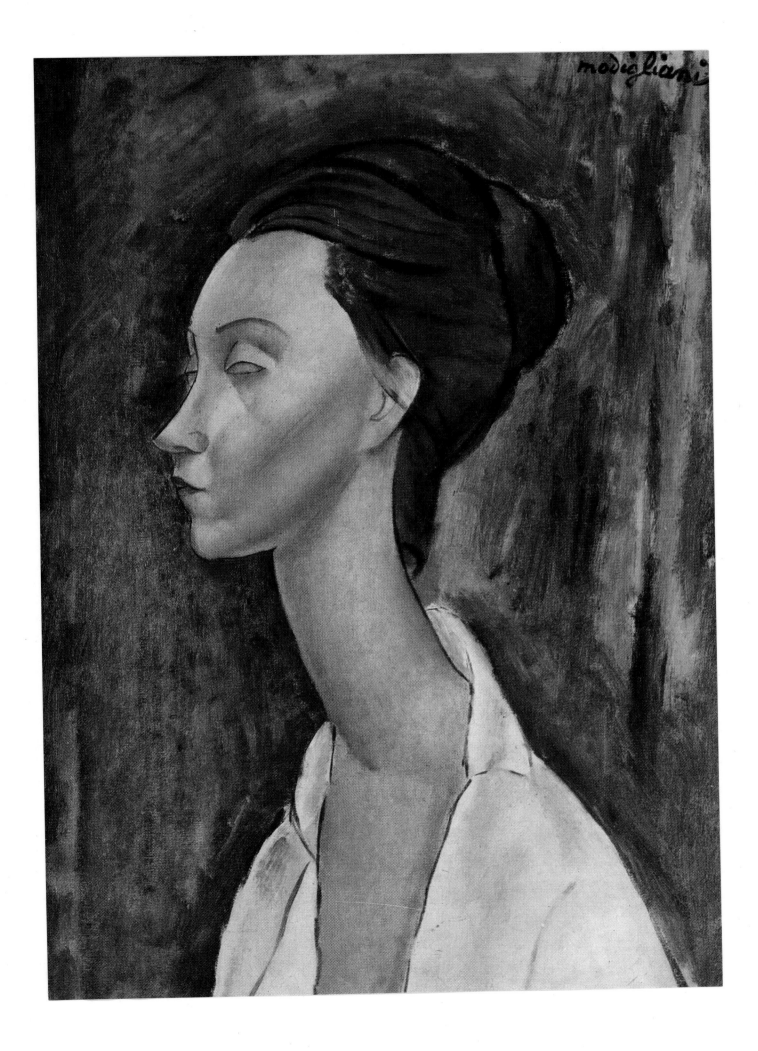

Painted 1919

PORTRAIT OF JEANNE HÉBUTERNE

Oil on canvas, 51 1/4 × 32″

Collection Mr. and Mrs. Sydney F. Brody, Los Angeles

Here the sitter is posed before a door. It is one of Modigliani's last pictures —it may have been the very last. Jeanne reveals the first signs of the approaching maternity; she was expecting their second child, destined to die unborn with Jeanne's suicide. Rightly regarded as one of the finest pictures Modigliani ever painted, it has what has been called *eleganza tutta Toscana.* The suffering yet patient woman is painted with unmistakable warmth and understanding, in all her childlike withdrawal into herself from a hostile world. Here, spiritualization reaches a new height. Christian Zervos has written about the artist's last works that they "changed little in form or technique; we find in them only changes towards a greater penetration in the quality of sentimental perception which unites and fuses the whole picture—whereas in earlier works the emotion was often localized."

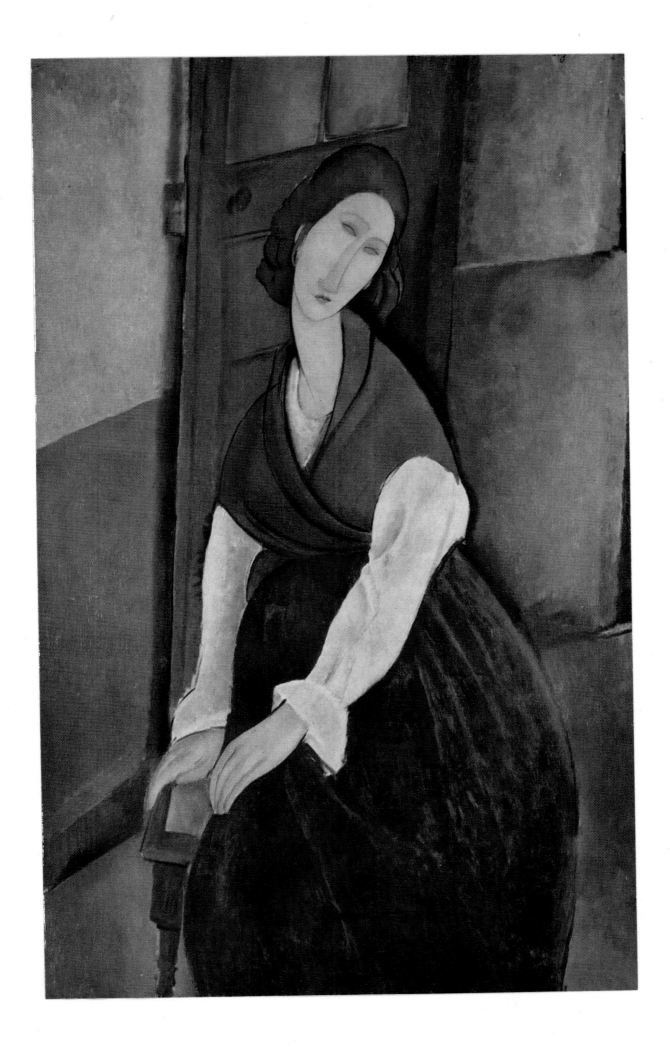

SELECTED BIBLIOGRAPHY

For a more comprehensive listing of writings about Modigliani, including articles that appeared in newspapers and magazines, the reader is directed to the extensive bibliographies in Giovanni Scheiwiller's *Amedeo Modigliani*, 5th ed., Milan, 1950, and in the same author's *Modigliani*, Zurich, 1958.

GENERAL WORKS

CARRIERI, R. *Dodici Opere di Amedeo Modigliani*. Milan, 1947.

CERONI, A. *Amedeo Modigliani, peintre*. Milan, 1958.

———. *Modigliani: dessins et sculptures*. Milan, 1965.

COCTEAU, J. *Modigliani*. Paris, 1951.

DESCARGUES, P. *Modigliani*. Paris, 1951.

FRANCHI, R. *Modigliani*, 3rd ed., Florence, 1946.

JEDLICKA, G. *Modigliani*. Zurich, 1953.

LIPCHITZ, J. *Amedeo Modigliani*. New York, 1954.

MAUD, D. *Modigliani*. New York, 1929.

MODIGLIANI, J. *Modigliani: Man and Myth*. New York, 1958.

NICOLSON, B. *Modigliani*. London, 1948.

Omaggio a Modigliani, edited by G. Scheiwiller, with contributions by Braque, Cendrars, Cocteau, and others. Milan, 1930.

RAYNAL, M. *Modigliani*. Geneva, Paris, and New York, 1951.

RUSSOLI, F. *Modigliani*. New York, 1959.

SALMON, A. *Modigliani, sa vie et son oeuvre*. Paris, 1926.

———. *La Vie passionnée de Modigliani*. Paris, 1957.

SAN LAZZARO, G. DI. *Modigliani peintures*. Paris, 1953.

SCHAUB-KOCH, E. *Amédée Modigliani*. Paris and Lille, 1933.

VITALI, L. *Disegni di Modigliani*, 2nd ed., Milan, 1936.

WERNER, A. *Modigliani the Sculptor*. New York, 1962.

CATALOGUES

Edinburgh: Royal Scottish Academy, and London: The Tate Gallery, published by The Arts Council of Great Britain, 1963.

New York: The Museum of Modern Art, 1951.

Rome: Galleria Nazionale d'Arte, 1959.